CZECHOSLOVAK CULTURE

Recipes, History and Folk Arts

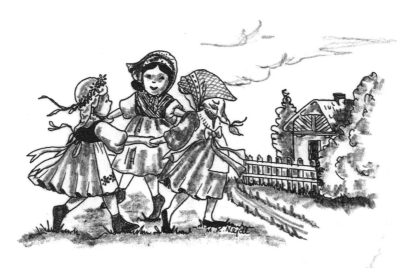

Compiled by Pat Martin

Edited by John Zug
Photography by Joan Liffring-Zug
Graphic design by Esther Feske and Judy Waterman
Egg and folk art drawings by Marjorie Kopecek Nejdl
Editorial assistants: M. Melvina Svec, Charles Vyskocil,
Lillian Prihoda, Michelle Nagle Spencer, Scott
Elledge, Miriam Canter, Kathryn Chadima,
and Georgia Heald

Penfield
Press

Kristin's Costume

On the front cover, Kristin Kos is wearing a very special costume. Here is her grandmother's description of the kroj:

In the Podluži region in southern Moravia, it is as though all the rich creative forces of the past generations had been let loose. At every step we meet expressions of the people's many creative instincts.

The beautiful dress shown here, worn by Kristin M. Kos, is completely handworked, an orgy of ideas and original artistic design, and there is no part of it unadorned.

Heavy embroideries on snow-white gently rounded sleeves, collar and apron (*fěrtoušek*) are bordered with bobbin lace and a pastel colored longer skirt. The vest (*kordulka*) is completely made of shirred silk ribbons which are reworked and embellished with silk and sequins on both front and back. Broad silk ribbons, also hand-embroidered, are worn around the waist, as bows on a collar, and uniquely folded into loops on top of a conical headdress worn by women and girls.

Kristin's great-great-grandmother, Jozefa Sedlaček, reminisced about the interesting custom she remembered from her girlhood: the girls and women plaited their hair on their foreheads in a distinctly lacy pattern.

Among the best known exquisite folk costumes of the Podluži area is this dress from the town of Lanžhot.

The eggs shown with attached ribbons were hung on pussy willow branches in the rites-of-spring festivals. On Easter Sunday boys plaited willow whips to threaten the girls, who often bought immunity with an egg. Monday after Easter was reserved for the girls to chase the boys.

—*Blanche Kos*

ISBN 0-941016-61-7
Library of Congress Number 89-60571
Copyright 1989 Penfield Press
Julin Printing Company, Monticello, Iowa.

About the Author

Pat Martin served eight years as Coordinator of the Czech Village in Cedar Rapids, Iowa. She helped originate four and organized five annual Czech festivals and events with the assistance of Czech organizations, community organizations, and hundreds of volunteers. Although Pat now teaches fulltime in the Cedar Rapids Public Schools, she stays involved with her Czech Village friends.

Acknowledgments

In addition to those named with their recipes or photographs, or in articles, we acknowledge with thanks the help of Lillian Chorvat, CSA Museum, Berwyn, Illinois; Jan Sopoci, Sokol U.S.A., East Orange, New Jersey; Marjorie Gober, Marengo, Illinois; Milan and Norma Getting, Bellevue, Pennsylvania; Maxine Bruhns, Charles Cubelic, and Mrs. Mickey Walker, all of Pittsburgh, Pennsylvania; Ellen (Mrs. Leonard) Soukup, Ridgeway, Iowa; Ruth Wondriska, West Hartford, Connecticut; Carole Jezek Vermillion, Greendale, Wisconsin; Faith Knutson, Park River, North Dakota; Marie Greicar, Pisek, North Dakota; Irma Ourecky, Wilber Czech Museum, Wilber, Nebraska; Don and Katie Haselbauer, Minneapolis, Minnesota; Debbie Meyer, New Prague, Minnesota; Charlotte Tingo and Shirley Hummitsch, both of Marshfield, Wisconsin; Tom Kuchvalek, North Riverside, Illinois; Sarah R. Lea, Chicago, Illinois; Vicki Hughes, director, Usher's Ferry, Pioneer Village, Cedar Rapids, Iowa; the Czech Heritage Foundation, Cedar Rapids, Iowa; and the Iowa City Public Library.

Books by Mail *(to one address):*
This book: $13.95; 2 for $24; 3 for $32.
The Czech Book: $6.95; 2 for $12; 3 for $18.
Czech Wit & Wisdom: $5; 2 for $9; 3 for $12.
Cherished Czech Recipes: $4; 2 for $6.50;
3 for $9.
Prices subject to change. *All prices postpaid.*
Penfield Press
215 Brown Street
Iowa City, IA 52245-1358

Contents

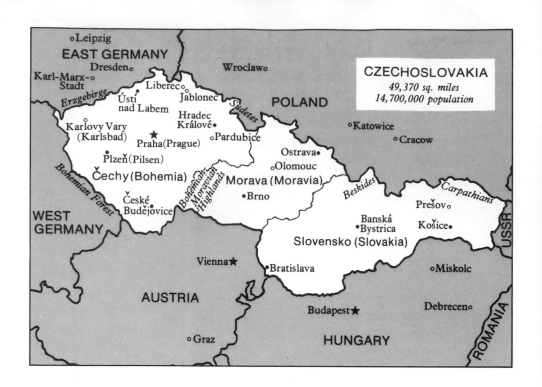

CZECHOSLOVAKIA
49,370 sq. miles
14,700,000 population

Yesterday and Today

The Indomitable Pioneer Spirit of the Creative Czechoslovaks

The immigrant leaves behind intolerance in religion, autocratic rule, heavy burdens of government, a hard and fast class system, severe military service, and a perpetual struggle with poverty, for the United States, where fair play, a square deal, and justice are afforded to all.

—Sarka Hrbkova
Professor of Slavonic Languages
University of Nebraska

My Antonia, written by Willa Cather "in memory of affections old and true," is the story of a Czech woman who embodied the pioneer spirit. Antonia represented hard work, pride, love of the land, and desire to do what was best and right—in essence, the character of the Czech pioneers who came to this country.

Bohemia, Moravia, and Slovakia have retained identity, language, and culture throughout the centuries despite being caught in the cross-fire of major wars. The future of the people has always been dependent on the winners of the cross-fire.

Among the first settlers in the early 1600s were religious exiles from the areas now known as Czechoslovakia. Augustin Herrman, who arrived in 1633, was one of the early leaders of New Amsterdam, which became New York City. Biographer Earl L. W. Heck called him "the first great American."

A Czech family that included master rangers of the royal forest went to Holland after 1620, and changed the family name to Philipse. Members of this family were among the early Dutch arrivals in America. They built Manor Hall at Yonkers, New York, where the family had 156,000 acres of land. At one time, Frederick Philipse's daughter Mary and George Washington were enamored of each other. But during the American Revolution the Philipses supported the Tories and that was the end of their American connection. Manor Hall is owned today by the state of New York. Frederick Philipse built the Old Dutch Church at Tarrytown, New York.

Later immigrants included many who came because of oppression and lack of employment, or because they had a fierce desire for the freedom and opportunity that was the promise of the New World. These people were skilled in farming and in many professions and trades.

Still later immigrants, settling in industrial cities such as Pittsburgh, worked in the steel mills, on the railroads, in the coal mines, and at many other jobs. Those who wanted to farm found land in Wisconsin, Nebraska, Iowa, Kansas, the Dakotas, Oklahoma, and Texas.

The first lawyer west of the Mississippi was Joseph Sosel, who in the Old Country had espoused unpopular political views. He escaped punishment when his friends smuggled him across the border in a barrel. He settled in Cedar Rapids, Iowa.

The immigrants were of robust body and spirit. To survive the three-month voyage across the ocean in overcrowded, unventilated, unsanitary, and inflammable quarters, the pioneers had to have strength of body and mind. Many died of starvation, suffocation, or disease on these voyages. Some immigrants formed themselves into groups, and appointed watchmen who took turns protecting the passengers' lives and precious-but-scant property from ignorant, barely skilled, or drunken seamen who were captain and crew.

Not until 1855 were immigrants guaranteed a permanent immigrant depot where they were protected from thieves and were given assistance, in exchange for money, in purchasing tickets to their final destinations. Not until then were they given a decent and honest reception to these shores.

These pioneers had vision. They had dreams. And they had courage. Imagine a farm family from Slovakia arriving in Pittsburgh on a bitter cold day, frightened and homesick, amid throngs of people who did not speak their language and in an atmosphere of red skies, black soot, and smoke. Imagine the family seeking to homestead in Nebraska, coming from a land of rolling hills and trees and finding the flat prairies, which were utterly devoid of trees until man began to plant them.

In Willa Cather's *My Antonia*, when Jim Burden saw Antonia in middle age, life had been rough on her. Her weathered face told of the hard work she had endured on the Nebraska prairie. But Jim Burden loved her still for what was within her. Her magnetism and her warm, lively soul were still brightly alive.

"These were the real sources of my love for her," Jim said.

For the pioneers 300 years ago or today, advancing age does not diminish character.

6

In the Old World, rigid classes divided the people. In the New World, the baby born in a log cabin could one day become President, illustrating a social flexibility that united the people and made them as one. A "new aristocracy," for want of a better term, was created. It is composed of people with strong talents and strong intellects, who understand that the "cultivated person" knows who he is, is comfortable with that knowledge, and for that reason is at ease with others like himself. That person's major roles may involve food preparation, or religious rituals, or care of the young or old, or classical learning, or exploration of old beliefs and old arts, or a career in a profession or business, or whatever. It is all a creation of the freedom that still beckons to these shores many who are certain there must be a better way, and are confident they will find it here. When they find it, their appreciation of their new land cannot be matched among those who have no personal memory of how it was in other days, in other places. So we say to the person of Czechoslovak descent, "Know your heritage."

In the novel, Jim Burden describes Antonia as not only a person, but also a symbol of courage, hope, and that elusive quality of being able to see good in so many things.

"It is no wonder that her sons stood tall and straight," he said. "She was like a rich mine of life, like the founders of early races."

It is no wonder that those who inherit the richness of the Czechoslovak culture stand tall and straight, for their culture is, like Antonia's, a rich mine of life.

Czechoslovak National Revival

The Resurrection of a Culture

The heritage that Czechoslovaks proudly preserve and cultivate has always faced a struggle for survival. As late as the mid-1800s the Czech language was "socially and intellectually unacceptable" in its own homeland. The German language was dominant except in stores and public places that were patronized by apprentices, domestic servants or peddlers.

Subservience to the Austro-Hungarian monarchy continued until the collapse of that empire at the end of World War I in 1918, when Czechoslovakia—including Bohemia, Moravia, and Slovakia—declared its independence. Slovakia had been under Hungary since the Battle of Pressburg in 907.

By 500 B.C., the time the Slavs first appear in history, they had a common language. That language developed through the centuries. The philosophical and theological writings of Thomas of Stitny (1331-1401), were written in Czech rather than the customary Latin. His writings demonstrated that the Czech language could be used for dealing with even the most abstract of subjects.

The development of a language and the development of a culture go hand in hand, and political turmoil can be a major factor. In 1608 a decree of the Estates of Bohemia declared Czech to be the only official language of the country. Just 12 years later, in 1620, the Battle of White Mountain ended Bohemian independence.

In the long centuries under the Hapsburg dynasty, the struggle for language and culture had its ups and downs. After 1620, authorities of the monarchy destroyed all Czech writings they could find, and banned the Czech language from the schools. But the language and the culture refused to die.

Strong leadership came later from Frantisek (Francis) Palacky (1798-1876). Educated in German and Latin schools in his native Moravia, he visited a school friend in Slovakia and came upon a number of Czech books in that friend's library. Palacky was much impressed by *Labyrinth of the World* and *the Paradise of the Heart* by Jan Ámos Komenský. Palacky later read a magazine article *A Discourse Upon the Czech Language* by Josef Jungman. This patriotic essay sparked Palacky's nationalism and he joined a group dedicated to the regeneration of their nation. Members of this informal

coalition of Czechoslovakians compiled grammars and dictionaries, and published scholarly works.

In 1827 Palacky became editor of the journal of the Bohemian Museum. An admirer of Edward Gibbon's *Decline and Fall of the Roman Empire,* he devoted the years after 1832 to compiling his history of the Czech nation in Bohemia and Moravia, entitled *Geschichte von Böhmen* in five volumes, and *Dejiny Národu Českého.* He was active politically, serving as chairman of the 1848 Prague Slavic Congress and later as a deputy in the Reichsrat. He steadily advocated equal status for each nationality in the Empire, a goal that proved easier for the government to proclaim than to attain.

Weakened by conquering nations for centuries, the sense of National Revival began in the early 1800s and flourished into the Twentieth century. Started by young aristocrats resentful of attacks on their inherited privileges, the revival survived criticism and in the end resulted in an over-all promotion of culture and confidence for the common man as well.

The ethnic and intellectual consciousness of an entire people was raised. The talents of ordinary men and women made a special imprint on the culture, and particularly on the creative arts of the period. This influence is found in the painted woodcut, in pieces of painted furniture, in pottery, glassware, and ceramics, and in folk architecture. The shapes and colors of folk costumes, which originally were worn every day and later only on festive occasions, were formed in a special way by all Czechs, Moravians, and Slovaks regardless of economic, social, or intellectual status.

Until 1918 political growth came slowly and piecemeal, but there was great economic and cultural progress. Illustrious intellectuals and artists, such as Smetana, Dvořák, Manes, and Aleš, devoted their talents to the national cause. Aristocrats painted on china, but the artistry of the peasant with the egg was just as significant. Everyone became involved in a national awareness of culture, art, literature, and pride of the people, and everyone was richer for it.

Because a sense of the revived culture and national consciousness was brought to the New World by Czech, Moravian, and Slovak immigrants who remembered their roots while maintaining pride in being Americans and Canadians, the United States and Canada are richer for it as well.

Centuries of History
Briefly Told

Czechoslovakia's Declaration of Independence did not come until October 28, 1918, as World War I was coming to an end. The forming of a distinct nation of peoples, however, had been under way for more than 1,500 years.

Czechoslovakia has three distinct regions. *České* (Bohemia) is the westernmost, *Morava* (Moravia) is the middle one, and *Slovensko* (Slovakia) is the eastern region. There are three distinct languages. All are in the Slav language family, but vocabularies and pronunciations are quite different. In general, however, people of the three areas can understand each other fairly well.

The language of *České* is Czech. Prague is the capital of Czechoslovakia. The land is mostly urban and industrial, with some agriculture.

Moravians speak their own dialect. Brno is the largest city. Heavily agricultural in the southwest, *Morava* is industrial in the northeast.

Slovakians speak Slovak. The largest city is Bratislava. *Slovensko* is rural, agricultural, and mountainous, with recent industrial development.

The peoples are called Czechs, Moravians, and Slovaks (or Slovakians). When speaking of the people as a nation, the term is "Czechoslovaks" or "Czechoslovakians."

Some 2,000 years ago, under pressure of Roman invasions, the Celtic Boii tribes moved north and east from ancient Gaul (now France) to a new home north of the Danube River. Roman maps came to identify the area as Boiohemie, and the name later became Bohemia. The Celtic Boii tribes did not retain their identity.

About 500 A.D. Slavic people migrated from the Vistula River area to the western part of what today is Czechoslovakia. According to legend they were guided there by Jan Cechus, a chieftain, and are known today as Čechs (Czechs) after that leader.

In the ninth century the Czechs and Slovaks came under the Great Moravian Empire of Rastislav. In 863 this leader invited the Christian missionaries Cyril and Methodius to introduce Christianity. From the spoken language, these two men developed a written language so that the Bible could be introduced to the people. Rastislav's people were the first Slavs to adopt Christianity and to have a written language.

Between 1100 and 1400 Bohemia became a powerful political and military force, and Prague became a crossroad of European trade. The Holy Roman

Empire invited German merchants, artisans, and miners to settle in Bohemia and Slovakia. New skills in agriculture and commerce were introduced, and the arts of ceramics, glass, and woven materials were refined. In the Thirty Years War (1618-1648), Prague was occupied by Saxons in 1631 and by Swedes in 1648.

This small country of 49,370 square miles is rich in graphite, radioactive minerals, coal, and other deposits, as well as forests and agricultural lands, all of which has lured armies and conquerors. Slovakia came under control of Hungary in 907. The Battle of White Mountain in 1620, in which Catholic forces defeated Protestants, brought Bohemia and Moravia under the Hapsburgs' Austro-Hungarian empire, which did not collapse until 1918.

Through the centuries the Slovaks, Moravians, and Czechs resisted repeated efforts to force them to be assimilated into the language and life of their conquerors. When freedom finally came, it lasted less than a quarter-century. Czechoslovakia fell to Nazi Germany at the start of World War II. After that war there was brief freedom, but Czechoslovakia has been under repressive communistic rule since 1948.

Although the people were Polish, southern Silesia —north of Bohemia and Moravia—became a part of Bohemia in the 1300s when a Bohemian princess married a Polish prince. Such an occurrence was not unusual; it was happening "all the time" in Europe in those days. Southern Silesia was a part of the Austro-Hungarian empire. After World War II, it became a part of Poland.

When Czechoslovakia was formed after World War I, people in Ruthenia, a part of the Ukraine, asked to join and were admitted. After World War II, they were taken over by Russia and became a part of the Ukraine again.

In the twentieth century, Tomás G. Masaryk and Eduard Beneš rose to leadership and are honored today. Born March 7, 1850, in Hodonin on the Moravia-Slovakia border, Masaryk was the son of a Slovak father and Moravian mother. The father was a coachman, the mother a maid. The son became the leader and liberator of Czechoslovakia, and the "father of his country."

Masaryk earned his doctorate in 1876 from the University of Vienna, and the same year married an American music student, Charlotte Garrigue. In 1882 he became professor of philosophy in the University of Prague. Involved in politics from 1889 on, he served in the Austrian Reichsrat, opposing Austria-Hungary's alliance with Germany and championing the cause of ethnic minority groups.

At the start of World War I, Masaryk and Beneš left for western Europe, where they made clear to Allied leaders the Czechoslovak goals:

1. Czechoslovak independence.
2. Czech-Slovak unity.
3. Breaking up the Austro-Hungarian empire on ethnic lines.
4. Creation of new states between Germany and Russia as a move against German imperialism.

In 1918 Masaryk was elected president of the new Czechoslovakian republic. He was re-elected in 1920, 1927, and 1934. He resigned in 1935 and died in 1937.

Eduard Beneš (1884-1948) was born in Kozlany, Bohemia, and was educated in Prague, Dijon, and Paris. When World War I ended, he became foreign minister of the new government, headed by Masaryk, under whom he had studied. In 1935, Beneš succeeded Masaryk as president.

Beneš built diplomatic support for Czechoslovakia, but Britain and France, at the 1938 Munich Conference, gave Hitler the approval under which Germany invaded Czechoslovakia. Beneš resigned and headed the Czechoslovak government in exile in London during World War II.

In 1945, at the end of World War II, Beneš returned and resumed his presidency of Czechoslovakia. In 1948, he resigned rather than sign the Communist constitution.

The Republic of Czechoslovakia, with its constitution modeled after that of the United States, was a model democracy. Its admirers want Czechoslovakia to again be a nation of freedom, initiative, and human rights.

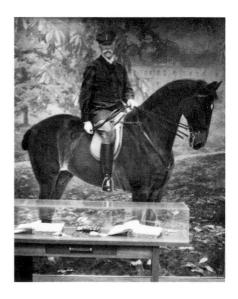

President Tomás Garrigue Masaryk on his horse Hector. Background: Castle of Lany.

Artist: Hornik, Czechoslovakia, 1932. CSA Museum, Library and Archives. Berwyn, Illinois.

The Golden City

The Name Lives Through the Centuries

So rich and beautiful was Prague five centuries ago that it was called "The Golden City." The name, like its beauty, has remained. Prague is a city generous in styles that are gracefully blended by age. Here Gothic, Baroque, Romanesque, and Art Nouveau complement one another. As a city, Prague offers concentrated history.

Of course, Prague and Czechoslovakia are behind the Iron Curtain. If you leave your restaurant after 10 p.m. and see no one but police and if, when you are accosted, you are advised to hustle to your hotel and keep off the street, you are indeed reminded that this is a police state. Perhaps you will recall that war's destruction left these bridges and castles intact because Czechoslovakia, fully intending to defend itself, was simply "given away" by the only major powers that could have saved it—once at Munich and once at Yalta. So today there are Americans who stay away and those who find their visit worth-while. This story is for the latter.

Prague abounds in lovely views. Its skyline is one of the most beautiful in Europe. Great castles and ornate spires rise gracefully above the cobblestone streets, historic parks, and gardens.

The River Vltava, a river made famous by Smetana's symphonic poem, cuts through Prague on its way to the Elbe and the North Sea. It enlivens Prague with green islands over which white gulls soar and circle, and to which beautiful white swans return every year.

In New Town is the famous Wenceslaus Square, a broad tree-lined boulevard in the center of the modern city with hotels, shops, and restaurants. At the head of the avenue, an enormous equestrian statue of St. Wenceslaus stands in front of the National Museum.

Since the fourteenth century people have passed through the gate of the Old Town Bridge Tower to cross the Charles Bridge, where royal processions wound their way to coronation ceremonies at St. Vitus Cathedral. This handsome stone bridge was started in 1357, during the reign of Charles IV. On the bridge parapets are thirty groups of statuary, most of them representing saints. These splendid decorations, added in the early 18th century, give the bridge its unique character. This is a bridge—its actual length is 1706 feet—for walking and enjoying the marvelous views on both sides of the river...the Old Town Water Tower, the National Theatre, and Kampa Island.

A favorite place in Prague is Malá Strana, or Little Quarter, founded in 1257. Only on foot, for cars are not permitted, may the visitor wander the narrow, crooked streets and study the baroque churches, the picturesque façades and palaces, the Gothic towers, and the Renaissance houses. Here also the visitor may enjoy terraced gardens and ridge-tiled roofs. St. Nicholas Church, constructed in the eighteenth century by the Jesuits, is a crowning achievement of Baroque architecture.

Old Town Square displays amazing ancient houses. Nearby is the magnificent Tyn Church, with its delicate Gothic spires.

In Bethlehem Square is the rebuilt chapel where Jan Hus preached. On National Boulevard is the monumental National Theatre, a symbol of the Czech Revival one hundred years ago. A steeply winding street leads to the Castle Hradčany, and the Hradčany district is also the location of the Prague Castle and St. Vitus Cathedral.

Throughout the city are small shops such as confectionary shops with elaborate pastries. There are *horky parky* (hot dog) vendors, as well as many excellent restaurants in Prague, but some visitors prefer to spend their evenings at inns or beer houses.

There is the Prague Municipal Museum, Mozart's Prague Home with historic parks and gardens, the Tyl Theatre, the Military History Museum. Not far from the Old Jewish Cemetery is the little Gothic Church called St. Martin's-in-the-Wall, literally built into the city wall in the twelfth century. On and on. . .a guidebook lists more than 275 places of interest in Prague, the city of 1,000 or more spires.

What you will not see is the beautiful monument to Woodrow Wilson, the American president whose efforts after World War I assured the independence of Czechoslovakia. It has been destroyed by the communist government.

Czechoslovakia is heavily forested, with one-third of its area covered by firs, spruces, oaks, beeches, and junipers. The great Tatra Mountains of Slovakia are magnificent, with wild, steep crags and transparent lakes. Here wildlife ranges from orchids and balsams to marmots and bears! Bohemia holds mountains, too, and the well-known Bohemian forest south of Prague.

The country contains hundreds of castles. Some are romantic hilltop ruins; others are dominating fortresses. The Wallenstein Castle at Mnichovo Hradiště has a rich collection of porcelain and a library of medieval manuscripts. Legends still cling to some castles, such as that of Cachtice in Slovakia, where in the sixteenth century a cruel Countess Bathory is said to have tried to recapture her fading looks by bathing in the blood of young girls!

There are towns designated as historical art preserves. Domažlice, 57 kilometers southwest of Plzeň, is a town under National Trust as an Ancient Monument. The country is rich in religious shrines, one of the most noted being Our Lady of Svatá Hora, a hill above Příbram. The birthplace of Jan Hus is at Husinec, where one small room of his original home is preserved.

Volcanoes which were once active in the region left Czechoslovakia with hot springs at Karlovy Vary, Mariánské Lázné, and Františkový Lázné, all in western Bohemia. The mineral springs of Karlovy Vary have been visited by people from all over the world, including Beethoven, Goethe, Schiller, and Peter the Great of Russia. This place is also the home of Moser crystal.

Not the least of Czechoslovakia's natural wonders are the crystal-clear spring waters from which famous beers are made.

Bohemian glass and porcelain are made from the fine silica sand, kaolin and clay deposits in the northwest. Gold was once mined 33 kilometers southeast of Prague, and silver coins were minted at Kutná Hora. Here a magnificent cathedral honors St. Barbara, patron saint of the mining folk.

Other points of interest include the historic citadel of Bratislava, capital of Slovakia, standing high above the Danube. Begun in the ninth century, this stronghold was completed in the thirteenth. With its round tower reminiscent of fairy tales, the Křivoklat castle, about forty-five minutes from Prague, is an attraction for tourists. Built in the thirteenth century, it is now a museum. In Slovakia, many people do fine embroidery in their homes. A picturesque folk music festival is held each June in Stražnice, Moravia. In Brno, the capital of Moravia, trade fairs display industrial equipment.

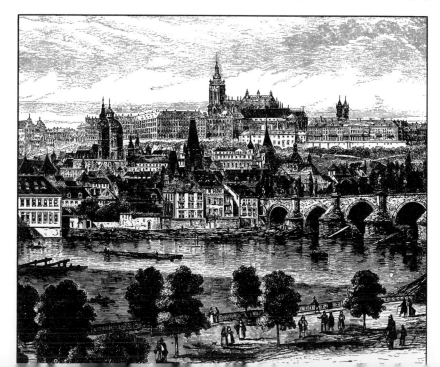

Prague, 1885

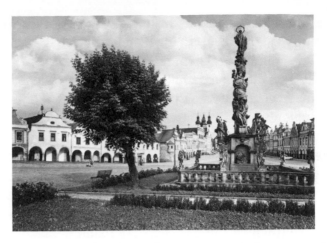

Telč, Czechoslovakia. Plague statue in foreground

Janosik
The Slovak Robin Hood

As Robin Hood is to English-speaking story tellers, so Duro Janosik is to the Slovaks.

The legends of Janosik tell of the peasant boy who grew up seeing merciless cruelties suffered by his people at the hands of their overlords.

The feudal lord, in return for his support of the emperor, had total control of the people on his lands. In some cases, troops carried out a sadistic master's orders, and it was a toss-up whether the worst mistreatment went to serfs or slaves. Whippings and torture were not unusual.

Janosik's time was the last of the 17th century and the beginning of the 18th. He grew to manhood observing and experiencing such conditions, and he fled to the mountains, where he lived in the forests and in the huts of the shepherds.

Soon he was joined by others like himself. Arming themselves with knives and guns, they became a bandit gang, raiding and robbing the rich and giving to the poor, keeping little or nothing for themselves, and always escaping back to the security of the mountain forests.

Some of the exploits were so bold that it was said that Janosik had supernatural powers, but eventually such a force of men was sent against him that in 1713 he was captured, tortured and hanged.

To this day, the memory of Janosik lives on in the hearts of the Slovak people. Janosik is the symbol of courage, and of hope for a free Slovak nation.

Memories and Parables

By John Joseff

In Czechoslovakia in 1970, we were taken to a very old church, some 400 years old. It housed a huge organ, with bellows that had to be pumped by hand, using a long handle that you pushed back and forth. At another church, we descended a hundred steps or more into a crypt, where cardinals and priests were laid to rest in stone caskets resting one atop another in rows. Ours was a feeling of complete reverence. We have a heritage to be proud of and it is unfortunate that we cannot be exposed to the arts and culture of our people in Europe, as they have much to offer.

Here are some parables to ponder:

Who am I to judge another, when I must first reflect what I see in the mirror?

How can I my praises sing, if upon another I inflict venom's sting?

Give of your love to all, not just a few; it will multiply when it comes back to you.

Don't let dark shadows bind or circumvent; instead, let your heart spread the sunshine of content.

Our words often go astray, sometimes to hurt, and stand in our way.

Czechoslovak Civic Coats of Arms

—Courtesy the Czech Cottage, Cedar Rapids, Iowa

PRAHA — TÁBOR — KOŠICE — PLZEŇ — OLOMOUC

Life in America

The Immigrants Gathered Together

When the Slav-speaking newcomers reached America, they sought each other for strength, comfort and security in a new setting. In cities such as New York, Pittsburgh, Chicago, Cleveland, St. Louis, Milwaukee, Cedar Rapids, and others, they founded neighborhoods and churches. In the rolling prairies of Iowa and Nebraska, and in the spacious acres of Kansas, Oklahoma, and Texas, they homesteaded or bought farmland near each other.

Easing the transition from Old Country ways to American life were the churches, fraternal organizations, and other groups, and the special language newspapers. Today newspapers printed in the Czech language include *Hlasatel*, 6426 West Cermak Road, Berwyn, Illinois 60402; *Hospodar*, published in West, Texas; *Našinec*, Granger, Texas and *Hlas Naroda*, Cicero, Illinois.

Council of Higher Education

The high school valedictorian spoke on "Three Great Czechs," who were composer Antonin Dvořák, writer Svatopluk Čech, and painter Václav Brožik. The year was 1901.

The next day, one who had heard the address asked the young man if he would continue his studies. The response: "I would like to, but I cannot afford it at this time."

"I will underwrite the expense," the man said, but the graduating student said he could never accept such a gift and would wait until he earned the money.

The man did some hard thinking about that response and soon offered the student an interest-free loan to be repaid after completion of his college studies. This offer was gratefully accepted.

The student, J. D. Hrbek, went on to head the Department of Slavonic Languages at the University of Nebraska. The lender was W. F. Severa, who came to America in 1868 at age 15, and became a pharmacist and drug manufacturer at Cedar Rapids.

About a year after his loan to Hrbek, Severa and some friends founded the Council of Higher Education to encourage American youth of Czechoslovak background. Financed entirely by donations, the Council has made interest-free loans and grants, encouraged the teaching of Czech and Slovak language,

In 1984, the Council made loans of $400 to $1,000 to 30 women and 24 men, and granted scholarships of $500 to $1,000 to 30 women and 29 men. All had finished one year of college; some were graduate students.

Insurance and Fellowship

The oldest (1854) of the Czech fraternals is CSA Fraternal Life, with headquarters in Berwyn, Illinois. The largest is Western Fraternal Life Association (WFLA) with headquarters in Cedar Rapids, Iowa. These and other fraternals have local lodges throughout the United States.

The Czech Catholic Union Fraternal Insurance Society was founded in Cleveland, Ohio, in 1879. The original name was Bohemian Roman Catholic Central Union of Women in the U.S.A. The founders sought to protect wives and children of immigrants in the event of the death of the father or breadwinner. This group started in the oldest Cleveland Czech Catholic Parish, St. Wenceslaus (Sv. Vaclav).

There are two million Slovak Americans. They belong to many groups, which cooperate through the Slovak League of America, an umbrella group, with headquarters in West Patterson, New Jersey. Daniel F. Tanzone is president.

The oldest Slovak fraternal, founded in 1890, is the National Slovak Society of Pittsburgh, Pennsylvania. Zivena Beneficial Society, named for the Slovak goddess of life, is the oldest (1891) Slovak fraternal for women. It is at Ligonier, Pennsylvania, as is the United Lutheran Society. First Catholic Slovak Ladies Association of Beachwood, Ohio, is the largest fraternal in the United States, with $110 million in assets. These are among the ten Slovak fraternal organizations. Members of all Czechoslovak fraternals have insurance and an opportunity to enjoy the social life at regular meetings.

Czechoslovak Council

The Czechoslovak Council of America works diligently for the day when human rights and freedom will again be achieved in Czechoslovakia. It informs members of Congress and others of developments within Czechoslovakia or affecting the Czechoslovakian people. It aids Czech and Slovak refugees, and publishes in Czech, Slovak, and English. The council is supported by donations.

Czechoslovak Society of Arts and Sciences

The Nazi invasion of Czechoslovakia caused the emigration or escape of some 20,000, of whom about one-fourth were intellectuals. The 1948 coup caused more than 60,000 to leave, of whom at least one-tenth were learned people, including professors and professional people. The 1968 invasion by Russia and the Warsaw powers caused another large exodus.

Leaders of this emigration founded the Czechoslovak Society of Arts and Sciences. It supports educational, scholarly, literary and artistic endeavors of the Czech and Slovak intelligensia abroad. It is non-political and has about 1,600 members.

There are 20 local chapters, in Washington, D.C., New York City, Albany-Schenectady-Troy, Hartford, Cleveland, Pittsburgh, Los Angeles, San Francisco, Vancouver, Toronto, Montreal, Ottawa, London, Geneva-Zurich-Bern, Vienna, Munich, Sydney, Melbourne, Perth, and Pretoria.

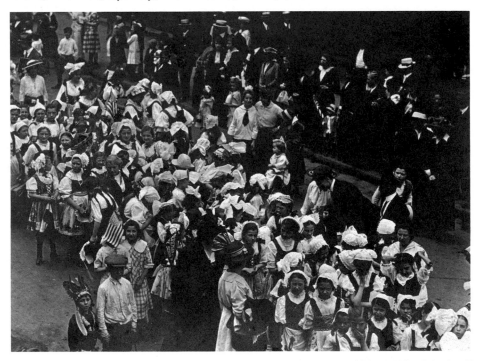

Photograph courtesy of Mr. and Mrs. John Joseff

May Day was a celebration on 73rd Street in New York City in 1913. Hundreds of Czechs, Moravians and Slovaks of all ages gathered for a parade, which wound its way past the famous Czech Narodni Budova, National Hall, and the Czech school and popular Czech restaurants.

City Life in the East

John Joseff and his wife Jeanne have pleasant and fond memories of their "growing up" years in "Little Bohemia" in New York City from 1913 to 1938. The city was an enclave of ethnic groups. The Czech neighborhood was on the East Side between 70th and 73rd Streets, from Avenue A to Second Avenue.

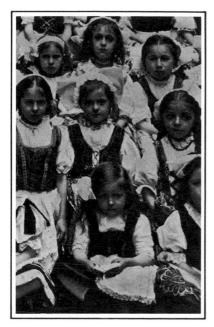

Jeanne Joseff is in the front row, second from the right, in this photograph taken in 1914, when she was five years old. The photograph was by Joseph O. Zaklasnik.

"I never felt alone because of the close ties with neighbors and friends," John said. "It was a self-contained neighborhood and everything necessary for our daily living was within walking distance.

"On our block alone, we had a bakery, pork store, grocery store, ice cream parlor, laundry, candy store, and beer parlor. We even had a funeral parlor, as they were called in those days. You could be born on our street, live your life, and be buried from our street.

"How could I ever forget *sekanina* on Czech bread, rye with the floured crust on the bottom. *Uzeni,* hot right from the pork store! How my mouth waters just to think of the great food we enjoyed. My mother's *livance* (pancakes), cinnamon roll-ups with browned butter, were a masterpiece. It's no wonder I was called 'beefy' in those days.

"All the Czech people were warm and kind-hearted, and we all cared for each other very much."

Married 50 years in 1987, John and Jeanne live in Manassas, Virginia. They visited the Czech community of Cedar Rapids in 1985 as a result of reading *The Czech Book* by Pat Martin, and presented the Czech Heritage Foundation with an original Czech *kroj,* a woman's costume, created in Pilsen (*Plzeň*) more than 70 years earlier. The Joseffs visited the mother country in 1970 and one of Jeanne's relatives gave her the *kroj* (costume).

An Old-Fashioned Christmas

Candles, Cookies and Love

By John Joseff

I remember Christmas in the 1920s, a time when emotions ran high and expectations made your heart jump for joy. The week before Christmas, there was beehive activity. Every family in our tenement complex had a live tree. Every tree was adorned with colorful ornaments, hard candy, strings of popcorn, handmade Czech dolls, and candles. An angel or a star topped the tree. All members of the family took part in decorating the Christmas tree.

The candles were beautiful, creating a shimmering light that made the tree come alive. Special metal candle-holders were attached near the tips of the stronger branches. Each was placed so the candle flame would not ignite the branch above it. I never knew of a house fire caused by lighted candles on a Christmas tree, but as I think upon it now, it is amazing that there were no fires.

The Czech mothers spent all week baking cookies, pastries, and coffee cakes. The cookies were mouth-watering tidbits of delight. The Czech pastries, as only Czechs know how to bake, were gastronomical treats. The Bohemian houska, filled with almonds, raisins and candied fruits, was a braided masterpiece, covered with powdered sugar. That, with a cup of coffee or a glass of milk, was wonderful. Pure sweet butter was used by all the mothers in baking.

As a boy, I would hang up my black stocking on the bedpost at the head, anticipating sunrise that would produce a surprise—a stocking filled with sweet goodies. There was no affluence in our neighborhood, but Christmas was special for all Czech families because they all cared for each other, and they shared. Children were a chain of love that affected every family.

My mother made her own cherry brandy, and when I reached the age of 16, I got my first taste of that titillating liquid of ambrosia.

We had a player piano that my stepfather picked up for $20. Neighbors, who were all friends, visited at Christmastime, and the music, baked goodies and cherry brandy made for a Christmas that was something very special. The smiling faces and laughter filled the room with an ambiance that sparkled.

Yes, Christmas had a very special meaning and place in the hearts of all Czechs, especially those who had left their homeland to pioneer in a new country.

The Slovaks

Between 1899 and 1910 thousands of Slovaks came to America. The peak was in 1905 when 52,358 were admitted. Many went to Pittsburgh, Pennsylvania, and Allegheny County. The 1930 census showed 81,676 Slovaks living in Allegheny County, 25,050 born in Slovakia and 56,025 American-born.

Slovakia, a small Slavic nation, was joined in 1918 with Bohemia, Moravia, Carpathia, and Ruthenia to form the republic of Czechoslovakia. From 906 to 1918, Slovaks had been harshly ruled by the Austro-Hungarian empire. Those who came to America sought better living conditions and political freedom.

In the Pittsburgh area, those who had lived in eastern Slovakia settled along the Monongahela and Ohio Rivers. Those from western Slovakia settled along the Allegheny River. They established themselves in Pittsburgh and in such towns as Braddock, Duquesne, McKees Rocks, McKeesport, and others. Pittsburgh was their central home. They took jobs in the steel, railroad and coal industries.

Today these Slovak-Americans celebrate their culture with 23 other ethnic groups in the annual Pittsburgh Folk Festival, sponsored by Robert Morris College. This major event fosters the Pittsburgh theme of "unity in diversity" and draws 30,000 to 40,000 visitors each year.

The festival is the Friday, Saturday, and Sunday before Memorial Day. Participants vary from year to year, but the events and displays richly depict the customs and traditions that make Pittsburgh's ethnic diversity fascinating. There are the Carpatho-Rusyns (Slavs from Carpathian mountains), and groups whose forebears came from such countries as Bulgaria, China, Croatia, England, Germany, Greece, Hispania (Argentina and Spain one year, others the next), Hungary, India, Ireland, Italy, Latvia, Lebanon, Lithuania, Philippines, Poland, Scandinavia, Scotland, Serbia, Slovakia, Slovenia, and the Ukraine.

In 30 years, a group called the "Slovaks" (later the Pittsburgh Area Slovak Folk Ensemble) presented dance and music themes for religious holidays, an engagement, a wedding, a christening, a reunion, and tales of folk heroes such as Janosik, the Slovak Robin Hood, and Joe Magarac, the mighty steelworker. One theme based on long-ago practices tells of a marriage prearranged by parents. At the spinning bee, older and young women sing traditional songs while making the wedding dress, hat, pillows, and coverlets. The bridegroom

and his friends celebrate with the bottle dance. The bride and bridegroom ride to the wedding in a wagon decorated with white and red ribbons. Married by the village priest when an Easter cloth is placed over their hands, they are showered with corn and wheat, and the bride tosses poppyseeds over her shoulder. Legend holds that the number of poppy plants that grow will be the number of children the couple will have.

The Pittsburgh Connection

In Pittsburgh, Pennsylvania, on May 30, 1918, after a long parade of Slovak Americans, Tomás G. Masaryk, the liberator and first president of Czechoslovakia, delivered a stirring address. This led to the signing of "The Pittsburgh Agreement," one of several (Cleveland, Chicago and New York City) which helped sway world opinion in favor of the new nation.

The incident is remembered, especially at the University of Pittsburgh with its famed nationality rooms. Milan P. Getting, chairman emeritus of the Czechoslovak Room Committee, recalled that in 1918, there were 2 million Slovaks and 6 million Czechs in what was to become the Czechoslovak Republic. Uniquely, in Pittsburgh that ratio is reversed. Pittsburgh Slovaks played an important role in the continuing joint Slovak-Czech efforts.

Masaryk's son Jan, who served Czechoslovakia as foreign minister, spoke in 1939 at the dedication of the Czechoslovak Room. Dr. Alice Masaryk, the oldest daughter, "was the European Committee Chairwoman for the Czechoslovak Room during the construction from 1925 to 1939," Getting wrote, "and came many times to renew her ties among her many friends." She died in Chicago in 1939.

A charming story of the Pittsburgh-Masaryk connection is that of Stanley Prostrednik. In 1901, at Styrsky Hradec, Austria, his mother ("the biggest patriot of Sokols under the sun") was expecting and her three oldest sons refused to attend the Sokol Slet at Praha. She made them go, and when they returned, "Mother, as I was told, greeted them with 'You have one more Sokol in the family' and that was me, Number 13."

Prostrednik, who joined Sokol in 1919, became assistant to the chief horticulturist at the residence of President Masaryk. Drafted and later taken prisoner, Prostrednik escaped from a concentration camp in Slovakia, and began a journey that took him to Belgrade, Constantinople, Casablanca, Martinique, St. Lucia, Bermuda and finally Pittsburgh, where he was hired by Mrs. Mary Lawrence to be in charge of horticulture at Hartwood Acres, which was then a private estate, later a county park.

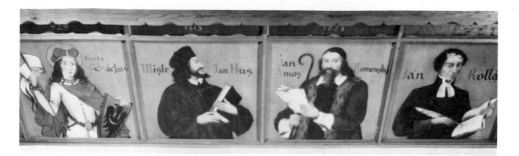

Portraits in Czechoslovak Room, University of Pittsburgh

University of Pittsburgh

The University of Pittsburgh's 42-story Cathedral of Learning contains 18 Nationality Rooms. For the Czechoslovak room, Dr. Bohumil Sláma, one of the leading architects of Prague, used different art forms to illustrate Czechoslovak history and ideals, love of freedom and love of learning, and to present the work of Czechoslovak artists. The ceiling and all cabinet work are of larchwood, which grows to great height in the valleys of the Carpathian mountains in Slovakia.

There are ceiling portraits of Cyril and Methodius, Christian monks who came to Moravia in 863, introduced Christianity and created the Cyrillic alphabet; Václav (the good King Wenceslaus of the Christmas carol); Jan Hus, martyr to the cause of religious freedom; Jan Ámos Komenský (Comenius), whose ideas revolutionized education; Ján Kollár, Slovak poet who initiated the first Congress of Slavs; L'udovit Stur, founder of the Slovak literary language, who organized the Slovak attempt for freedom in the nineteenth century; and Bishop Stefan Moyzes, pioneer in popular education among Slovaks and first president of the Matice Slovenská, which promotes Slovak arts, letters and sciences.

Slovak dancers, Pittsburgh Folk Festival

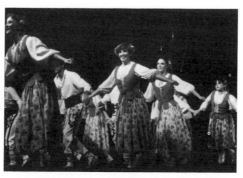

25

Masaryktown, Florida

In 1924 Slovak and Czech Americans from New York, Ohio, Pennsylvania, and New Jersey began dreaming about a paradise in Florida where they could plant orange groves instead of laboring in the steel mills and coal mines of the North.

These people became the original 135 shareholders of some 10,000 acres in Hernando County, later adding some 14,500 acres in adjoining Pasco County. They called their land "Joscak's Paradise," after Joseph Joscak, the editor of the *New Yorksky Dennik* daily newspaper in New York City, who first encouraged these settlers to move to beautiful Florida. Their community was named Masaryktown, in honor of Tomás G. Masaryk, the first president of Czechoslovakia. Masaryktown's streets were named for American presidents and Czechoslovak poets, writers, and national heroes.

Most of these settlers were Slovaks. In the true pioneer spirit, they made the best of what they found in Florida. Frosts and other difficulties ended their dreams of orange groves. They tried raising onions, sweet potatoes, and cucumbers, but had difficulty finding a market. Some returned to New York, where they took jobs and sent money to wives and children in Florida.

A break in their luck came when Stephen Otruba moved to Masaryktown and started a poultry farm. Next, the first incubator was installed, and the egg producers organized a cooperative, the Hernando Egg Producers, Inc. This cooperative became so large and successful that Masaryktown became known as the egg capital of Florida. Nearby Spring Hill holds an annual Chicken Plucking Contest. Masaryktown boasts a large egg-processing plant, but there are no longer chickens in Masaryktown. Small producers are gone, and only large-scale production is profitable.

In 1932 a Sokol gymnastic chapter was organized. Churches were erected, clubs were formed and a beseda folk-dancing group began performing. In 1964, the T. G. Masaryk Memorial Library was erected, housing more than 3,000 books in English, Czech, and Slovak languages.

According to Violet R. Cimbora, vice-mayor of Masaryktown, the 1986 project of building a new Masaryk Museum and Library was a major undertaking for a town of 800. Masaryktown holds two annual celebrations: the first Sunday in March for Masaryk's birthday, and the last Sunday in October for Czechoslovakian Independence Day.

Flags Fly in Cleveland

In Cleveland, Ohio, the first Czech and Slovak immigrants found employment in industries that did not require knowledge of English. They worked in steel mills and cigar factories, made barrels, and held many other jobs. Women found that they could participate in the work force while tending the homes and caring for children. Richman Brothers, for example, delivered semi-finished garments to women and, after their completion, picked up the garments. Hard work was a language all these Czechs and Slovaks understood; they were determined to succeed in their new land.

The first Catholic priest in Cleveland was a Father Krasny, who left Bohemia during the revolution in 1848, when the country was dominated by the Austro-Hungarians. Today, churches are strongholds for religious and cultural identity. There are four large Catholic Czech parishes (Czechs outnumber Slovaks in Cleveland), five Slovak Catholic churches, and three Slovak Lutheran congregations.

Along with the binding influence of religion, work was a common denominator that caused men and women to build halls, unions, subdivisions, and summer camps as monuments to their social and cultural strength.

Karlin Hall (Česká Síň Karlin), named for a district in Prague, is a landmark of the Fleet Avenue-Washington Park area of Cleveland where many Czechs and Slovaks settled. Founded in 1936, the club sponsors St. Joseph and St. Wenceslaus Day parties in March and September, respectively. The club also stages concerts, publishes a social calendar, provides free polka music every Wednesday, serves food every Wednesday and at benefit dinners, and sponsors tours to Europe, Hawaii, Las Vegas, and the like. According to Joe Kocab, Karlin Hall is a hub of activity because of its modern new facility, lots of enthusiastic volunteer help, and easy access to a freeway.

"It is probably the only club in the city where the flags of the U.S.A., Czechoslovakia, Canada, Poland, Hungary, and Italy stand side by side symbolizing the unity of all our peoples," said Kocab, the "Mr. Czech" of the Cleveland area. A former high school administrator, Kocab is the national president of the Czech Catholic Union Fraternal Insurance Association. He also hosts two radio programs of Czechoslovak brass music every Sunday, one on WRMR and the other on WCPN-FM.

Of 150 Karlin Hall shares, 116 are owned by clubs and lodges and 33.8 are owned by individuals. St. Joseph Society and St. Stephen Society of the Czech Catholic Union are fraternal insurance lodges and the largest stockholders.

Others include St. John's Catholic Club, Knights of St. John, Happy Chums Outing Club, Bicycle Club, Ceska Vlast, Cechoslovan, Prazskych Pepiku Club, St. John Nepomucene and St. Augustine Society of the Catholic Order of Foresters, and the District Alliance of Czech Catholics. All members of these groups are entitled to attend the annual stockholders meeting and possibly be elected one of the 15 directors.

Karlin Hall is in the heart of Slavic Village, which itself is interesting. The *Slavic Village Voice* reported: "Buildings in this area were transformed into mountain village chalets like those seen in the Carpathian mountains bordering Poland and Czechoslovakia. Some property owners erected façades in a Highlander style, using stone, natural woods, carvings and folk-art murals. With the help of church groups, volunteers, senior citizens and ethnic organizations, the first Harvest Festival was held in 1979, attracting 12,000 visitors, a figure that increased annually. The Slavic Village illustrates what can be done to breathe new life into an aging inner city area and make it so attractive that the home folk love it and visitors are glad they came."

Another interesting group, the Workingmen's Gymnastic Union (Dělnická-Tělocvična Jednota) is a product of the industrial revolution in the late 19th century in central Europe. Founded in 1909, it was the first DTJ unit in America. Early members sought friendship with others who spoke their language. Gymnastic classes, similar to those of Sokol, were a part of the fellowship. Several DTJ units were formed in Cleveland, and in 1925 a 40-acre summer camp was started at Taborville, named for a town named Tabor in Czechoslovakia. Taborville is some 20 miles east of Cleveland. Nearly 50 families live there year-around, and the village is Cleveland headquarters for the DTJ, with a social hall, musical and dramatic presentations, an annual Český Den and Harvest Festival, and gymnastic exhibitions.

Although the Slovak Dramatic Club of Cleveland no longer stages dramatic productions, it sponsors a Slovak Heritage Festival one day during the Labor Day weekend. This event is a wonderful day of dancing, music, Slovak culture, folklore, and delicious Slovak pastries and other foods. Costumes of Slovakia are worn at this, "the largest Slovak event in Ohio!"

Historic Bohemian National Hall was built in 1897 by hard-working immigrants and was renovated in 1975 by members of a newly merged unit, Sokol Greater Cleveland. The hall is on the National Register of Historic Places and is the home of an active Sokol unit with summer and winter gymnastic exhibitions, competitions, and clinics, Czech language classes, monthly fish fries, card parties, holiday parties, and a Czech Holiday Fair.

In Broadview Heights, southwest of Cleveland, there is a camp of summer

cottages that provides Slovak cultural and ethnic activities every Sunday during the summer.

Another popular group is the Sokol Greater Cleveland Czech Folk Dancers. Named because it grew out of the Sokol movement. Starting in 1972 with 12 dancers, it grew to be a 45-member group that has performed throughout the United States and Canada. The performers wear Czech costumes *(kroje)*. When directions for Czechoslovak folk dances proved difficult to obtain, they began by learning a *beseda,* which is a collection of polkas and waltzes arranged together in various patterns to reflect the spirit of a given region of Czechoslovakia. All five *beseda* were performed. They are Czech, Hanacka, Moravian, Slovak and Czechoslovak. In 1985, the group published a book, *Folk Dances of Czechoslovakia,* containing the history, dance directions, diagrams and sheet music for all five of the authentic *beseda.* The purpose of the book is to assure the preservation and perpetuation of the Czechoslovak heritage.

A favorite view of Prague's Charles Bridge and the Hradčany Castle, both of which also appear on the stage curtain of Bohemian National Hall's Grand Ballroom in Cleveland.

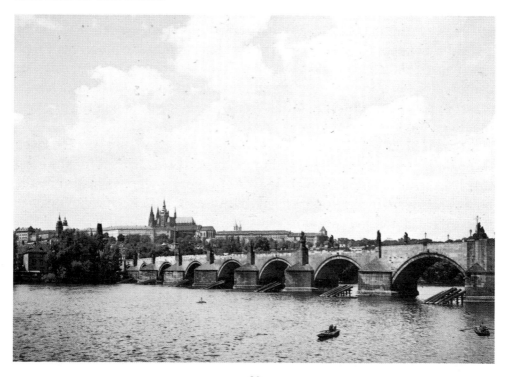

The Great Midwest

States with the most Czechoslovaks are Illinois, Pennsylvania, New York, Connecticut, Maryland, Massachusetts, Michigan, Wisconsin, Iowa, Minnesota, North and South Dakota, Missouri, and Texas.

The Cedar Rapids, Iowa, area boasts the highest percentage of Czechoslovaks—nearly one-third. Other cities with large numbers of Czechoslovaks include Baltimore, New York, Boston, Cleveland, Detroit, Chicago, Milwaukee, St. Paul, Omaha, St. Louis, and Corpus Christi.

Illinois has more Czechoslovak-Americans than any other state. Thousands of Czechs, Moravians, and Slovaks made their way to this country in 1848. Although many continued west to Iowa, Kansas, Nebraska, South Dakota, Texas and Wisconsin, thousands remained in Chicago. They established the city's first Czech-Moravian-Slovak communities on the South Side, where DeKoven Street and Dvořák Park became familiar names.

As families moved west, there followed "Česká Pilseň," "Česká California," and others. By 1920 Cicero and Berwyn, the first suburbs west of the Chicago city limits, were virtually Czechoslovak cities. They produced the epitome of Czech culture in the Chicago area, with Czech language, culture, history, and entertainment flourishing along with Sokol gymnastic programs, Czech newspapers, and church services in the Czech language. Czechoslovaks are conservators of tradition, or *tradice*. Nowhere in the United States has the effort to preserve cultural tradition been more evident than in the Berwyn-Cicero area.

Cermak Road begins at the shore of Lake Michigan and proceeds west through Chicago, Cicero, Berwyn and beyond. It was named for the great Czech-American Anton Cermak, mayor of Chicago, who was killed by the bullet an assassin meant for President-elect Franklin D. Roosevelt. "I'm glad it was me and not you" were the mayor's last words to FDR.

There are great Czech restaurants on Cermak Road in Cicero and a very popular Slovak restaurant less than a mile south of Cermak Road on Harlem Avenue. Large fruit dumplings might be your Slovak lunch. Czech specialties include roast duck, *svíčková* (similar to beef stroganoff), and many others. Nearby bakeries offer Czech breads, biscuits and cookies, coffee cakes, kolaches, *babovka, houska,* and sometimes prune pie.

On Cermak Road in Berwyn is "F. Pancner, Incorporated" offering hand-painted eggs, cut glass crystal, unique signed Czech crystal bowls and plates, dolls, records, books, spices, greeting cards printed in Czech, Slovak, and English, and more. Fred Pancner started this business in 1913 at the original Czech neighborhood at 26th and California (Česká California). The store has been at the present location since 1942 and Fred worked there until he died in 1985 at age 93. Family members now operate the business. In Cicero, on Cermak Road, is M. Pancner Gifts and Cards. The store was founded by a brother of Fred.

A few blocks south of Cermak Road, where Harlem Avenue intersects Riverside Drive, is the CSA Fraternal Life, founded in St. Louis before the Civil War, and its Czechoslovak Heritage Museum. Costumes from all three areas of Czechoslovakia are displayed along with crystal, fabrics, musical instruments, ceramics, dolls, pictures of Prague, and numerous historical items. There are sculptures by the famed Czech-American Albin Polasek, paintings, photographs, Czech publications issued in the United States beginning with 1868, and various world and Czechoslovak classics. Museum hours are Monday through Friday 10 to 4.

An important cultural organization is Berwyn's Moravian Folklore Circle, founded about a half-century ago. A part of the United Moravian Society, this group promotes the culture of Moravia, and stages an annual Moravian Day every September. Members and guests celebrate by wearing colorful costumes, dancing, singing Moravian songs, and offering Moravian and Czechoslovakian food and traditions. The Bohemian National Cemetery is a beautiful 100-year-old park.

Phillips, Crest Hill, and Lidice

When the sadistic "protector" of occupied Czechoslovakia was murdered, the Nazis chose to make the town of Lidice an "example." The town was razed, and the people were taken from their homes. All Lidice's 173 men over 16 were shot and buried in a common grave, and also 18 who came on the run from Kladno upon seeing the flames and hearing the dynamiting. A huge wooden cross marks the grave; a barbed wire wreath hangs from the cross.

Phillips, Wisconsin, and Crest Hill, Illinois, erected monuments in memory of the people of Lidice, Czechoslovakia. Both cities hold an annual memorial service for the people of Lidice. Crest Hill, southwest of Chicago, was once known as Lidice, Illinois. The name was changed in the late 1940s.

The Nebraska Czechoslovaks

The early settlers told grandchildren of their rapture at seeing the elk, deer, and buffalo roaming free through Nebraska's endless prairie grasses that waved with every wind, as far as the eye could see. They told also of Indians who painted their faces and carried bows, arrows, tomahawks, and stone hammers. They told adventure stories of wagon trains headed west, and of fur traders and prairie dog towns. They told of hardships that not all survived—life in sod houses and dugouts, blizzards, windstorms, homesickness, Indians, prairie fires, and grasshoppers.

The first Czech settler, Karel Zulek from Podmoklany, Bohemia, came in 1856 and chose land near the Missouri River.

Two events brought the Czechs to Nebraska in waves. First was the failed 1848 revolution in Bohemia that was followed by political persecution as well as a shortage of available land. Second was the Homestead Act. In 1862, during Abraham Lincoln's presidency, the Free Homestead Act was passed. Any man or woman at least 21 years old, or younger if head of a family, could have 160 acres by living on it five years and paying $18 in fees.

A continuing flow of Czech immigrants helped fill the rich lands of Nebraska, Wisconsin, Iowa, Kansas, and Texas. Some Nebraska pioneer authorities believed that of every four Czech immigrants up to 1880, three settled in Nebraska. One such immigrant was Jan Herman. He had been an important political figure in Bohemia at the time of the 1848 revolution and left for his own safety, settling first in Wisconsin and later taking claim to land near the present town of Wilber.

The five adult children of Floyd and Evelyn Herman, whose farm home is near Wilber, Nebraska, are fourth generation "100 percent" Czechoslovak-Americans. They are descendants of Jan Herman, who came from Mecin, Bohemia, the Duras family from Zelinice, the Spirks from Merklin, Vaclav Lorenz from Klatovy, Andrew Rezabek from Radkovice, near Plzeň, and Joseph Fisher from Cumeoburg.

In 1963, Governor Frank Morrison proclaimed Wilber the "Czech Capital of Nebraska." The twenty-fifth annual Wilber Czech Festival was held in 1986. The Wilber Czech Museum features a pioneer section, beautiful Czech dolls, Czech costumes, embroidered linens, handicrafts, and special displays.

Cedar Rapids, Iowa

The Czech Museum and Library in the Czech Village of Cedar Rapids, Iowa, includes an immigrant home that provides a stepping stone back into the history of the Czech immigrants. The kitchen and attic of the house were built in 1880. The adjoining parlor and the attic above it were built two years later, doubling the size of the house. After restoration and the move to the museum site, the home was furnished in the period of 1880-1900. More than 5,000 hours of volunteer labor went into the project. The work included removal of 12 coats of paint from the woodwork in the kitchen.

The Czech Museum and Library was founded in 1978. It is dedicated to the preservation, restoration and display of materials, artifacts, and crafts of Czech, Moravian, and Slovak origin and to the presentation of the rich and colorful heritage of these peoples. The museum displays many antique national costumes, plus glass, ceramics, porcelain, carved woodenware, linens, laces, embroidery, beadwork, sculptures, pipes, furniture, maps, decorated eggs, and dolls.

The Czech Village has a bandstand, a 1976 gift from the Iowa Bicentennial Commission and the Kosek family. The village clock tower in front of the bandstand was a gift to the people of the Czech Community from an anonymous donor. Czech families operate many farms in the area.

At Usher's Ferry, a city park in Cedar Rapids, Iowa, is a little house that is now open to the public, but once was the home of a Czech *Babi* (grandma, pronounced Bub-bi) and *Deda* (grandpa, pronounced Jedda).

Many school groups and other visitors find their way to this home, which was built when the home country was under the rule of the Austro-Hungarian emperor. As they tour the little home, visitors learn much about how life was in the days of the Czechoslovak immigrants to America.

Babi *and* Deda *House, Usher's Ferry, Cedar Rapids, Iowa*

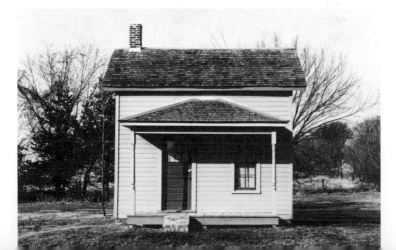

Going West

Before 1866, five Indian tribes—the Cherokee, Choctow, Chickasaw, Creek, and Seminole—claimed lands that were in the Oklahoma territory. Even though Indian lands were not legally available, white settlers invaded them, planted crops, and built homes. These settlers became known as "boomers" and "sooners."

Their illegal occupation precipitated battles and massacres. Whenever possible, United States military troops tried to evict the settlers. Finally, an area in the western half of these territories, about two million acres, was purchased from the Indians by the government, which then could open large tracts for legal settlement.

The first great run for free homesteads took place in the center of the state, including land where Oklahoma City, Norman, Guthrie, Edmond, and Stillwater are located today. On March 23, 1889, President Benjamin Harrison issued the proclamation opening the western territory. At noon on April 22, 1889, trumpets heralded the signal, a pistol shot. The rush was on. It was unique. Some 20,000 participants, including many Czechs and Slovaks, had come from Kansas, Nebraska, New Mexico, Illinois and elsewhere on horseback, on foot, and by mule train and covered wagon. "Sooners" and "boomers" presumably were ousted before the land rush. Even so, there were many disputes, and it took years to straighten out just who legally had earned certain portions of the two million acres involved in the "rush."

The land where Oklahoma City now stands would remain uncharted until 1890, but tents were pitched and "civilization" began. John Hubatka, one of the first police guards and later police chief, was a strong friend of the Czech and Slovak pioneers. Some of them were not fortunate enough to get a homestead and returned to their homes in other states. Others were among the lucky. The early Czech family names included Kunc, Kolar, Yager, Kozak, Pesek, Spacek, and Maruska. In Oklahoma City, a John Hrabe and his sons started a cigar shop and grocery store. A Dr. Ryndak was a physician and Mrs. Ryndak was a midwife.

The push to the west continued. In Oklahoma, there were nine land openings, some conducted by "rushes" and others by drawings. Other well-known "rushes" included the Cheyenne-Arapahoe Run, 3 million acres, in April, 1892; the Shawnee Potawatomie Run, 900,000 acres, in September, 1891; and the greatest of them all, the Cherokee Outlet, more than 6 million

acres, in 1893. The Cherokee Run, under President Grover Cleveland, involved a land purchase of more than $8 million.

Czechs joined in all the land openings and settled in nearly every county in Oklahoma. Husbands and wives worked together to break the land manually and grow crops. Wheat, cotton, and cattle gave many a livelihood. Most settlers were farmers; some owned stores. A first priority for all Czech settlers was to replace the sod house with a home of two or three rooms.

The Will Rogers World Airport and the Tinker Air Force Base, both in Oklahoma City, are on land originally acquired by Czechs either in a run or by purchase. Oil was discovered on some of the homestead lands, especially around Oklahoma City, Prague, and Drumright.

Two Czech communities, Prague and Yukon, stage festivals to proclaim and celebrate their ethnic heritage. Prague's name was suggested by Mrs. Theresa Barta in honor of her native city. Names of early Prague mayors include Vlasak and Vobornik. Other family names included Barta, Eret, Suva, Bonty, and Simek. In 1951, when Prague was 49 years old, the Lions Club staged a kolache festival as "practice" for the 50-year event. The festival was held annually until 1956, was revived in 1965 and has been an annual success ever since. Queens are crowned, kolaches and klobase are devoured, and a parade is a highlight. Kolache Festival is the first Saturday in May, and draws some 35,000 visitors. Prague is 50 miles from Oklahoma City and 65 miles from Tulsa. Farming is still a major industry; Prague is surrounded by beautiful farms and ranches, and is known for cotton and oil.

Prague is the site of the National Shrine of the Infant Jesus at St. Wenceslaus Church. Because people were no longer allowed to worship at the original shrine in Prague, Czechoslovakia, Pope Pius XII in 1949 designated Prague, Oklahoma, to be the home of the Shrine, under the care of the Benedictine Order of St. Gregory Abbey of Shawnee, Oklahoma. It is the object of pilgrimages from all over the world.

Prague, Oklahoma, has an interesting history. When it was founded in 1902, three miles from Indian territory, it was noted for its 13 saloons that attracted both whites and Indians. It was also where Jim Thorpe of Carlisle Indian School fame, considered by many to be the greatest athlete of all time, got his start.

Yukon, just west of Oklahoma City, was founded in 1891 by Czechs. The first annual Czech Festival was held in 1966 as a celebration of Yukon's 75th anniversary. The event, on the first Saturday in October, preserves Old World customs dear to Czechoslovakians. Czech bands perform. Folk dancers in colorful costumes from Bohemia, Moravia, and Slovakia dance the beseda

and other folk numbers. Festivities begin with a big parade in the morning, and the day ends with dancing at the Czech Queen Coronation Ball at the Yukon Czech Hall. Throughout the day, visitors browse at a craft show that displays works by artists from Oklahoma and the southwestern United States. When the sun goes down, festival-goers enjoy traditional Czech dinners at the many Yukon restaurants. Yukon has been proclaimed the "Czech Capital of Oklahoma."

A Mucha Painting in Pisek, N.D.

The town of Pisek, North Dakota, was named for the town of Pisek in southern Bohemia. In the 1880s, when the settlers, all Catholic and Czech, Moravian, or Slovakian, were about to build a church, two names were proposed.

Believing that the Moravians were more numerous and would win, one of the group, Frank P. Rummreich, on a trip to the Old Country, commissioned artist Alfons Mucha (1860-1939) to do a painting of Saints Cyril and Methodius, who introduced Christianity to Moravia in the ninth century. The painting, a huge 6x10 feet, took two years to complete. Meanwhile, the church had chosen the name favored by settlers from Bohemia: Saint John Nepomucene, who lived in Prague in the fourteenth century.

Thus, while the famed Mucha later did two more paintings of the two saints, Pisek doubtless has the only church named for Saint John Nepomucene that is also graced by a Mucha painting of Saints Cyril and Methodius. Mucha, who was a cousin of Rummreich's sister-in-law, donated the painting "because it is for our countrymen." But the Pisek families sent him about $1,000, including 100 gold pieces.

St. John Nepomucene Catholic Church
Pisek, North Dakota

My Czech Heritage

By Františka Brzoň Paleček

Born on a farm in Kansas, Františka Brzoň Paleček is the grand-daughter of Czech immigrants. One of nine children, her formal education was limited, yet her knowledge of pioneer farming is a treasure. She studied art under professors of the University of Nebraska and Kansas State University. Her oils and sculpture have been widely exhibited. She lives near Munden, Kansas.

My grandfather, Vaclav Brzoň, was born in 1825, at Lipcicidi, Bohemia. He married Anna Pipka in Bohemia. Vaclav came to United States because he was tired of being a soldier, thinking that in U. S. he would find freedom from military action. In 1865 they homesteaded near DuBois, Nebraska. As a mason, he built his own and neighbors' rock (limestone) houses. Anna Pipka and Vaclav Brzoň raised seven children. My mother's families, Blecha and Pešek, came from Bohemia and Austria. They settled by the Nemaha river in Nebraska, not far from the Brzoňs, also about 1865. They had nine children.

My mother and father settled in the same county, Pawnee, in southeast Nebraska. The first of their nine children was born in 1899. They came to Kansas about 1910, thinking they could make a better life here, which my father, "Michael Sr.", always regretted. He thought it rained more in Pawnee County, Nebraska, than in Republic County, Kansas. My parents lived in Republic County until their deaths. Father was a farmer and blacksmith, and owned a steamer and threshing machine. My mother was a very good cook and seamstress, interested in dance, music, and politics. She had an outstanding memory.

Mother and father talked in Czech at home, and taught us to talk and read in Czech. They also learned English and German. The country grade school brought a lot of English into our lives. There were Polish and English students in our "Dry Lake" district 94 country school. Some of the English-speaking children called us Czechs "Bohunks," which was considered derogatory.

My father and mother subscribed to the magazine *Domácnost* and newspaper *Hlasatel,* both in Czech. Evenings were often spent in reading out loud in Czech, everyone taking turns.

As a farm family, we had horses, cattle, hogs, goats, geese, chickens, ducks, guineas, and turkeys. We would dress turkeys, ducks, and geese, put them in barrels, and send them to a distributor.

We owned 480 acres of land. Wheat, oats, rye, barley, corn, poppy, and a large truck garden were planted. We were always saving so we could pay the mortgage. If we didn't save, father said, we would go to the poorhouse.

We girls made over clothes, not once, maybe twice, so we would be in fashion. We five girls were all good seamstresses. Mother was taught to sew professionally, and she taught us how to make patterns for our own designs.

There was a lady, Mrs. Cora Davis, who drove her horse and buggy to give piano and organ lessons to my older sisters and to neighbors' girls. When she discontinued these lessons, I was left out. Sister Helen and my father (he played in the Pawnee City band when they lived there) would help me when I asked for music knowledge. I tried to learn on my own, achieving some degree of proficiency.

Only one sister went to high school, for one year. All the others stayed at home after eighth grade graduation. We didn't travel very much. Father bought a 1924 Model T Ford.

My oldest sister, Olga, worked in a restaurant. She probably would not have done this, except that she was in love with a nice Polish young man. My mother did not approve of a Polish and Catholic. There was a lot of friction between the two, which caused us a lot of heartache. I couldn't understand why one would discriminate because of anyone's nationality or color.

Olga married him, and they had two beautiful children. They were poor in worldly goods, but became quite prosperous to a farmer's standards of yesterday. They lived together until he died in 1983 at age 83.

Mother was a very good cook. We ate many Czech foods she had learned from her Austrian-Bohemian mother, such as duck, sauerkraut, dumplings, *vdolky* (a flattened bread spread with butter and apple butter), *škubanky* (mashed potatoes with cooked butter and homemade cottage cheese), *rohliky* (a rolled bread), *kolačky, houska* (a twisted sweet bread with raisins and nuts and poppy seed on top), and limburger cheese. None of us liked this cheese, only mother, and she ate it outdoors!

Sundays she would dress a mature hen, make noodles and bake *kolačky*. We would usually have chicken noodle soup and *kolačky* for our Sunday noon meal. I thought this hen soup the very best, and to this day, no soup seems to compare with it.

We as a family were all free thinkers. To belong to an organized religion would only inhibit my open-minded thinking. Father and mother belonged

to the *Západní Česko Beatrská Jednota* (Z.C.B.J.) when they lived in Nebraska. They dropped this membership when they moved to Kansas.

When we were in grade school, mother made us wear asafetida, a gum resin from alliacious roots. Mother would put a piece about the size of a walnut in a cloth bag and tie it around our necks. This foul-smelling thing was supposed to ward off disease. I hated it so much. Some of the other children wore it also.

Mother would pluck feathers from live ducks and geese in the late summer. The fowl then would have time to grow another coat before winter. When she got through with this plucking the fowl would look shaggy and ungainly. We young children would catch the birds for her, which were confined in a shed or wire mesh enclosure. Some winter nights were spent in stripping these feathers, which were later used for pillows and feather beds.

In the 1920s Cuba, Kansas, a Czech settlement, sponsored the music and calisthenics organization Sokol. Mother longed to have us children participate. Again the distance and money problem deterred us.

It was a custom of the Czech families to prepare a daughter's dowry when she would marry. I embroidered or appliquéd dish towels, pillow cases, buffet and table scarves. Crocheted lace was implemented into many wearable or aesthetic articles. A featherbed and a pair of feather pillows was a must in our family, the daughter receiving these articles when she moved into her first home. Some furniture, a cow, a sow, and chickens were the complete dowry. The husband was supposed to have the house ready for the bride.

Seed corn, flour, chicken feed, and sugar sacks were used to make dresses, underwear, drapes, tablecloths, napkins, shirts, et cetera, especially in the 1930s during the dust storms and the Great Depression. The chicken feed sacks came in cotton prints, sugar sacks in unbleached muslin, flour sacks in bleached muslin, and seed corn in a heavy unbleached fabric that was especially nice for table covers and linen-like dresses. Being able to design, I could make original garments that I was never ashamed to wear at home or formally, although they cost only a few cents for thread. The upkeep of a sack fabric article was more difficult than today's synthetic or stretch fabrics. The cottons needed starching and ironing.

In the late fall or winter, hog and beef butchering was performed by the Brzoň and Paleček men. After the meat cooling process was completed we women made *jitrnice* (in today's stores it is spelled jaternice). We used the jowls and all other meat parts of the head. Only the eyes were discarded. I remember those eyes! Liver, kidneys, and heart with the head meat were all boiled together with a little salt. When cooked it all was ground, then mixed

with garlic, corn meal, allspice and pepper, and put in casings —hog guts. We had a special contrivance for the stuffing into the intestines. The cleaning of the guts was an unpleasant task. I usually did it outdoors.

When these *jaternice* were baked to a golden brown we thought they were delicious with corn meal mush and some other foods. *Sultc* was made from the legs of the swine.

Father usually rendered the lard in an outdoor iron kettle with a fire built around it. Also the hog meat was cooked outdoors in the iron kettle. When the meat was cooked it was put in 50- or 25-gallon stoneware crocks with lard poured on it to keep it fresh.

The cracklings *(škvarky)* were saved and later made into lye soap in the big iron kettle. When the soap was solid it was cut with a corn knife, as our butcher knife blades were too short for this thick mass. The soap bars were laid out to dry on boards in an old shed.

Music and dancing—polkas, schottische, waltz, two step, Charleston, square dances, et cetera—were enjoyed by the family and neighbors. Dances were held in barns and homes one night of each week in the winters of the 1920s. A violin and guitar or piano kept the rhythm for the dancers.

Mother said I was always creative. She planned to give me visual art drawing lessons, but there was no art teacher in our nearby towns. To go elsewhere was out for our limited income.

In 1934 I married a farmer stockman, and we had three sons. In 1952, when I was 40 years old, I decided to pursue a visual creative career. With the support of my husband, Frankie, I took some night art classes in Fairbury, Nebraska, sponsored by the University of Nebraska, and in Belleville, Kansas, sponsored by the Kansas State University. With three semesters and many art books on drawing and painting I worked on my art most every day even if it was only for a short while. I also took a few piano lessons.

I took my art work to shows in Kansas, Nebraska, North Dakota, Alabama, and Colorado, receiving recognition and prizes. Subject matter was never a problem for me. I have more ideas than I can create. My main medium is oil. I also sculpt, using osage orange (a tree) and mixed media to create fantastic sculptures. I was invited to show some of these creations in the "Czech capitals" of Wilson, Kansas and Wilber, Nebraska.

In 1970, after thirty-six years of marriage, my husband died of a heart attack. I have nine grandchildren. I live here in the country the same as usual, creating. Groups of people come to see my art work here in Republic County, Kansas.

40

In 1963 I helped establish the North Central Kansas Association of Artists. In 1975 I helped organized the Munden Czech Singers, a group of about 16 members. We sing whenever we are asked. We sang at the Czech capitals of Kansas and Nebraska; the towns Wilson and Wilber are considered Czech capitals because of the Czech festivals held there. On March 10, 1983, the Munden Czech Singers made a tape of a number of Czech songs.

Rosie Šimek Paleček of Munden, Kansas, my mother-in-law, would say this poem to my three sons when they were small:

Bude zima bude mraz, It will be winter, will be frost,
Kam se ptačku kam skovaš Where will the little bird hide?
Ja se skovam do mezu, I will hide in the fence row.
Až to přej dé vilezu. When it passes, I'll crawl out.

A Czech prophesy to a man:

Never marry an old lady;
 her hands are as cold as a frog.
Marry a young girl;
 her hands are warm as a featherbed.

41

Good to Lean Against

Trees of the Alvin Petrik Family

By Anna Petrik

We, Alvin and Anna (Kolarik) Petrik, our three sons, and their families, along with many other relatives, have our beginnings with family trees that have grown to span five generations in America, with roots, trunks, and branches. The trees, alive and well, are growing in the area west and south of Caldwell, Kansas, as well as immediately across the border in Oklahoma.

Caldwell is a small town on the Kansas-Oklahoma border some fifty miles southwest of Wichita, Kansas. On the Chisholm Trail during the late 1860s and early 1870s, when cattle were driven from Abilene, Texas, to the railroad that ended at Abilene, Kansas, Caldwell was an important stop and watering hole. The trail crossed Indian lands through what became, in 1907, the state of Oklahoma. Caldwell was for the cowboys a wild first-chance to stop on the route north, and a last chance going south. In the years when activity on the trail was the most exciting, land was being homesteaded in Kansas between Caldwell and Bluff City, twenty miles to the west. J. Kolarik, my grandfather, settled here about 1874.

The Czech Cemetery Association, organized in1881, has been active for more than 100 years. In the *Czesko Slovankský Hřbitov* (Czech Cemetery), five miles west of Caldwell on the Bluff City road, are the graves of early Czech settlers who died in the Chisholm Trail era. Other graves of Czech settlers and their descendants are in nearby burial grounds. It is mute testimony that as a people, Czechs immigrated here, prospered, and remained. Today one can find those same names listed in the Caldwell area telephone directory.

On September 16, 1893, the United States of America opened to settlement the Cherokee Strip, an area along the northern border of the Oklahoma Territory. After a series of "starting" shots were fired, settlement was made by men "running for it" any way they could, by horse, buggy, on foot, in groups, or as individuals. When a man found what he thought would be a suitable quarter of land (160 acres), he planted a stake to claim it as his. Some immigrants left Czech settlements in northern Kansas and Nebraska to make the "run." Caldwell was a key starting point for the race, one of the wildest means of settlement in American history.

Having staked the claim, the settler had to meet the conditions set down by the United States government in order to keep it. J. Skalnik (my grandfather) and A. Petrik (Alvin's) were among the thousands who made the race.

F. Jindra (Alvin's) came a few years later and bought land in the territory. Sod houses were built and men sent for wives and children. Within five years each family held a firm foothold on their own land. All settled less than twenty miles from the Kansas border.

The men and women of the four pioneer families of which we are descendants came to America for a variety of reasons: to avoid the ever-present conscriptions to the Austrian army, oppressions of the Church of that era, adventure, and an earnest desire to find opportunity in a new land. Most were in their late teens or early twenties when they arrived in America, and they never went back to their homeland, not even for a visit. Some of the trades (weaver, baker, tailor) learned and used in Europe were of little value in the new land, and here all four men became farmers. At least two never got used to farming and could not learn to like it once they found themselves actually tilling the prairie. The grandfather, J. Kolarik, also operated a country store, and later managed a hotel in Caldwell. Family unity was strong, and women did what they could to keep things together, all the while rearing large families, even if it meant working fields alongside husbands and older children.

These were the same women who continued to practice exacting skills of working intricate patterns in embroidery, knitting, quilting, and crocheting. This was an era during which frivolous work was frowned upon by the man's world. Yet life on the prairie was hard, and the women early came to the conclusion that to have something beautiful meant they would have to create it themselves. "Fancy work" was an acceptable evening or winter day outlet, especially if a mother could make something either for her daughter's future hope chest, or piece a quilt to give when a son finally married. Much of the work was done after the "necessary chores" were completed for the day. Many beautiful things were handmade by kerosene lamplight. One grandmother, A. Skalnik, was an expert at fiber skills, and many pieces of her work are today treasured.

Despite hardships, all four families managed to prosper while teaching themselves to get along in speaking, reading, and writing English. All acquired additional land near their homes, and much of this is today owned and worked by one or more of the many descendants. However, one now finds active and thriving agri-businesses.

Our family is thankful for its solid heritage and we are very proud still to be called "Czech." We would not want to live in any other area of the United States. The family trees are love with ever-deepening roots —something good to lean against.

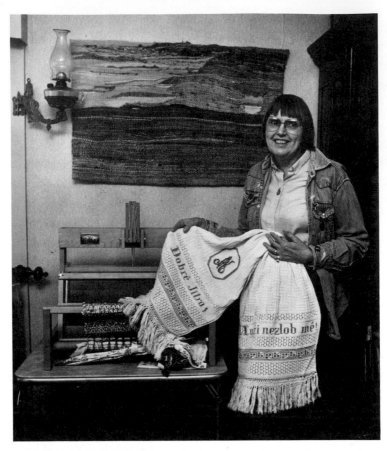

Anna Petrik holds a scarf for a bedroom rocker. This scarf was knitted before 1890 by Antonia Konopička Skalnik. Both the scarf and the embroidery are cotton. The border is an authentic counted design which was common in the Old Country. The knitting seems to have no wrong side. The fringe is hand-tied. The embroidery is flawless, and the back shows no ending or beginning stitches. This piece is unique because one end is worked with embroidery to the reverse of the other. One could flip the side over, according to which best suited the occasion! On one side the Czech words read "Good Morning" and the other side has "Husband Don't Bother Me." Subtle messages in a Victorian era! In the background is Anna's Rain, a 39x26-inch tapestry which was hand-woven, using an eight-harness loom. The tapestry has been an award winner in two juried exhibitions in Kansas. In the raging thunderstorm of abstraction, one can find yarns of various weights and textures. Many shades of green, blue, gray, and brown were used. Some of the yarn came from the artist's hand spindle.

Texas

Czech, Moravian, and Slovak roots are deep in Texas soil. Among the town names of Texas are Hostyn, Moravia, Nada, Novohrad, Praha, Ratibor, Rosanky, Smetana, and Tabor.

Dr. Anthony Michael Dignowity, one of the first to arrive, reached San Antonio in 1833—three years before the battle of the Alamo. In that battle, 187 defenders, including Jim Bowie and David Crockett, lost their lives. In April, 1836, one month after that battle, Texans led by Sam Houston defeated a Mexican army in the battle of San Jacinto, capturing General Santa Anna, president of Mexico. This battle won independence for Texas. Bedrich Lemsky, one of the musicians who marched into the San Jacinto battle, had arrived from the Old Country earlier in 1836.

Many families can call themselves Texans today because of the Rev. Arnost Bergman. He was a leader in the first Czech settlement in Texas (1847) at Cat Spring in Austin County. Impressed by his letters to friends back home, telling of the wonderful Texas soil and climate, many made the grueling overseas voyage to Texas.

These hardy and determined immigrants told of arduous journeys across the Atlantic and long and exhausting travel by ox cart, wagon, or horseback from Galveston or Houston. There were no roads, no bridges. Their possessions were few and their funds meager.

Settlers kept coming, leaving behind hundreds of years of subjugation under the Germanic influence of the Austro-Hungarian empire with its religious, economic, and social persecution. They brought their families or sent for them after reaching their destinations in the New World. Soon the immigrants from the areas now known as Czechoslovakia were in substantial numbers in the communities of Fayetteville, Flatonia, Hostyn, Industry, Nelsonville, Bleiberville, and others. The great push was into Fayette County which is known today as the "seat of Texas Czechdom."

Thousands of other hardy pioneers followed, and that was just the beginning! We all know how Texans love to be the BIGGEST and the BEST. Well, today the Czechoslovak presence in Texas—more than 700,000—is the LARGEST in the South. Texas has the LARGEST rural Czech population in the United States, and the Czech language is the third most spoken language in Texas, after English and Spanish. The University of Texas offers courses in the Slavic languages.

The Czech, Moravian, and Slovak settlers in Texas were stimulated by the Komenský (Comenius) tradition to build schools wherever they settled, and to establish fraternal organizations to preserve security and culture. The Czech Catholic Union of Texas (KJT) was organized in 1889 under the leadership of the Rev. Joseph Chromcik. That organization's sister group (1897) was the Catholic Union of Czech Women of Texas (KJZT). Both offered low-cost life insurance, plus religious and social activities. The Slovanic Benevolent Order of the State of Texas (SPJST), also established in 1897, has an estimated 57,000 members state-wide and regularly hosts meetings, socials, dances, theater productions, and youth programs. Again, sociability and security are key aims.

Mental and physical fitness means strength and security also, so Sokol gymnastic societies came to Texas. Sokol (meaning falcon, which symbolizes high ideals) was a part of the nationwide Sokol network promoting physical fitness as well as social and cultural identity. Book clubs are a part of Sokol.

Texas Czechoslovaks today still encourage ties with one another —locally, nationally, and internationally. Rudy Klecka's Klub Kontinental in East Bernard, Texas, sponsors a "People to People Farm Exchange" with the agricultural cooperative JZD Agrokominat of Slusovice, Czechoslovakia. Farmers, ranchers, and dairymen are exchanged to study agricultural practices while also broadening the understanding between the Americans and Czechoslovakians. Americans participating have included farmers from the Texas cities and towns of Houston, Victoria, Richmond, Rosenberg, Hallettsville, Caldwell, Petrolia, Aquilla, Yorktown, Dallas, and East Bernard.

Texans interested in Czechoslovak culture are proud of their music, art, and language. Some radio stations still air the polka shows that originated in the 1920s, and more classical Czechoslovakian composition is encouraged as well. The Czech language is still spoken in numerous areas, and two Texas newspapers are printed entirely in the Czech language. Distinctive Czechoslovak arts and crafts abound in Texas. Fine crystal, lace and quilt work, and garnet jewelry may be found at Klecka's Dry Goods in East Bernard, about 45 miles southwest of Houston, and elsewhere.

And Festivals, Festivals, Festivals are part of the old Texas spirit of "Let's show them how to have a good time." There are festivals annually in many Texas towns. Czech Day at the State Fair of Texas is an annual event eagerly awaited.

South Texas

This article from Alvin J. Prochaska, president and co-founder of the Czech Heritage Society of South Texas, Corpus Christi, draws on A History of the Czech-Moravian Catholic Communities of Texas, *translated and edited by Rev. V. A. Svrcek.*

The 1980 census reported 4,103 persons of Czech ancestry in Nueces County, 73 of whom were born in Czechoslovakia. The county has only two cities of any size, Corpus Christi, the county seat on the Gulf of Mexico coast, and Robstown, a few miles to the west.

S. L. Kostohryz (now spelled Kostoryz) came to the area and bought some 8,000 acres of land southwest of Corpus Christi. He divided the property into 80-acre farms. The first Czech settlers arrived in 1906. The area became known as the Bohemian Colony Lands. The first to buy land were Frank Kocurek, Ferdinand Polacek, John Koblizek, George Zezula and John Brandesky. Many others soon followed.

My father, at age 3, arrived in Robstown in 1907. Just about all of the first settlers bought uncultivated lands heavy with underbrush. To break up the root-filled mesquite flats and make possible the farming of the rich soil, a special plow was invented by Tom Mrazek, who came to America in 1880 and to Robstown in 1907. The "Mrazek Plow" was used in breaking most of the land of the county, and in road construction.

The Czech Heritage Society of South Texas was organized in 1980. Its objectives are to preserve, maintain and promote the customs, language, heritage, and social relationship of people of Czech descent. There are more than 450 dues-paying members. Each spring, the Society presents a Czech Heritage Festival at the Bayfront Plaza Convention Center in Corpus Christi. The Society has restored a vintage Czech-Texas house, circa 1901, starting a Czech History and Genealogy Research Library, and a photo collection of South Texas Czech pioneers. The Society also boasts of its Czech Heritage Singers.

The area has three main places where Czechs congregate —the large and modern Sokol Hall and the Moravian Hall in Corpus Christi, and the Robstown Community Hall, which in 1962 replaced the 1919 building called the Czech Community Center, also known at that time as the Robstown Moravian Hall.

Alvin J. Prochaska, left, and Leroy A. Ryza are at the Jalufka House in Corpus Christi, Texas. The 1901 house was restored by the Czech Heritage Society of South Texas for offices, meeting rooms, a history and genealogy research library, and a collection of photos of Czech, Moravian, and Slovak pioneers. Prochaska is president, and Ryza is vice-president of the Society.

West and Caldwell

"Howdy" and "Nazdar" are words of greeting spoken by non-Czechoslovaks and Czechoslovaks alike who enjoy kolache pastries, roast pork, drop noodle soup, and dumplings served at annual ethnic celebrations in West and Caldwell, both in Texas.

Westfest, held annually on Labor Day weekend, crowns a Miss Westfest, holds a fun run, a parade, and a horseshoe pitching contest along with the traditional festivities of music, dance, and Czech foods. West also boasts Sulak's Restaurant, the Old Czech Smokehouse, Nemecek's Meat Market, Kolacek's Kitchen, Nors Bakery, and Village Bakery—all shops featuring delicious Czechoslovak goodies!

The Czech folk dancers of West vary Czech dancing with their "Texas-Czech" style, thus preserving their Czech culture and heritage. They have performed throughout the state, in Oklahoma, and in Czechoslovakia. These dancers got their start at the 1976 Westfest. West is north of Waco on Interstate 35.

The Caldwell, Texas, Kolache Festival features a kolache-baking contest, with county and state divisions. This event, annually staged the second Saturday in September, also displays a mini-museum with items of local Czechoslovak history, plus music, food, dancing, gymnastic demonstrations, and festive events. The celebration has a quilt show and sale and demonstrations by artisans and craftsmen. People from every building and business in downtown Caldwell are invited to participate.

A Letter from Texas

By the late Mollie Krizan, Dallas, Texas

My parents were raised at West, McLennan County, Texas. They were John and Johanna Divin. They had twelve children. The oldest child died in infancy and they raised eleven of us. We had an eighty-acre farm, so we had plenty to keep us busy. Mules were used in the field work. We had six to eight cows, with young calves for butchering in the spring. We had a beef club, with about 20 farmers, and starting on Easter Saturday we had the first butchering.

The butcher cut up the yearling, and each member got a portion of a roast, steak, stew meat and some of the bones for soup, and some liver for whoever wanted it. Every Saturday one farmer gave a yearling, and the meat was weighed. At the end of the season if a farmer had given more or less weight in his yearling than he had taken in meat, he either got a refund or he had to pay up. We had plenty of milk, butter, and cottage cheese. The clabber (*kyška*) we fed to the hogs.

Mother always had 250 to 300 hens so we used eggs and we sold eggs. That helped to buy groceries and clothing for six girls and five boys. In the spring she would get 100 to 200 baby chicks so we had plenty of fryers to eat.

We would have five to seven hogs for our winter meat. We made sausage, *jaternice* but no *jelita,* and we used cooked rice, not bread in the *jaternice.* We also made head cheese, which was delicious with homemade bread. My father would clean the intestines and the stomach, for the cheese that was stuffed. The cooked parts of the head were cut up in cubes and seasoned. Then it was put on a board, another board was put on top, and a big stone was on top of that to press it down.

The intestines were cleaned and stuffed with sausage meat. I still have the old-fashioned grinder that my husband got from his home place. We had a smoke house to smoke the sausage, ham, and bacon. With 11 of us you can imagine how long a 200-pound hog would last at our house. We butchered one about every four weeks. We also rendered lard from the fat part of the hog.

My father raised sugar cane. We would strip the leaves from the cane. Then it was hauled to the syrup mill and there it was run through the press and the juice was cooked in huge vats. When the syrup was done, it was put into wooden kegs. That was some good eating with good old homemade bread.

Names to Be Remembered

Jan Ámos Komenský

Emperors and conquerors come and go. The work of an educator, Jan Ámos Komenský (1592-1670), also known by his Latin name, John Amos Comenius, is as important in education today as it was when he lived.

Born in Moravia, Komenský noted early that teachers were harsh and

strict. The boys sat for 10 hours a day and went up one by one to the teacher to say their lessons. If a boy was noisy, the teacher beat him. Subject matter was mostly religious and classical. Most teachers did not care whether the boys understood what they were studying. Instead they wanted memorization and QUIET.

Komenský called these schools "slaughterhouses of the minds." He introduced new thinking which prevails today. He sought to make school pleasant and more interesting to pupils, starting with what the child knows and proceeding to what the child does not know.

Komenský produced the first schoolbooks that included pictures, illustrations, and examples, a revolutionary and startling idea at the time. He sought to open all areas of knowledge to the child, including the pupil's own body, the community, and the world. He urged universal education, teaching in the local language, physical education, health education, vocational education, and the use of drama in the schools. He believed that these principles were basic to human betterment.

With the start of the Thirty Years War in 1618 and the battle of White Mountain in 1620, Komenský was forced into exile. Although his writings and library were destroyed by burning during two different upheavals, he strongly influenced educational methods in Poland, Germany and England. It is believed that he was offered and declined the opportunity to be the first president of Harvard College, which was then being organized in America,

and went instead to Sweden, which had invited him to help establish a new educational system. He wrote more than 200 books.

Barred from returning to his homeland, Komenský wrote: "I love my country and its language, and my greatest wish is that it should be cultivated."

The Comenius World Council, Hartford, Connecticut, is a world organization dedicated to the application of the ideas of Comenius (Latin for Komenský) which foreshadowed the United Nations, the world ecumenical movement, and other current developments seeking human rights and the unity and freedom of mankind.

Karel Havlicek

Karel Havlicek (1821-1856), journalist and patriot during some of the darkest days of oppression, gave his life for his people. He was born October 31, 1821, in Borova, Bohemia. At age 24 he became editor of the newspaper *Pražshe Noviny* and its literary supplement *Česká Vcela*.

Prince Klemens Wenzel Nepomuk Lothar von Metternich, who became chancellor of Austria the year Havlicek was born, was a powerful leader in Europe, dedicated to preserving monarchy and long-existing class structures.

In 1848, when riots broke out in Vienna, Metternich fled to Britain, his career ended. On March 15, press censorship was ended, and on April 25 the constitution was published. But after a few brief months of freedom, oppression returned in 1849 with all the evils of secret police, censorship, and denial of liberties. All newspapers were closed down.

All but one. Havlicek, who had founded the Národni Noviny (National News) on April 4, 1848, defied the government. He told of the rise of liberty in France and Germany. Among other strategies, his headlines were about "The problems of Ireland" although from the articles, it was evident that the problems under scrutiny were those of Bohemia.

An inspiration to his people and a threat to the government, Havlicek was tried twice before a jury, and was found "not guilty" both times. The government twice offered him a considerable sum plus an annual salary to cease publishing, and twice he refused the offer.

Finally, at 2 a.m. on December 16, 1851, the secret police entered his home, pulled him from the arms of his weeping wife Julia and daughter Zdenka, and took him away to spend four years in prison at Brixen (now in Italy), from which he was released in such poor health that he soon died —on July 29, 1856, in Prague, at age 35.

In prison, he wrote:

Promise me, but I will not be a traitor!
Command me. My colors are Red and White!
Threaten me. My heritage is Honesty and Strength!

A monument to Karel Havlicek, sculpted in 1911 by Josef Strachovsky, stands on Solidarity Drive near the Adler Planetarium in Chicago.

Vaclav Havel

The Czech playwright Vaclav Havel visited the United States in May of 1968 for the American premier of his *The Memorandum* at the New York Public Theater. Three months later Soviet tanks rolled into Czechoslovakia and the "Prague Spring" was at an end.

Since then, Havel has had his phone bugged, his apartment ransacked, his plays and writings banned. He has spent four years in prison (1979 to 1983). He has been followed when he goes for walks; sometimes the police walk alongside him and exchange small talk.

Marie Winn, who translated two of his plays, which had been smuggled out of Czechoslovakia, visited him in Prague and wrote about it for the *New York Times*. She quoted Havel as saying:

"Of course I have a lot of friends who are perfectly free to visit me no matter what. These are other so-called dissidents, historians, journalists, or philosophers, people who once had a true profession and who now work in men's rooms or boiler rooms, or as cleaning women or the like. They have nothing to lose. . .

"Everybody has some basic certainty that gives them life support. It may be a job, a home, a car, and they don't want to lose it. That's why they'll remain quiet and obedient. Dissidents are actually those lunatics who decide, one fine day, that they don't care if they lose everything. . .

"It's paradoxical. By persecuting us the regime gives us more and more reason to see that what we are doing is terribly important. . .Of course you in the West may suffer from an opposite problem —so many people speaking freely that no weight at all is attached to their words, as Saul Bellow has written in *Herzog*."

Jaroslav Seifert

On October 11, 1984, Jaroslav Seifert (1901-1986) became the first Czechoslovak to win the Nobel Prize for literature. Considered "the voice of the people," his poetry spoke to them with passion of the cruelest days of Nazi occupation, his love of Prague and of people, his country, and all humanity. He lightened hearts and kept hopes alive.

Seifert was born in Sizkov, a workingman's district of Prague. His parents were poor. His father was a Marxist; his mother, whom he idolized, was a Catholic. As a youth, Seifert joined the Communist party, but quit in 1929 because he found the party "anti-intellectual."

After World War II, because he did not cooperate with the repressive government, Seifert's works were not published, but he never stopped creating poetry. His works were circulated by *samizdat,* the underground literature. In 1983, one year before Seifert won the Nobel Prize, an Iowa City, Iowa, publisher, Morty Sklar, published Seifert's *The Casting of Bells* in English through his "The Spirit That Moves Us Press." In 1985, the same press published the patriotic and sentimental *Eight Days: An Elegy for Tomás Masaryk* and *Mozart in Prague: Thirteen Rondels.* English translations of all three poems were by Paul Jagasich and Tom O'Grady.

Seifert was the first writer in the Soviet bloc to win the Nobel prize for literature since 1970 (Alexander Solzhenitsyn). In awarding the Nobel Prize, the Swedish Academy said, "He is loved as dearly for the astonishing clarity, musicality and sensuality of his poems as for his unembellished but deeply felt identification with his country and its traditions."

In 1985, accepting an honorary Doctorate of Letters from Hampden-Sydney College in Virginia, Seifert said: "The best place, the best position for poetry, I think, should be between heaven and earth —high enough to touch heaven, but at the same time firmly rooted in the earth. Poetry should never lose any of its human warmth or its function to remind humans of their earthly existence."

Franz Kafka

Franz Kafka (1883-1924), born in Prague and educated in law at the University of Prague, wrote novels and short stories. He asked that all his manuscripts be destroyed after his death, but instead they were published. In 1987 his *Letters to Felice* sold for $650,000 at an auction at Sotheby's Gallery in New York City. Kafka's novels, still widely read, deal with life in Prague and with a dictatorial and petty bureaucracy.

Paul Wilkes

Paul Wilkes, Slovak-American novelist and journalist, published his first novel, *Fitzgo, the Wild Dog of Central Park,* in 1974. He graduated from Marquette University, earned a master's degree in journalism from Columbia University, and has written for public television, the Baltimore Sun, and national magazines.

Milan Kundera

Milan Kundera, son of a famous pianist, wrote the two-year national bestseller, *The Unbearable Lightness of Being,* which was made into a motion picture in 1988.

Kundera was born April 1, 1929, in Brno, Czechoslovakia. After World War II, he enrolled in the Communist party. As a student after the 1948 takeover of Prague, he was expelled from the party. He became a professor at the Prague Institute for Advanced Cinematographic Studios, but lost his post after the 1968 Russian invasion. In 1975 he settled in France, and in 1979, the Czechoslovak government, in response to publication of his *The Book of Laughter and Forgetting,* revoked his citizenship.

Critics have called Kundera "the most important writer from behind the Iron Curtain since Solzhenitsyn." His books have been translated into twenty languages. In an interview in *Afterword,* Kundera said:

"If someone had told me as a boy that 'one day you will see your nation vanish from the world,' I would have considered it nonsense, something I couldn't possibly imagine, but after the Russian invasion of 1968, every Czech was confronted with the thought that his nation could be quietly erased from Europe."

Peter Rovnianek

One of the first Slovak Americans to be successful in newspapering was Peter Rovnianek, who helped found the National Slovak Society in Pittsburgh in 1890. In 1888 he began writing for *Amerikanszko-Szlovenszke Novini,* the first Slovak newspaper in America. He became editor a year later, and made it the leading Slovak weekly in North America. He standardized spelling and grammar, and invigorated Slovak pride among readers, giving Slovak Americans a voice in this country as well as abroad.

St. John Nepomucene Neumann

Born March 23, 1811, in Prachatice, 90 miles southwest of Prague, John Nepomucene Neumann was named for the saint who was from a nearby town. Educated in České Budéjovice and Prague, he came to the United States in 1836.

Ordained a priest in New York, he served in Buffalo, Pittsburgh and Baltimore, became head of the Redemptorists in the United States, and in 1852 was named bishop of Philadelphia.

Father Francis A. Novak, CSSR, wrote in *Czech Catholics at the 41st International Eucharistic Congress* (1976): "Like most Czech Bohemians, Neumann was endowed with idealism, a penchant for hard work and perseverance, the great gift of humility, and a distaste for glory.

"He was especially sensitive to the plight of poor Catholic immigrants, who arrived from Europe, in an unfriendly America. . .On all his far-flung diocesan visitations, he urged his people to take pride in accomplishment and do quality work despite social rejection and debasing working conditions. He prophesied that better days were ahead. . .He preached and exemplified patriotism which rose above the passing problems of bigotry and poverty. To American Czech Catholics, Bishop Neumann. . .embodied all the components of Jesus and applied them to his contemporary situation."

Pope Paul VI declared Bishop Neumann blessed in 1963, and raised him to sainthood in 1977. His birthplace, a home for the elderly, was managed by the Catholic Sisters of St. Charles Borromeo until they were expelled by the Communist government.

The Czech Chapel of the National Shrine of the Immaculate Conception in Washington, D. C., was dedicated in 1983 to Our Lady of Hostyn in honor of St. John Nepomucene Neumann and all the Czech saints.

For the faithful, the shrine is a New World embodiment of the church at Hostyn, a pilgrimage destination for centuries, which was erected in appreciation of divine intervention that enabled the Moravians to repel the Mongol hordes in 1241. The Communists have dispersed the Jesuits from Hostyn and turned it over to secular priests who receive the crowds of pilgrims.

Raising the Flag

One of the five marines who raised the American Flag on Iwo Jima in 1945 was Sergeant Michael Strank of Franklin, Pennsylvania, son of Czechoslovak immigrants. The event was the subject of a Pulitzer Prize-winning photograph by Associated Press photographer Joe Rosenthal.

Gregor Johann Mendel

Czechoslovaks can claim Gregor Johann Mendel (1822–1884), the father of the science of genetics. He was born in Silesia, the son of poor peasants, and spent most of his life in Brno, Moravia.

As a boy, Mendel watched with interest as his father worked on fruit trees in his orchard. Mendel studied two years at the Philosophical Institute of Olomouc, Czechoslovakia. In 1843, taking the name of Gregor, he entered an Augustinian monastery at Brno, Moravia. Four years later, in 1847, he was ordained a priest. Failing an examination for a teaching certificate, with his lowest marks in the sciences, he was sent by his abbot to the University of Vienna, where he took science courses from 1851 to 1853.

Returning to the monastery, Mendel conducted breeding experiments with garden peas, crossing varieties in a pioneering study of plant hybridization and of the elements of heredity that are now known as genes. In 1866 the Natural Science Society, of which he was a founder, published his paper *Experiments with Plant Hybrids,* the importance of which was not recognized until 1900 when it came to the attention of other European scientists researching genetics.

In his last 10 years of life, Mendel served as abbot, and his administrative duties cut into his time for research. He died in 1884. His obituary showed that he was held in high respect, but included no comment on his scientific achievements. His own writings, however, show that he knew the importance of his work, and was convinced that eventually his studies would be carried on.

Scientific Greats

Jaroslav Heyrovský won a Nobel prize in 1959, the country's first, in physical chemistry. Among other Scientists are Vaclav Hlavaty, mathematician, who solved equations to support Einstein's unified field theory; Josef Ludwig Franz Ressel, inventor of screw propellers for steamships; and Johannes Evangelista Purkinje, pioneer in experimental physiology, histology and embryology.

In Motion Pictures

Movie stars included Ann Dvorak, Kim Novak, Sissy Spacek, and Robert Ulrich.

Ivana Trump

Ivana Trump, the glamorous wife of the New York City real estate owner Donald Trump, is active in the Trump hotel properties, including the Trump Plaza Hotel and Casino and Trump's Castle Hotel and Casino, both at Atlantic City, New Jersey. Properties under her control have 3,500 employees. She was born in Czechoslovakia.

Andy Warhol

The American artist, Andy Warhol, was born in Pittsburgh in 1928 to Czechoslovak immigrants. The parents, Ondrej and Julia Warhola, were married in 1909 in Mikova, Czechoslovakia. Ondrej came to the United States to escape military service. Julia stayed to care for her sick daughter who died at the age of six weeks, and was unable to join him until 1921.

The artist studied painting, design and art history at Carnegie Institute of Technology, Pittsburgh, before becoming a magazine illustrator and fashion designer, signing his work Andrew Warhola.

Acceptance of his work by fine arts museums followed his astute observation of American merchandising tendencies which personalized products: "The product as person, the person as product!" By the time of his death in 1987 at age 58, his work was in many museums. At several auctions after his death, his own collection of works of art drew high prices.

Alois Kohout Lecoque

Alois Kohout Lecoque, well-known artist, was born in Prague March 21, 1891. He studied in Yugoslavia and Paris, adopting a French name because he thought it would help him as an artist.

In World War II he was a prisoner of the Nazis in Yugoslavia, but escaped. Jan Masaryk presented Lecoque's *Rooftops of Prague* to President Dwight D. Eisenhower. Lecoque's works are in many museums in Europe and America. He came to America in 1961, aided by Roderick A. Gorman, collector and translator of Czech poetry. Lecoque lived in Chicago and later in Hollywood. He died in 1981 at age 90.

Frank Kriz

Frank Kriz represented the American Sokol organization and was the first American to win a gold medal for the long horse vault in gymnastics in the 1924 Olympics.

Karla Masaryk

Charlotte Garrigue, an American, met Tomaš Masaryk at the University of Leipzig, where both were students. In marriage, she became Karla, and he adopted her maiden name as his middle name. She mastered the Czech language and taught it to their two children, Jan and Alice. He became "the father of his country." She became a devoted partner, and an inspirational leader of women who were seeking equal status socially, intellectually, and economically with their male counterparts. Karla Masaryk's name was used to symbolize such progress.

When a men's lodge, C.S.P.S. (Czech Benevolent Society, 1879) refused to admit women to its insurance group or to allow them to pay premiums according to age, a group of men broke away from the national lodge and started their own lodge, Z.C.B.J. (Western Fraternal Life, 1897), allowing women to join. C.S.P.S. eventually decided to include as full members the wives of members. When the first C.S.P.S. women's lodge was formed, it chose the name "Karla Masaryk Lodge."

In Opera

Three sopranos of Czechoslovak origin received acclaim in the United States and Europe. Emmy Kittl Destinn (1878-1930), Maria Jeritza (1887-1982), and Jarmila Novotná (1907-) all sang in concerts and operas in Europe and at the Metropolitan Opera in New York.

In Tennis

World championship tennis has kept Czechoslovakia on the sports pages. On July 4, 1987, Martina Navratilova defeated Steffi Graf of West Germany, 7-5, 6-3, at Wimbledon, England. For Navratilova, the win was a record sixth consecutive Wimbledon singles championship, and tied her with Helen Wills Moody for a record eight Wimbledon championships over-all. Other names familiar to tennis fans: Ivan Lendl, Hana Mandlikova and Helena Sukova.

Stanley Mikita

Stanley Mikita is a Slovak Canadian who became famous in professional hockey. He grew up in St. Catharine's, Ontario, played hockey in high school, and joined the Chicago Blackhawks in 1958. He won numerous trophies and awards, was elected to the Hockey Hall of Fame, and authored two books, *Inside Hockey* and *I Play to Win*.

More Czechoslovaks of Interest

Chuck Bednarik, of Slovak descent, Philadelphia Eagles football great.

Admiral Claude C. Bloch, former commander of the United States fleet and commandant of the Washington Navy Yard.

Joseph Bulova, Czech-born watchmaker "whose name became synonymous with time."

Antonin Cermak, the Chicago mayor who was fatally wounded February 15, 1933, by an assassin's bullet intended for President-elect Franklin D. Roosevelt.

Eugene Cernan and James Lovell, American astronauts.

Anthony Fiala, leader of the 1903 Ziegler Expedition to the North Pole.

Bud Fisher, Czech immigrant who created the comic strip *Mutt and Jeff.*

George Halas, founder and coach of the Chicago Bears football team.

Augustin Herrman (1605-1686), the largest exporter of American tobacco. His map, *Virginia and Maryland as it is Planted and Inhabited This Present Year, 1670, Surveyed and Exactly Drawne by the Only Labour and Endeavour of Augustin Herrman Bohemiensis,* was as extensive and complete as its title.

Aleš Hrdlicka, appointed Head Curator of Anthropology of the United States National Museum in Washington in 1910. In 1918 he founded *The American Journal of Physical Anthropology.*

Roman Hruska, United States Senator from Nebraska.

Otto Kerner, former Governor of Illinois.

Dr. Alois F. Kovarik (1880-1965), Yale University physicist who joined the United States Signal Corps in World War I and helped develop devices to detect German submarines. He was born at Spillville, Iowa.

Ray Kroc, founder of the McDonald fast-food chain.

Stan Musial, who led the National League in batting seven times.

William Paca, a signer of the American Declaration of Independence.

Albert Pick, who came to Chicago in 1857 from Karlovy Vary (Carlsbad) and founded of the Albert Pick hotel chain.

Mildred Prchal, Sokol instructor and teacher of John Kriza, who became the solo dancer of the American Ballet Company.

Antonin Raymond, a Czech immigrant and architect who collaborated with architect Frank Lloyd Wright.

Jack Root, world champion light-heavyweight boxer (1903).

Dr. John Zeleny (1872-1951), a physicist who taught at the University of Minnesota.

The Moravian Brethren

After World War II, Old Salem, in North Carolina, was threatened with demolition, but it was preserved. Old Salem is a dozen or so blocks of eighteenth-century homes, shops and gardens surrounded by downtown Winston-Salem.

Of 111 properties acquired by Old Salem Inc., 60 have been restored and nine, including a bakery, are open to the public. Old Salem was built by members of the Moravian Church, also known as Unity of Bohemian Brethren and Moravian Brethren. An earlier name was *Unitas Fratrum,* or Unity of Brethren. It was founded in 1457 by followers of Jan Hus.

The first Moravians to cross the Atlantic came in 1735. They founded the town of Bethlehem, Pennsylvania, in 1741. Organized in Bethlehem in 1744, their symphony orchestra was the first in America. In 1766 they founded Salem (from Shalom, the Hebrew word for peace). They also founded Moravian College in Bethlehem and Salem College in Winston-Salem. The Schoenbrunn Village State Memorial, a settlement founded in 1772 by a Moravian mission, has been restored in New Philadelphia, Ohio.

The last bishop of the Moravian Church in Moravia was the educator Jan Ámos Komenský. He and his followers were driven from their homeland following the Battle of White Mountain in 1620, and for 100 years the Moravians were in Saxony. Their settlement was known as Herrnhut. Some of those left in Moravia went underground, fulfilling the prayer of Bishop Komenský that a "hidden seed" might be preserved in his native land.

Zeal for evangelism was brought to England by Moravian Brethren on their way to America to do missionary work among the American Indians. They strongly influenced John and Charles Wesley, who founded the Methodist Church.

Moravians have rich traditions in music and worship. They emphasize mission work among primitive peoples, and were the first Protestant religion to foster evangelism, believing it a duty. The northern province of the Moravian Church is centered in Bethlehem, Pennsylvania, and the southern province in Winston-Salem. The church sponsors 15 missionary provinces, including two in North America—one in Alaska and one in Labrador.

The first Moravian Church members to arrive in America were deeply religious, but unlike more austere immigrants in search of religious freedom, they wore brightly colored costumes and were never considered drab. They enjoyed good food, good music, and good fabrics!

Jan Hus Churches

Numerous groups of Presbyterians, Baptists, and Methodists named religious structures after Jan Hus, religious reformer and martyr of the early 1400s.

Ruth Wondriska of West Hartford, Connecticut, writes that her father, the Rev. Frank J. Zavodsky, was pastor of three Bohemian Methodist churches named in honor of Jan Hus —at Chicago, Cedar Rapids, and St. Paul. In 1919, after an absence of 20 years, he returned to the Jan Hus Bohemian Methodist Church in Chicago, where he remained until his retirement in 1947.

In 1897, Ruth's grandfather, Rev. Francis J. Hrejsa, became the first Bohemian Methodist minister ordained in the United States. He helped to establish five Bohemian Methodist churches in Chicago, and others in Iowa, Minnesota, and at Muscoda and Madison in Wisconsin.

The Jan Hus Bohemian Methodist Church, a landmark in the Lawndale area of Chicago, was the third Bohemian Methodist church in that city. According to Marjorie Gober of Marengo, Illinois, it started as a Sunday School in a tailor shop. In 1894 the first services were held in a new church building at 2356 South Sawyer Avenue. Membership was 300. All services were in the Czech language until 1902. Then services were in both Czech and English until 1940, when services became English only. Today there are services in Spanish and English.

"In a changing neighborhood, Jan Hus Church is bringing Christ's message to people of the Spanish ethnic, with the Rev. Jose R. Valazquez leading them," Mrs. Gober writes. Mrs. Gober's great-grandparents were Moravian Brethren. They came to Chicago about 1850.

Jan Hus was born in 1372 or 1373. He graduated from the University of Prague, earned a master's degree, and became a teacher and priest, and later rector of the university. His era was a century before Martin Luther's. He preached in Czech rather than in Latin. He was accused of the crime of "remanence," or believing that the bread and wine of communion retained its material substance. Denouncing "trafficking in sacred things," he opposed Pope John's order for the sale of indulgences to finance a war. He attended the Council of Constance under a guaranty of safe conduct. Instead, he was arrested and put on trial for heresy. This priest, who believed that "in the things pertaining to salvation God is to be obeyed rather than man," was burned at the stake by men, praying loudly until the end.

Spillville, Iowa

Spillville's first settlers arrived in 1849. In 1860 they built the beautiful St. Wenceslaus Church on a hill overlooking the town. Modeled somewhat after the Church of St. Barbara in Kutná Hora, this dominant and imposing structure is another jewel in the modest crown of a northeast Iowa village with a little Old World enchantment. Its pipe organ, installed in 1876, was played often by Antonín Dvořák, the Czech composer, when he spent the summer of 1893 in Spillville. The organ is still in use.

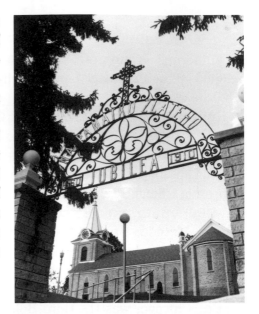

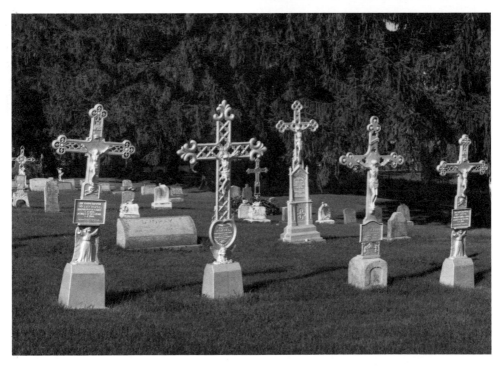

Saint Wenceslaus Churches

Svatý Václav

The subject of the Christmas carol "Good King Wenceslaus" was martyred for his vigorous support of German missionaries during the Christianization of Bohemia. Václav is the Czech name for Wenceslaus.

Václav descended from a family that united most of the Czechs and Moravians of Bohemia around 900 A.D. His father married a pagan. Václav was raised a Christian by his grandmother Ludmila, who became regent when Václav became ruler of Bohemia at age 14.

Václav's mother, Drahomira, had Ludmila murdered and became regent herself. Václav, the second ruler of Bohemia, is believed to have assumed power at age 15 in 922. During his brief reign many stone churches were constructed.

In 929, on his way to mass, Václav was murdered at the church door by his younger brother Boleslav. Because of reports of miracles at the tomb, Boleslav had the remains moved to St. Vitus Cathedral in Prague. Boleslav's aims were thwarted by his own act. The cathedral immediately became a pilgrimage site and remained so.

Legends of the goodness of this young ruler and of the family violence he endured led to his sainthood in the Roman Catholic Church. Ludmila was sainted also. Four later rulers were named in Václav's honor: Václav I (1205-1253), Václav II (1271-1305), Václav III (1289-1306), and Václav IV (1378-1419). Czechs of Cedar Rapids, Iowa, built St. Wenceslaus Catholic Church, and when the congregation outgrew that structure, they built St. Ludmila Catholic Church, honoring both the martyred king and his martyred grandmother.

Other Catholic churches named for St. Wenceslaus include:

Iowa—Clutier, Duncan, Iowa City, and Spillville.
Kansas—Wilson.
Maryland—Baltimore.
Michigan—Gills Pier.
Minnesota—New Prague.

Missouri—St. Louis.
Nebraska—Bee, Dodge, Omaha, and Wahoo.
North Dakota—Dickinson.
Ohio—Maple Heights.
Oklahoma—Prague.

Fitness With Sokol

This commemorative postage stamp was issued in honor of the 1965 centennial of Sokol in the United States.

Founded in 1862 by Miroslav Tyrš and Jindřich Fuegner, Sokol is a physical fitness program featuring gymnastics and calisthenics for all ages.

"Our idea is not for any faction, but for the entire nation," Tyrš explained. "It is not subject to change as are religious or political ideologies. Rather, it is eternally true and important. It stands, in that respect, elevated above temporary disputes."

Tyrš, an editorial staff member of *Reiger's Encyclopedia,* was the first Sokol physical director and the first editor of the Sokol publication.

The organization is based on the belief that only physically fit, mentally alert and culturally well-developed citizens can form a healthy, strong nation.

Its goals are:
1. To strengthen and improve the health of individuals.
2. To train people of strong will, capable of self-denial, people of firm and constant character who can put their plans into action.
3. To form of them more competent working units.
4. To teach them to work for society and in society.
5. To make them the basis of a healthier posterity.
6. To increase their defensive capacity.
7. To influence them by beauty, and to inculcate in them a sense of beauty.
8. To make them forever conscious that liberty and freedom are a priceless gift, their protection a sacred duty.

In 1965, to honor the United States Centennial of the Sokols, a commemorative "Physical Fitness—Sokol" postage stamp was issued. The image depicts the statue of a discus thrower that stands near the State Department in Washington, D.C. The stamp is proudly displayed at the Museum of Sokol South Omaha, Nebraska. To visit the museum, call Ed or Bea Pavoucek in Bellevue, Nebraska.

When the stamp was issued, Postmaster General John A. Gronouski said, "Issuance of the Sokol Physical Fitness Commemorative five-cent postage stamp honors the many Sokol and Falcon organizations, and helps to further the goals of President Johnson's Council on Physical Fitness."

Other acclaim has come from the United States Congress. Representative Frank Annunzio of Chicago introduced a resolution in 1972 requesting the President of the United States to proclaim October 30 as National Sokol Day "in order that my fellow Americans will focus their attention on that day to an organization that is synonymous with our Nation's image, beauty, and strength." The resolution was passed without debate and was signed by President Nixon.

The Educational Committee of the American Sokol Organization states:

"The finest, purest minds in our country are desperately trying to awaken the average American citizen to take his place in the ranks of those who serve, to strengthen every fiber of our life in the struggle that is being fought between the forces that believe in the sanctity of the human individual and those who consider him as merely a tool to be used as they see fit.

"Among the many fine organizations in this country that have served in the great traditions of self-sacrifice for the betterment of all of our citizens are the Red Cross, Boy Scouts and Girl Scouts, Fraternal Groups, Veterans Organizations, Social Service and Church groups.

"We feel that the Sokol Organization has a rightful place in the service groups because of its outstanding record in preserving physical fitness since 1865 in the United States of America."

The first Sokol chapter in the United States was founded at St. Louis, Missouri in 1865, only three years after the founding of the organization in Europe. Sokol takes a leaf from the book of the ancient Greeks in emphasizing "a sound mind in a healthy body" and in its belief that regular exercise contributes to both. Its primary purpose is not the discovery and training of individual stars, but to bring the benefits of physical exercise to masses of people of all ages. Besides gymnastics, sports programs include volleyball, track and field, and others.

Whether at Chicago's Soldiers Field, New York City's Madison Square Garden, Pittsburgh's Civic Arena, Washington, D.C.'s Armory, or elsewhere, the Sokol *Slet* or festival fills the field with men, women, juniors, and children in a thrilling spectacle of mass calisthenics performed in unison. The *Slet* consists of artistic and rhythmic gymnastic competitions, volleyball tournaments and educational displays featuring Sokol and Czechoslovak historical and cultural artifacts. Banquets featuring guest speakers and social activities are a part of each *Slet*.

Sokol Greater Cleveland, Sokol Los Angeles, Sokol San Francisco and Sokol Minnesota have standing folk dance groups that perform regularly. Most other Sokols perform folk dances as part of their unit or district exhibitions, or learn them for the national *Slet*.

In Czechoslovakia, the Sokols prospered for many years before the nation won its freedom in 1918 at the end of World War I. The Sokol organizations were strong and large in Czechoslovakia, Yugoslavia, Bulgaria, Poland, and Russia before the Nazis and Communists banned them. Membership was nearly 2,000,000. The Sokols in Czechoslovakia were made illegal in 1948.

Sokols enter children in tots classes at age 3, and teach teamwork, sportsmanship, and the importance of honoring the father and mother. There has always been a great feeling of togetherness. They are a family. All the adults call each other brother and sister.

Sokol was an offshoot of an underground physical-fitness program begun when the people were seeking freedom from Austria-Hungary. Even though the American Sokol organization now accepts members and gymnasts from other ethnic backgrounds, it strives to perpetuate Sokol history and Czechoslovak cultural heritage. The American Sokol Organization headquarters is in Berwyn, Illinois.

The first Slovak Sokol unit was founded in 1892 at Chicago, followed by a second in New York City and a third in Bridgeport, Connecticut. The central organization was founded in 1896. Soon there were fifty-five Sokol halls with gymnasiums. In the beginning, there was debate whether the Slovak Gymnastic Union Sokol U.S.A. should be a national cultural and physical education program or whether it should also have a program of mutual aid for the members, similar to other Slovak fraternal societies in America. Ultimately the Slovaks founded their fraternal benefit system, which served both the membership and the Sokol program. It is known today as Sokol U.S.A. with headquarters in East Orange, New Jersey.

In 1905 the Slovak Catholic Sokols were founded. The headquarters today are in Passaic, New Jersey. Slovak Catholic Sokols holds its own national *Slets,* and is one of the largest fraternal organizations, with 50,000 members. All ages participate in its biennial *Slets.*

The American Sokol organization is not affiliated with any fraternals. American Sokol and Sokol U.S.A. jointly participate in biennial Slets. In addition to the American Sokol, Sokol U.S.A., and Slovak Catholic Sokols, there is a small group, the Delnicky American Sokol, with a hall at Astoria, New York. There are several branches in the New York and New Jersey area. Delnicky means workman.

Formerly, competitions in the United States and Czechoslovakia included entries from both countries. In 1938, at the *X Slet* in Prague, performances were by 32,000 boys and girls, 60,674 juniors, 28,600 men and 28,648 women, before audiences ranging from 170,000 to 250,000.

The American Sokol convention in September, 1938, voted to have a fund drive for "Sokol youth of America to help the Czechoslovak youth." The American Sokol Organization contributions helped children of refugees from the parts of the country that were taken over by Nazi Germany.

Sokols are active now in the United States, Canada, England, France, Switzerland, Austria, Argentina, Brazil, South Africa, Belgium, Australia, and Morocco. There are thousands of Sokol members and young gymnasts in the Sokol program world-wide.

The Sokol symbol is the falcon. Sokol is the Czech word for falcon. Literally translated, a *Slet* is a gathering of the birds; thus, a gathering of the falcons, or Sokols. The Sokol greeting is "Nazdar," meaning "On to Victory" or "On to Success."

Andrew Valuchek, writing in the program for the *XX Slet* of Sokol U.S.A., which was held in Washington, D. C., stated: "Today, when the struggle for equality of women in society is of concern, it serves to the credit of the Sokol movement that women were a part of the organization and participated on every level equally with men in the gymnasiums and on the *Slet* fields. Almost from the very beginning, there was never any differentiation among the sexes in helping to develop a healthy human being."

The Slovak Sokols also stressed in their *XX Slet* program that "only men and women who are sound in mind and body can carry the principles of democracy forward. The idea is humanism at its best. It is a practical humanism and starts with one's fellow man in everyday life."

The Music Is Alive

The music of Czechoslovakia is fresh, vivid, spontaneous, impatient of restraint, full of rich color and warm, imaginative feeling. In short, the music itself is alive. It is a pleasing blend of the classical and the folk music.

Bedřich Smetana (1824-1884) offered vivid expressions of patriotic feelings. While his people were still oppressed, the special warmth of his operas *The Bartered Bride* and *My Fatherland* helped to inspire the movement for nationalism, and attracted interest outside his homeland.

Antonín Dvořák told American composers not to look to Europe for inspiration, but to the folk music of America. He followed his own advice in creating his *Symphony from the New World*.

The Beseda

Hundreds of musicians and composers have contributed folk dances, which, like other ethnic traditions, have been handed down through the generations through practice, modification, and demonstration. One popular Czechoslovak folk dance form is the beseda.

A "beseda" is a collection of mazurkas, polkas, and waltzes, arranged in various patterns to reflect the spirit of a given region. The beseda was developed for the enjoyment of those attending festivals, weddings, and social gatherings. The various patterns of this spirited dance make it truly a spectacle to behold. Today the beseda is often performed for exhibition. For example, the Czech Folk Dancers of West, Texas, have been dancing the beseda for more than 12 years. They appear at many festivals.

The word "beseda" means a gathering, or "to get together and be happy." Another use of the word is to describe a visit, such as "We are going to visit someone" or "We have company visiting." The beseda dance, then, is for the get-together organized because participants enjoy one another and also enjoy their heritage.

Polka-Mania

The polka, one of the most widely known dances, is believed to have been introduced in 1830 by a peasant girl, Anna Slezak, who lived near Prague. She danced it on a Sunday afternoon at Elbeteinitz, in Bohemia.

The dance was first introduced in Prague in 1837, and in Vienna, St. Petersburg and London in subsequent years. Wherever it appeared, it achieved an extraordinary popularity, a kind of "polka-mania" with clothes, dots, hats, and streets named for the dance. Within 10 years it had spread throughout Europe and to America.

"Polka" is a Czech word meaning "half," and the polka is danced with a half-step. The music is written in 2/4 time. The first three eighth notes are generally strongly accented. It is a vivacious round dance performed by couples. Some say the true polka has three slightly jumping steps danced on the first three beats. On the fourth beat, the top of the lifted foot is placed against the heel of the other foot.

Polkas are not all the same. And Rollie Raim, Cedar Rapids, Iowa, band instructor and a clarinetist with polka bands, says the Czechoslovak polka is not always "folk music." Often, as in the case of the volumes of polka music by Smetana, these compositions are sophisticated and difficult to the point of rivaling classical music.

Czechoslovak Bands

Arlene Boddicker

There is no set formula for the tempo or instrumentation of a Czechoslovak band sound. At a band concert, the music is probably played with a slower and more melodic beat than at a dance. Dance music requires a faster, bouncy tempo, simply because feet cannot remain in mid-air!

Different areas of Czechoslovakia have different combinations of traditional instruments. For example, one area might have two clarinets in a small combo where another would have only one.

Generally speaking, however, the minimum instrumentation for a good, authentic polka sound today usually is a combination of the following: accordion or button keyboard or concertina, two clarinets, B-flat tenor saxophone, E-flat alto saxophone, two trumpets or cornets, a tuba or sousaphone, and drum. So says Arlene Boddicker, music educator and accordionist with "Arlene Boddicker and her Polka Dots" band in Cedar

69

Rapids, Iowa. The "Boddicker Czech Showcase" features dancing children. They have performed at Carnegie Hall and Nashville, and at festivals and concerts from Tennessee to California.

A good sound can be produced by six players, Arlene says, with accordion, drum, tuba, clarinet (doubling on B-flat tenor sax), second clarinet (doubling on Eb alto sax), and trumpet or cornet.

Sometimes music arrangements list parts for violin, banjo, trombone or flute. Throughout the years, instrumentation in Czechoslovak bands has changed with the times, says Rollie Raim. For example, a century ago the violin, not the accordion or piano, was the instrument on which most people, peasants included, learned to play music. It was inexpensive and was easily transported in an era when travel conditions were difficult. In those years, a violin was an instrument in polka bands.

Another example is the ancient bagpipe. It was played in Czechoslovak bands for years before being replaced by the tuba and other brass instruments. Although "authentic," the bagpipe would not be feasible in a modern polka band, Raim said, and the sax, popular today, was unheard of one-hundred years ago.

Music popular with Czechoslovak bands are polkas, marches (which also can be played to the polka 2/4 time), waltzes, and an occasional schottische. Three popular tunes played by Czechoslovak bands are *Village Tavern Polka*, *Clarinet Polka,* and the *Beer Barrel Polka.*

Beer Barrel Polka

In 1927, Czech bandleader Jaromir Vejvoda wrote his first song, *Škoda Lásky,* meaning "too bad for love." An immediate hit, it became popular in Western Europe as *Rosamunde,* in Scandinavia as *Hvor er Min Kone,* and all over the United States as *The Beer Barrel Polka.*

Before retiring in 1981, Vejvoda wrote more than 70 songs, but none rivaled *The Beer Barrel Polka* for world fame.

Singing Groups

There are singing groups wherever there are Czechoslovaks in sufficient numbers. Favorite songs include the *Czechoslovak National Anthem,* the *Prune Song, Our Czech Song* by Karel Hasler (1879-1941) and other songs by Hasler.

Composers and Musicians

Antonín Dvořák (1841-1904) of Bohemia was the first Bohemian composer recognized outside his own country. Dvořák was strongly drawn to chamber music for he was a viola player, and greatly admired the work of the classical masters. He wrote forty chamber works for various combinations of instruments. When he visited the United States, his interest in folk music expanded to include jazz and Negro spirituals, which influenced his "American" works. Dvořák was prolific in writing operas, choral works, orchestral works, and piano pieces. Most popular are his symphonies and his Slavonic Dances.

Bedřich Smetana (1824-1884) of Bohemia is to Czechs what Chopin is to the Polish. As a child prodigy, Smetana seems to have rivaled Mozart, at five playing in a Haydn quartet, at six having his public debut as a pianist, and at eight composing a few dance tunes. His ambition was "to become a Mozart in composition and a Liszt in technique." His vivid expressions of patriotic feelings came at a time when the Bohemians were still a subject race. He wrote nationalistic operas with a warmth for the characters and for their position in life as peasants. Two of his most familiar pieces are *The Bartered Bride,* an opera, and *My Fatherland.*

At the end of the eighteenth century the symphonies of Georg Benda (1722-1795) of Bohemia were as popular as those of Haydn (1732-1809) and Mozart (1756-1791). He was from an unusual family. His mother, Dorota Brixi, was from an important musical family; his father, Jan Jira Benda, was a linen weaver and village musician. Of their six children surviving infancy, five became celebrated musicians: Franz, Johann, Georg, Joseph, and Anna Hatašová. Franz Benda's four children became famous musicians: Maria Wolf, Friedrich, Karl, and Juliana Reichardt. Georg Benda's children, Friedrich, Catherina, Hermann, and Carl, were also celebrated musicians:

Frantisek Brixi, born near Prague and baptized in 1732, was one of the leading musical figures of mid-eighteenth-century Bohemia. He made use of folk music in his works, including 400 sacred songs. Mozart's favorable reception in Prague in the 1780s was partly due to Brixi's influence.

Johann Ladislav Dusik (1760-1812) of Bohemia was the first pianist to sit with his right side to the audience. He was also one of the first to indicate pedal instructions in his own piano pieces, and one of the first composers to truly exploit the capacity of the piano.

Influenced by the folk music of his native Moravia, Alois Haba (1893-1973) developed a system for composing with quarter tones and sixth tones, and constructed microtonic instruments including a quarter-tone piano. The masterpiece of his quarter-tone music is the opera *Matka* (The Mother), which begins with a profoundly moving funeral scene.

Leoš Janáček (1854-1928) composed symphonic music and opera, using native folk songs for composition materials. Born in Hukvaldy, Moravia, Janáček is known for *Taras Bulba*, a Slavonic rhapsody, and the charming light opera *The Little Vixen*.

Bohuslav Martinů (1890-1959), born in the belfry of a church, was a violinist in the Czech Philharmonic Orchestra, and later taught composition at the Prague Conservatory.

Stamitz is another Bohemian family of musicians. Johann (Wenzel Anton) Stamitz (1717-1757) composed 58 symphonies. Karl (Philip) Stamitz (1745-1801), son of Johann, composed concert symphonies. He once played in concert with the 12-year-old Beethoven.

Pianist Johann Wenzel Tomašek (1774-1850), Bohemia, composed piano works that were direct forerunners of the character pieces of the romantic period, such as Schubert's Impromptus and Chopin's music.

Josef Suk (1874-1935) was the son-in-law and pupil of Dvořák, a violinist, and leader of the Bohemian String Quartet. He wrote *Serenade for String Orchestra*.

Composer and pianist Rudolf Friml (1879-1972) and Jaromir Weinberger (1896-1967), both born in Prague, and pianist Rudolf Firkušný (1912-), born in Napajedla, Moravia, all won fame in America. Friml, another Dvořák pupil, is remembered for *Indian Love Call, Only a Rose, The Donkey Serenade*, and others, Weinberger for the opera *Schwanda the Bagpiper* (1927). Others well-known in America include Karel Husa, composer and conductor, a native of Prague, and Zdeněk Mácal, conductor of the Milwaukee Symphony, who was born in Brno in 1936. Raphael Kubelik, a native of Býchory, is conductor of the Bavarian Radio Symphony Orchestra. He is best-known in America for his recordings of Dvořák and Smetana compositions with the Boston Symphony. His father, Jan (1880-1940) of Prague was a violinist and composer whose music is often heard today on American Public Radio.

Folk Art

Folk art, like folk music, is a comprehensive term with different meanings and shades of meaning. Folk art is a product of tradition that has evolved. Factors that shape folk art, however, seem to include the following: a continuity that links the present time with the past, creative impulses of the individual or group producing the art, and "selection" on the part of the community that determines what art survives. These three factors have enjoyed a strong blending from the earliest years to the present Czechoslovakia, and folk art is the "art of the folk."

Folk art is determined by national consciousness, and folk art has always played a part in the everyday lives of all the Slav peoples. In fact, there is in Czechoslovakia a subtle and rich fabric of folk art probably unrivaled elsewhere. Three distinct regions of Bohemia, Moravia and Slovakia were united yet also tried to foster their own identities. Each area had its own traditions in folk arts, which were an important part of celebrating weddings, baptisms, harvest, the arrival of spring, and holidays and church feast days.

Austria, Croatia, Germany, Greece, Hungary, Poland, Turkey and the Ukraine all have influenced life and art in Slovakia, Moravia, and Bohemia.

Embroidery

People embroidered and decorated almost everything, including costumes for men and women, boys and girls. Historically, fabrics were colorful, enhanced by embroidery. Tailors and shoemakers embroidered everything, including breeches, bodices, fur jackets, shoes, and boots.

Jewelry

Jewelry adorned costuming in brooches, buckles, buttons, hat pins, combs, and in pure decoration on caps and clothing. Primitive jewelry was made of beads and even dried berries and spices strung on pieces of thread. In the district of Bohemia, gold and garnets were mined, so gold and garnets were plentiful in jewelry and costuming. Metal jewelry was made of copper, brass, iron, lead, or tin. Jewels were also made with gilded silver. Hair ornamentation was often elaborately jeweled. Popular jewelry motifs were from animal life and mythology.

Metal Work

Although methods of smelting ore were primitive, the blacksmith's art developed quite early. Patterns were profiled and chiseled, with motifs decorating sickles, spades, and axes. Decoration was almost always found on metal parts of wagons, chests, doors, and windows. Engraving on tin and copper was common. Wrought iron work was popular on religious articles, such as sepulchral crosses. Both in Europe as well as in the new world, wrought iron fences became popular, especially surrounding cemeteries.

Wood in Folk Art

Wood was used for homes, barns, and churches. The scraps often went for Christmas toys, tools, implements, kitchen utensils, walking sticks, wood cuts, and crosses for graves.

Toys

Although wood was often the material used for traditional toys, especially puppets, toys were often made by children themselves or by their parents from pieces of fabric, corn husks, and clay. Some toys were sculptured. Others were simple, such as musical instruments, usually pipes, with ornamental decoration.

Basket Making

Straw beehives were popular, especially in southern Slovakia, and even beekeepers created various styles of beehive architecture. Wickerwork is also a part of the folk art culture of the Czechoslovaks.

Ceramics

Even before he used wood, man made practical items out of clay. Food was stored in clay vessels. Some ceramic items were fashioned for ceremonial articles. Artists engraved drawings on ceramics and glass. Sometimes pictures were painted on the reverse sides of glass.

Masks and Effigies

Folk art also reflects concepts of life and death. Masks were used on some occasions, such as weddings. Masks also accompanied the course of winter, from the beginning of Advent to the end of Shrovetide. Effigies were used

for symbolic destruction or to represent life-giving forces. For example, an effigy of Old Woman Winter might be tossed into the river or stream to herald the end of winter and the beginning of spring.

Cottage Industries

In rural areas, cottage industries involving embroidery, lace-making, and wood carving developed. The products were sold house-to-house and the additional income was always welcome. The art objects were also sold at festivals and fairs.

Cottage industries also came into being by a reverse process, when highly complex crafts such as those of the cooper or blacksmith became folk crafts. Many individuals involved in cottage industries were exceptional artists whose varied and complex styles incorporated tradition as well as changing fashion.

Even gingerbread is a folk art in Czechoslovakia, and gingerbread bakeries are popular with Czechoslovaks! Ceramic molds are used to fashion ceremonial and festive cakes and cookies.

The clocks and wood carvings of the Bily brothers are in the Bily Clocks Museum, Spillville, Iowa. Each year, thousands visit the collection.

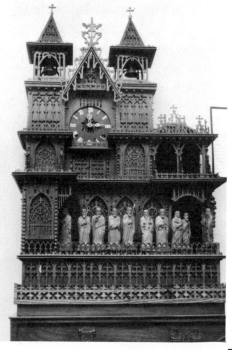
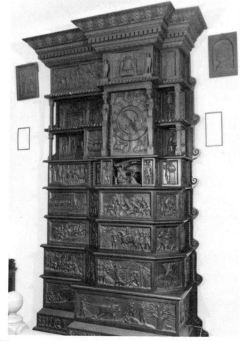

Bily Clocks of Spillville, Iowa

Woodcarving has existed about as long as man himself.

The extreme dryness of the climate in Egypt made possible preservation of woodcarvings from before 4000 B.C. From mummy cases to furniture to cabinets and doorways, woodcarving has been an art form in Egypt, Assyria, Greece, Rome, Scandinavia, Arabia, Japan, China, France, England, Germany, and Czechoslovakia.

Five centuries ago, woodcarving was at its highest peak of popularity and was used in decorating cathedrals in the Middle Ages. Church bench ends, choir stalls, roofs, pulpits, lecterns, altar pieces, and figure work from churches and cathedrals during this period abound in woodcarving of exquisite design and treatment.

Also for thousands of years, artisans from many regions have endeavored to improve their instruments of timekeeping. The first Strasbourg clock was built in 1352. A number of timepieces, including Big Ben in London, are famous attractions.

In America, there are no timepieces comparable to the Bily Clocks in Spillville, Iowa, where "New World" creations maintain "Old World" emphasis on the skills of both the woodcarver and the clockmaker.

In the late 1920s, Iowa's mud roads began to get the gravel that made them all-weather, and on the wooden fence posts at intersections north of Spillville, in northeast Iowa, little white wooden signs about two inches high and a foot long, in the shape of an arrow, appeared on fence posts. On each "arrow" one word was crudely painted in black letters: "Clocks."

After making five or six turns as directed by the signs, you came to a driveway that went sharply down to an area where you parked, surrounded by (and looking up at) a house and a barn and other outbuildings. Climbing some stairs, you entered the building that housed the clocks carved by the Bily (pronounced BEE-lee) brothers, Joseph (1880-1964) and Frank (1884-1965). If you were lucky, they were both there to identify the clocks for you. If they were not there, they may have been in their workshop or out working the fields of their farm. Occasionally, a visitor would seek to buy one of the clocks, but the brothers refused all offers, including one which legend says was a million dollars.

As boys, these two brothers of Czech ancestry, sons of immigrant parents, carved with crude knives on their school desks. Teachers often took away

their knives, but in due time the school presented the brothers those very desks.

Their father told the boys that whittling was a waste of time which could be better put to use on the farm, but their mother encouraged the boys' artistic talents. A neighbor who had carved a clock was unable to install the works, and asked Joseph and Frank to help. This turned their thoughts to the carving of clocks, and they began serious work about 1913. Joseph did most of the designing and joining of the woods, while Frank, with his long and dexterous fingers, did the carving. The brothers created 20 major and numerous minor timepieces, which today are housed in the Spillville home where the composer Antonín Dvořák and his family spent the summer of 1893. In this home Dvořák worked on his compositions, and one room in the home displays Dvořák memorabilia.

For their early clocks, the Bily brothers imported woods—European cherry, mahogany, boxwood, and white holly. Most of their work, however, is in native wood, including walnut, cherry, maple, butternut, and oak.

The most popular is the Apostle clock, which includes a cathedral and from which, on the hour, a tiny door opens and the twelve apostles parade in a circle. The American Pioneer clock stands more than eight feet high, weighs some 500 pounds, and displays carvings of events in American history on twenty panels. The chimes play "America." Some of the other clock names are Lindbergh, Little Brown Church, Roman Renaissance, Chimes of Normandy, Westminister Abbey, and History of Travel, all symbolizing what their names imply.

The exhibit is open daily April through October and by appointment in other months. Founded by Czechs, Spillville is still a bit of Old Bohemia, set in a picturesque Turkey River valley 13 miles southwest of Decorah in northeast Iowa. Small and pleasantly isolated, little Spillville nevertheless has contributed to the cultural life. Two Yale professors, a college president, a bandmaster, a violinist with the New York Symphony, a minister to Japan, and a Chicago scientist are among those who either were born in Spillville or lived there long enough to call it home.

—*John Zug*

Beautiful Glassware

Bohemian glass-making began in the thirteenth century in the sandy districts of the northwest part of old Bohemia. The first glass factories were in the forests where there was plenty of wood for fuel. Later, the glass furnaces were moved to areas with coal deposits.

Czechs have had a profound effect on glassware. Glass has been cut, colored, enameled, and engraved. In cut-glass vases there are thousands of cuts. Lead is added to this glass to make it soft enough to cut. Superb creations from these glass artists, including overlay and cut glass, are in royal palaces worldwide.

In big pots over roaring fires in the forests, glassmakers heated sand and quartz to the melting point. They blew the hot liquid with hollow blowing rods or poured it into clay or wooden molds. As the liquid cooled, it hardened.

According to an oft-told story a gold watch was dropped accidentally into a vat, and the molten glass turned red. After that, when a red color was desired, a little gold was added. Other metals added are ferrous oxide for green, cobalt for blue, and manganese for purple.

A glass vase or other object from a mold was cut, engraved, or etched. Perhaps it was painted or gilded. If the glassblower blew a layer of ruby glass over a layer of white glass in a mold. the ruby glass was engraved to let the clear glass shine through. In another form of artistry, colored enamel (a form of glass) was fused to clear glass and a picture was engraved on the enamel.

Czech glass decorators were first to cut into glass with a little whirling jeweler's wheel. They found ways to engrave beautiful pictures in glass with the point of a diamond, and they were the first to etch faces, flowers, and figures in glass with fluoric acid.

Vernon Brejcha, Artist in Glass

Hundreds of years ago in the Division of Technical Arts of the University of Prague, courses included painting, woodcarving, and glass ornamentation. Students in all disciplines learned about glass to the extent that they could demonstrate aptitude as "glassmen" or in "glassery."

Today, the ancient art of glassblowing is practiced by a "glassman," Vernon Brejcha, associate professor of design at the University of Kansas at Lawrence. His glass creations are in many museums and private collections.

Brejcha was born in Ellsworth, Kansas, where many Czechoslovak-Americans live. He grew up on a

Vernon Brejcha in his studio

Photograph by Suzanne Burdick
The Lawrence Journal-World

wheat farm in western Kansas, on the flat and desolate prairie. When he was a child, drawing led to painting and ceramics. Brejcha says glass changed his life "because, like nature itself, the hot liquid is alive for me. The intense heat of glass takes me back to the sun-baked prairies and wheat fields."

A glass blower since 1969, Brejcha makes Kansas his theme. He says: "My glass is about life—life from the soil and the heart. I have explored these aspects in my 'Egg Vase' and 'Germination' series, as well as in the 'Indian Tragedy' pieces, which depict the tragedy of the Plains Indians, who were forced from their homes to make way for the settlers.

"Annually, as the hot south wind is forming waves over the golden high plains, I return to the flat lands for the wheat harvest. Atop the grain combine, one's hands become a part of the machine. The Kansas sun shows no mercy; the grain flows into the bin as if it were a yellow liquid. Over the constant roar of the engine, chains, gears, and belts, the ear tries to detect how the grain and straw are separating.

"The roar is not too different from the burners on a glass tank as the melt gives off an intense heat like the prairie sun. Here the hands tune themselves

79

to primitive tools to master another golden flowing liquid, molten glass, giving off light only for the artist to enjoy before it stiffens into a statement that has to be made."

Brejcha's "Ghost Posts" and "Posts From the Memory Fenceline" are so named because the limestone fence posts, which weighed 500 to 1,000 pounds, belonged to the era of the early settlers and a way of farming that has come to an end. His glass replicas are about two feet high and weigh 20 to 25 pounds. Brejcha's work is in more than 30 museums in the United States and around the world. He has exhibited in more than 250 shows.

Ominous Cloud 11"x6"x6"

Prairie Plate 14"x19"x1"

Nocturnal Wait, a Post from The Memory Fenceline 24"x6"x5"

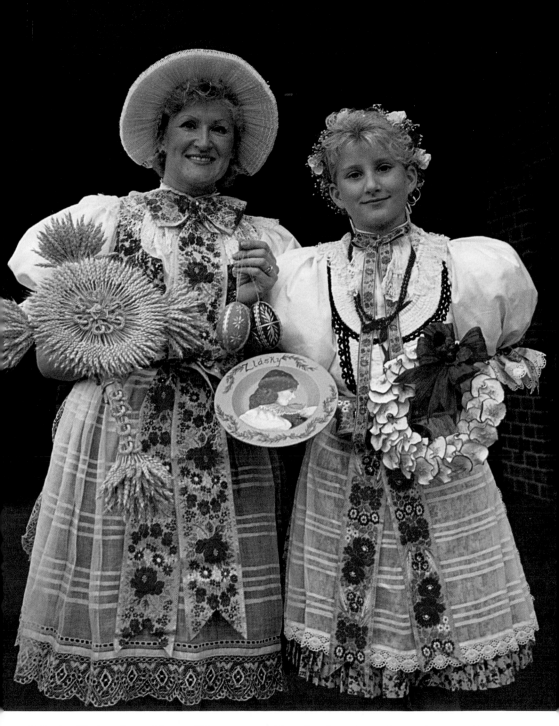

Sidonka Wadina-Lee of Lyons, Wisconsin, and her daughter Amanda are shown at the Milwaukee Holiday Folk Fair wearing Slovak costumes from Studienka, the village of their ancestors. Sidonka designs and paints wooden plates with Slovak scenes, and decorates goose eggs with cut straw in the Moravian style. Sidonka holds one of her traditional harvest crosses, while Amanda displays a Slovak apple wreath.

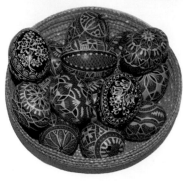

Left: The craft of making basters of
goose feathers is demonstrated by
Pauline Jasa and Georgiana Brejcha
at the Czech Village, Cedar Rapids,
Iowa.

Bottom: Christmas at the Czech Cottag
in the Czech Village.

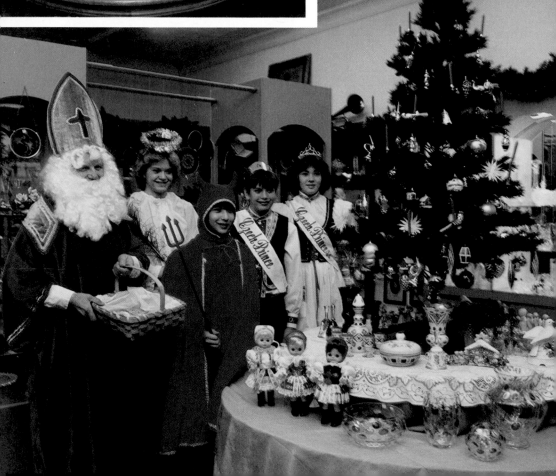

Left: Kraslice by Zora Duvall of Lake Forest, Illinois.

Right: Kraslice by Marjorie Kopecek Nejdl.

Houska, Czech braided bread from Minarik's Bakery, Cicero, Illinois.

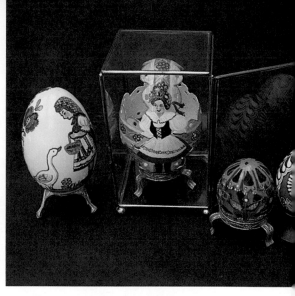

Below: Marj Nejdl of Cedar Rapids, Iowa, is noted for her cutout "lace" eggs and eggs decorated with scenes of Czechoslovakian life.

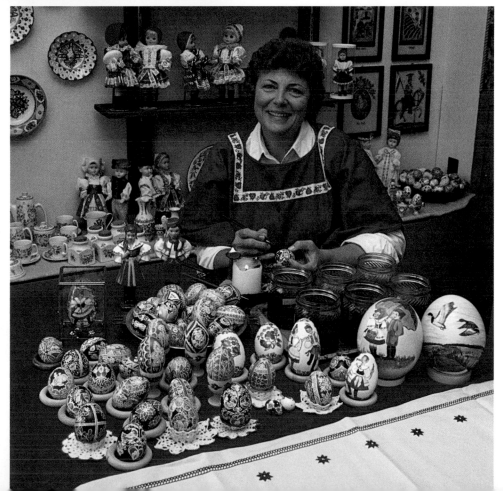

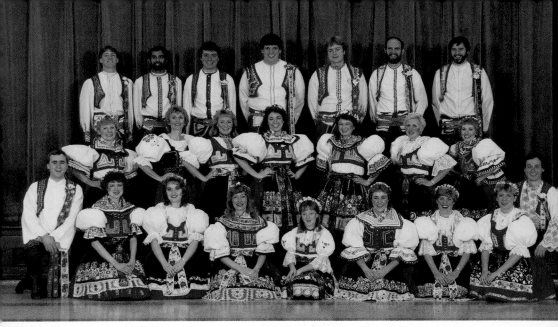

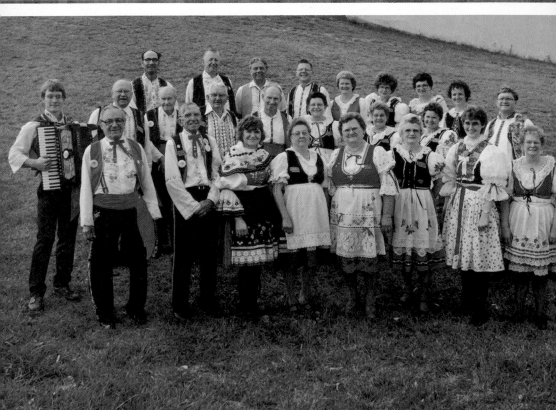

Top: The Czech Moravian Dancers of Milwaukee County, Wisconsin. The embroidered aprons are their Czechoslovak treasures.

Below: The Capital City Czech Choralers, Lincoln, Nebraska. They sing old Czech, Moravian, and Slovak folk songs at celebrations. The group was founded in 1980.

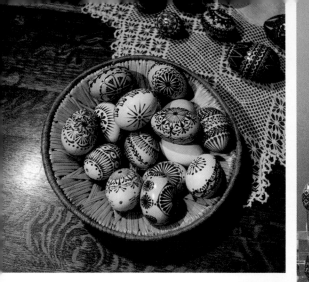

Kepka Belton, Ellsworth, Kansas,
wears a costume she designed. It is
similar to those from Moravia. The
tablecloth with spider design was
crocheted by her grandmother,
Barbara Kepka.

Eggs by Wash Hornick
Bristol, Tennessee.

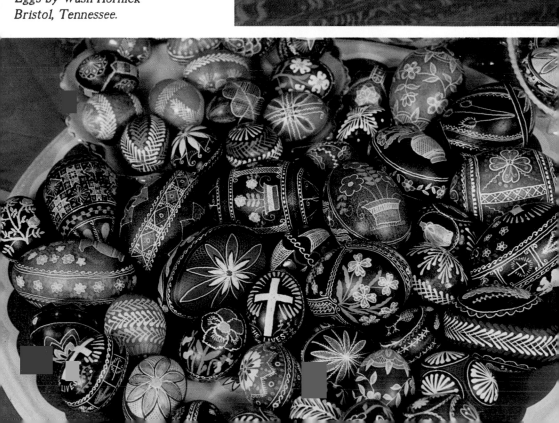

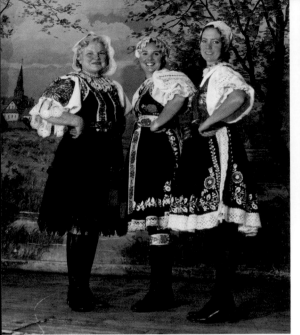

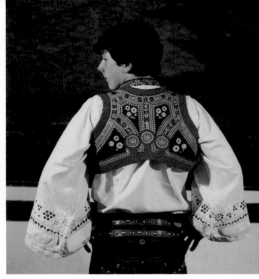

Left: In Slovak costumes are St. Paul
Czechoslovak dancers Laura Jansen,
Joan Sedlacek, and Catherine Haselbauer.

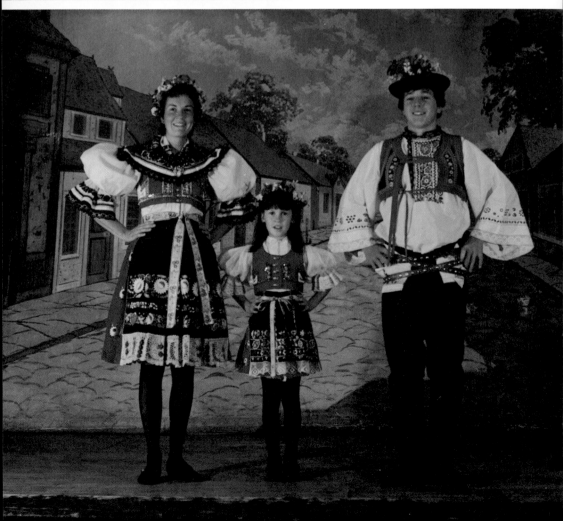

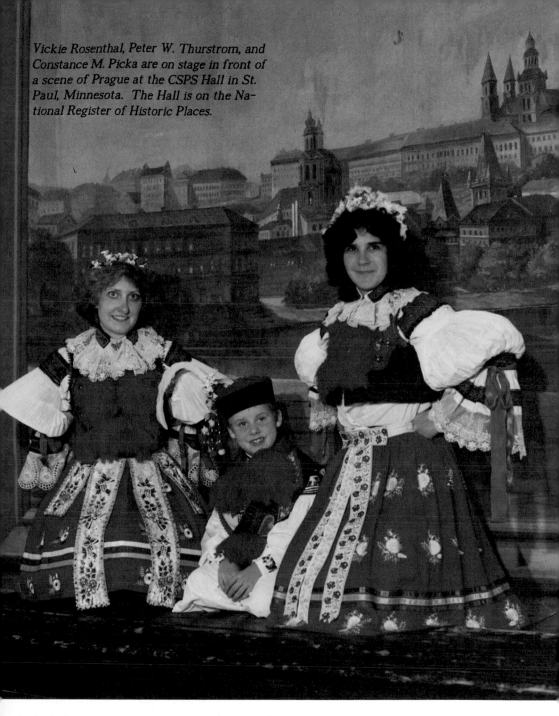

Vickie Rosenthal, Peter W. Thurstrom, and Constance M. Picka are on stage in front of a scene of Prague at the CSPS Hall in St. Paul, Minnesota. The Hall is on the National Register of Historic Places.

Left: St. Paul Czech Dancers include (from left) Patricia Andrle, Renae Andrle, and Richard Joseph Vanyo. The young man's hat has different flowers and feathers for each of his many girlfriends over the years while he was single. At his marriage, the feathers are clipped. Wealth is denoted by length of the belt and number of studs on it. The costumes of Patricia and Renae Andrle come from the village of Ratiskovic in southern Moravia. They are on the stage of the historic CSPS Hall in St. Paul.

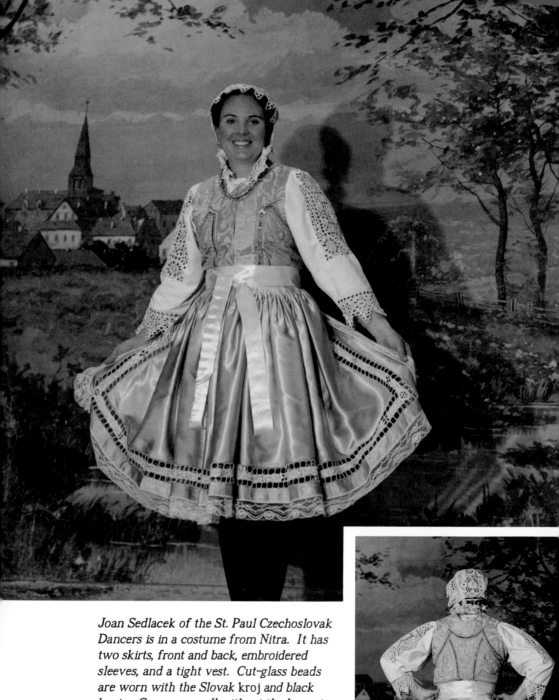

Joan Sedlacek of the St. Paul Czechoslovak Dancers is in a costume from Nitra. It has two skirts, front and back, embroidered sleeves, and a tight vest. Cut-glass beads are worn with the Slovak kroj and black boots. Caps are small without the bow at the back.

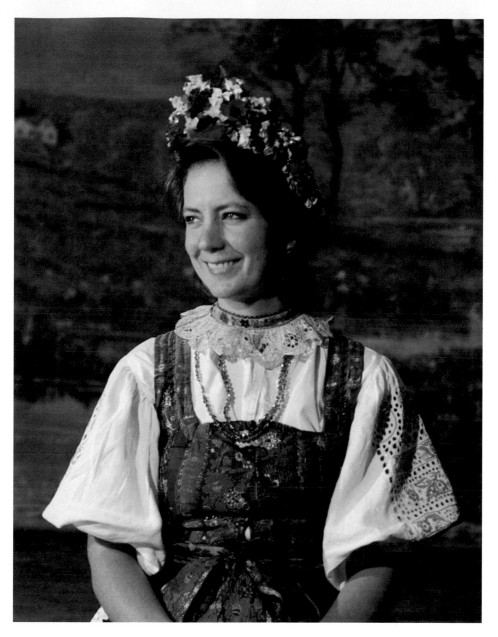

Catherine Haselbauer of the St. Paul Czechoslovak Dancers wears a costume from the Slovak spa town of Piestány. The flowers are worn by unmarried girls. As part of the marriage ceremony the flowers are removed and a cap is placed on the bride. The cut-glass beads are worn instead of garnets. The dancers wear authentic costumes from Czechoslovakia, many of them treasured family heirlooms.

Above: Jerry Voelker and The Jolly Gents of Green Bay, Wisconsin.

Right: Millie McComb, Moravian Cultural Society, North Riverside, Illinois, at Cedar Rapids, Iowa.

Left: Dr. Norman E. Sladek, left, and Attorney William J. Marek, at the Kolacky Festival of Montgomery, Minnesota.

Bottom: Lidice Memorial, Sokol Park, Phillips, Wisconsin

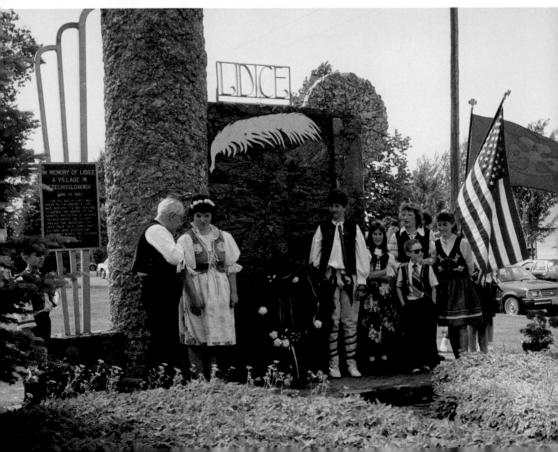

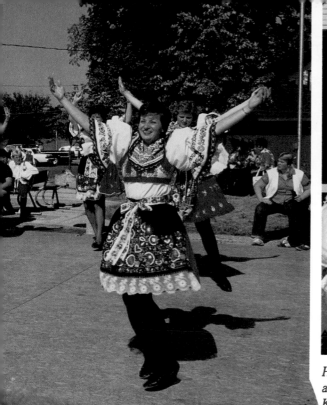

Honey Dowdy, coordinator,
and George Hlavinka, chairman,
Kolache Festival, Caldwell, Texas.

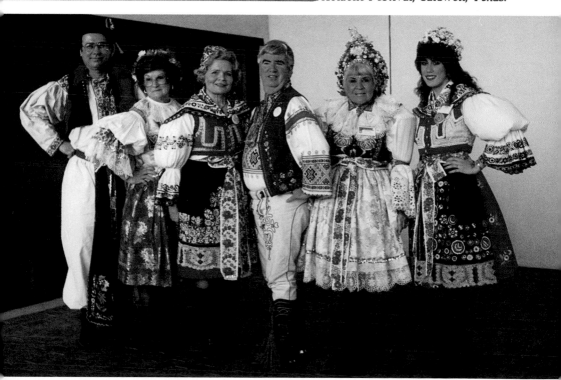

In Moravian costumes are Texans Alfred Vrana, Lorene Dudik, Henrietta Cervenka, Alden B. Smith, Willa Mae Cervenka, and Christie Oswald. They take pride in the Czech-Moravian culture of their state.

The West, Texas, Folk Dancers

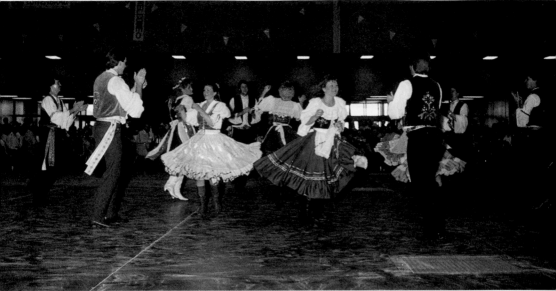

The Czech Folk Dancers of West, Texas, excite audiences with their "Texas-Czech" style. Ten founding (1976) dancers and 13 others are active members today. Founders Ernest and Maggie Grmela (standing, left) and the dancers do short and fast Czech folk dances created by the group members. These photographs were taken at the annual Corpus Christi, Texas, Festival.

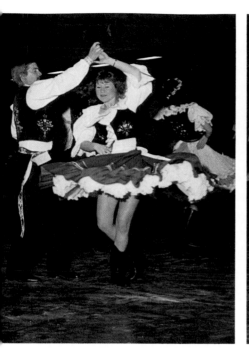
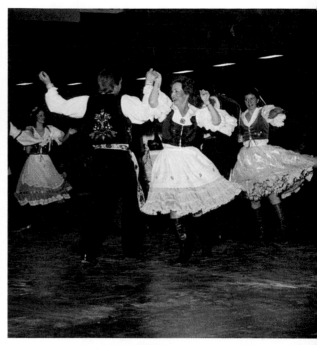
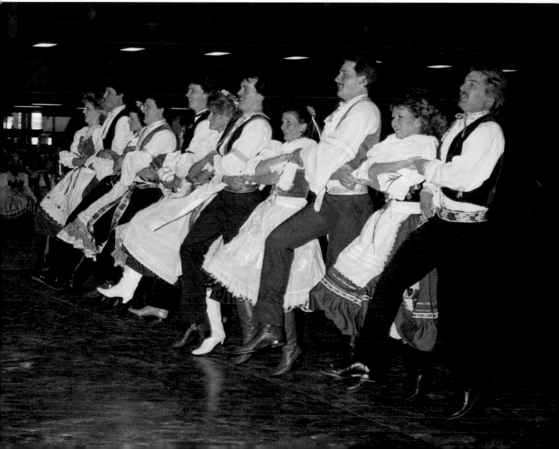

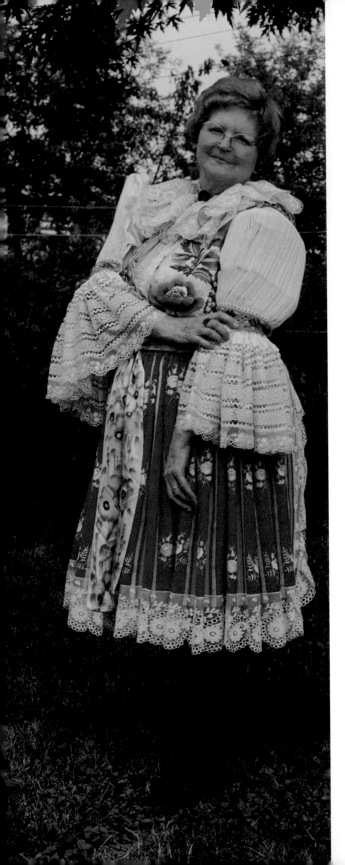

Blanche Kratochvil Kos of Forest Park, Illinois, is shown wearing a dress that consists of two breadths (šiřky) of petticoats made of shirting or homespun materials.

The black pleated shirt (šorec) is chintz. It is worn in the back over the petticoats tied to front, and is reminiscent of the old custom of having two aprons. All skirts and petticoats tie front to back and vice versa.

Over the šorec are worn two six-inch-wide panels of lavish embroidery on silk. These are the trhačky and they match the front of the vest.

The red cashmere apron (fěrtušek) was woven to specifications and each woman embroidered her own. As time progressed these were replaced by silk brocade.

The blouse consists of heavily starched sleeves pleated in round or bent cleat fashion. Sometimes these were doubled to better hold their shape.

The vest (kordulka) was trimmed and outlined with metallic bobbin lace. On the back of the vest was a pattern design made with orange soutache and trimmed with tassels (třapce) of orange wool.

A special lace trimmed the apron. The same lace starched and pleated was tinted a light blue for the collar(obojek).

The large ruffle falling from the elbow (kadrle) also has its own design. The embroidered bands at elbows, collar and shoulders, in green, yellow, orange, and or brown is a crest (štít) colorwise and design-wise denoting city or town and family.

When high black boots (čižmy) were worn, the horizontal folds were preset by the shoemaker.

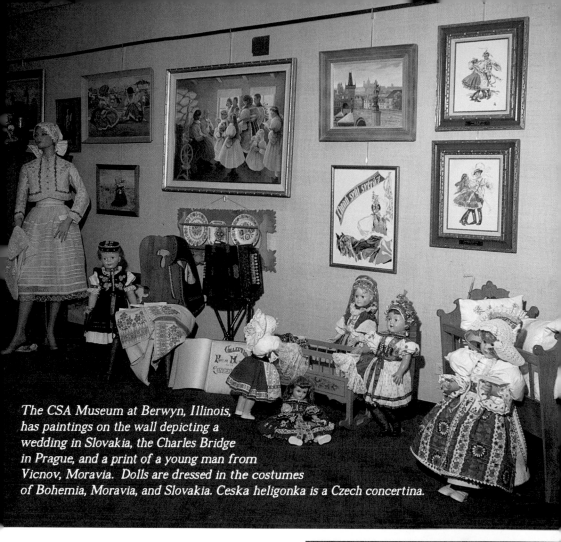

The CSA Museum at Berwyn, Illinois, has paintings on the wall depicting a wedding in Slovakia, the Charles Bridge in Prague, and a print of a young man from Vicnov, Moravia. Dolls are dressed in the costumes of Bohemia, Moravia, and Slovakia. Ceska heligonka is a Czech concertina.

Czech Dolls
Wilber Czech Museum, Wilber, Nebraska

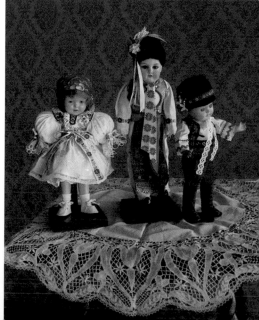

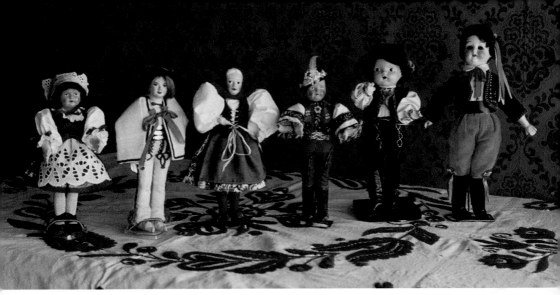

Dolls, Wilber Czech Museum, Wilber, Nebraska. The collection contains dolls from Dr. Angeline Simecek, Dr. Olga Stastny, and the Pospisil family.

Traditional embroidery by Sally Kriz, Cedar Rapids, Iowa.

Embroidery
Collection of Blanche Kos

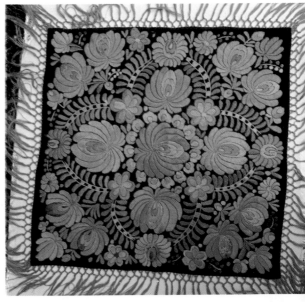

Needle Art

On Costumes and Embroidery

The row of Czech embroidery shown (left) by Sally Kriz of Cedar Rapids, Iowa, is usually done in Hardanger cloth or linen. It can be used on pillows, aprons, towels, tablecloths and, of course, folk costumes! This style of embroidery uses #5 DMC pearl cotton. True Czech colors are Blue 797, Red 666, Black 310, two colors of Yellow, 740 and 742, and white. You may substitute any other colors, however, to suit your own personal taste.

Sally, a past president of the Cedar Valley chapter of the Embroiderers Guild of America, has adopted an important personal goal of researching and preserving Czech embroidery. This goal has been furthered through a variety of efforts, one of which is Sally's organization of Czech embroidery workshops during Czech Village festivals, held annually the weekend after Labor Day in Cedar Rapids. Every time one more embroiderer becomes enthusiastic and learns the Czech designs, Sally becomes more convinced than ever of the importance of preserving this Czech art.

Embroidery, the ornamentation of textile fabrics and other material with needlework, is an ancient art. A tapestry with fine needlework, discovered by archaeologists and displayed in the Cairo Museum, was found to date from the fifteenth century B.C.

Everywhere—the world over—people have fashioned designs related to their environment, using local plants and animal fibers and coloring agents. The same can be said about the art of sewing decorative stitches on cloth. For hundreds and hundreds of years people have beautified their belongings with embroidery.

As travel routes were developed, barter and exchange brought "exotic" items to different cultures, such as beads, shells, seeds, coloring materials, and embroidery designs.

Because of its geographic position, Bohemia became a crossroad for various cultural and artistic influences. As a result, while some patterns of embroidery are distinctive, needlework arts from Italy, Persia, France, Belgium, Germany, and Norway all have influenced Czechoslovak costumes and linens.

Bargello is used as a border in Czechoslovak needle art. During the Middle Ages, "bargello" was the name of the palace of the powerful "podestas." These palaces, or bargellos, were also prisons and were regarded as excellent examples of 13th century architecture. These architectural patterns found

their way into embroidery, in which the pattern is established by counting threads and following a design which repeats again and again on the fabric.

Bargello, or "satin stitch" or "upright goblin," is used for letters, appliqués, and cutwork. Whether it is done in silk or wool, satin stitch looks like satin and is a beautiful addition to Czech embroidery. This embroidery stitch is difficult to work correctly because the satiny effect is achieved only if stitches are precise and close together. On flowers, for example, the effectiveness of the colorful and long satin stitch works well because it has the capability of providing both a glossy or satiny look and a padded look.

Hardanger embroidery is also represented on Czechoslovak costumes, particularly the Slovakian ones. This type of embroidery work is named for the little town of Hardanger on a fjord in western Norway. In its original form, however, it is accomplished on fine gauze netting with colored silks and has its roots in Asia and Persia. The square is the basis for Hardanger, and the squares are actually made by using a stitch to work around the square and then drawing the threads out. When the threads are drawn through the fabric, a perfect square must be the result. Hardanger is beautiful in a variety of decorative work—collars, cuffs, headdresses, and wide borders on aprons. It is also used for decorating table linen. Before undertaking this embroidery a set of instructions as well as a sampler of stitches should be studied.

Luxurious "cutwork" is derived from sixteenth century Venetian lace. This work is extremely popular in Czechoslovak costuming and was in demand throughout Europe in the seventeenth century. It consists fundamentally of a design outlined in buttonhole stitch with the background cut away. Both the simple cutwork and the more complicated Richelieu work —named for Cardinal Richelieu who set up schools for the learning of this lacework in France—are usually embroidered on firm linen or fabric that does not fray easily. Usually the fabric is natural in color or white, and the thread is generally the same color as the linen, because the background spaces, made when the fabric is cut away, make up a part of the design. The design could be muddled if other colors of thread were used.

Lace-making centers were created in Bohemia as early as 1587. At first lace was produced in castle workshops for the exclusive use of the nobility. A countess who learned to make spool or bobbin lace in Brussels taught the art to peasants so that they would have a skill to support themselves financially. Hundreds of years later bobbin lace is still created by the people of that area and by some American women of Czechoslovak descent. With bobbin lace the work is done with bobbins of thread, pins, and a pillow or cushion. This lacework is done by hand, twisting the thread around pins stuck in a pattern placed on the cushion.

Birds have always been popular motifs in embroidery and costuming

Tatting is produced with thread by means of one or two small shuttles and the fingers. Rings, ovals, curved lines, and semi-circles are knitted into a fabric structure that is firm, decorative, and open. Tatting is not a true lace, but a kind of lace. In true lace, stitches are used. In tatting, designs are formed of knotting and repeated in decorative patterns.

Netting is another form of lace-making that evolved in many cultures. Its origins are in the fish net, so it developed wherever fishing was common and nets needed repairs. The skill was adopted by the women, who made decorative pieces for the home, such as tablecloths, wall hangings, and furniture covers. After the net was completed, designs using such stitches as darning, weaving, and embroidery were added. Decorative patterns were the result.

According to Czechoslovak tradition, as soon as they were able to hold a needle in their hands, young girls were taught to copy the embroideries and lace patterns of their mothers and grandmothers. They did this as part of their education and to prepare their dowries. The pieces were utilitarian and included valances, pillows, pillow covers, table linens, sheets, and dresses. The dresses were for festival occasions, and for everyday wear. Often a young girl was judged by the delicacy and number of embroidered articles in her dowry.

When you view collections of costumes or Czechoslovak handiwork, project yourself backward in time to those centuries when women did not work outside the home. Imagine living with no television, movies, radios, or electronic games. People had lots of time to fill on long winter evenings. With no automobiles, mothers did not organize car pools. Work and leisure both were directed to that small home, and that small parcel of land. Celebrations and festivals were welcomed, just as they are today. The people appreciated times of togetherness and merrymaking. The costume worn at these festivals told of its geographic region and of the maker's individuality, skill, and artistry. Sometimes, years went into the work of art that became a costume.

Bobbin Lace Creator

Sonia Domsch

Sonia Domsch, who lives in the small northwest Kansas town of Atwood, says making bobbin lace is part of her heritage. Others are pleased that she has kept the tradition alive. In 1986 she received the National Heritage Award of the National Endowment for the Arts.

Mrs. Domsch's great-grandmother brought her bobbin lace craft to America. She taught her daughter, and that great-aunt started teaching Sonia. A widow, she supported her family by gardening, cooking, and selling the lace for 25 cents a yard.

After Sonia's marriage, her uncle urged her to continue to learn the art "because you are the only one in the family who took an interest in the craft." Sonia ordered patterns and mastered the art.

She has been asked to demonstrate her lace-making at the Kansas Folklife Festival, the Folk Festival in St. Louis, Missouri, and numerous other places.

Now her work is in museums. Other examples go to close family members for christenings and weddings. She makes lace for tablecloths, book markers, handkerchiefs, and doilies. This is a time-consuming craft. It can take as long as 23 hours to make one doily.

—Photo by Kansas State Historical Society, Topeka, Kansas

Kroje — National Costumes

Really now, you can't have a Czechoslovak celebration without a costume!

It doesn't have to be an authentic costume, although many lucky Czechoslovaks do possess authentic *kroj* that they proudly wear to Czech festivals. Your costume may be designed for you personally to duplicate an authentic costume or it may be "wash and wear" if that is your preference.

A little background information on these festive clothes may help you select or create a folk costume just for you!

Before 1850 there were seventeen areas in Bohemia and more than forty districts in Moravia where people wore folk costumes. In the borderland between Moravia and Slovakia, or Moravian Slovakia, there were twenty-seven such districts at the beginning of the twentieth century. These folk costumes were different from one another to a certain extent, depending on the districts of origin and the purposes for which the costumes were created.

Some of the most beautiful costumes originated during periods of cruel oppression, when the peasants suffered under serfdom and decorated their costumes as one way to show their personal individuality, self-expression, and taste. The costume was a sign of status and nationality. Differences in geographic location influenced differences in costume design and decoration. Today some people are knowledgeable enough to "read" a costume and identify the district the owner came from, as well as his or her social status.

If you want to create your own costume, use vivid, lively colors, for your costume is a celebration of your heritage. Centuries-old symbols used in embroidery are the heart, the bluebird, the dove, and native flowers. Poppies, spring mountain flowers, wheat, the cornflower (bachelor's-button), lilies of the valley, and daisies are all popular.

Traditionally the most beautiful embroideries were placed on fine linen, never on cotton. You may embroider or not. Perhaps purchased appliqués and trims will be preferable if your costume is a functional one. In today's world of fabrics and textiles, suit yourself! Natural or synthetic easy-care fabrics may be used as well as no-iron laces.

Centuries ago sheep supplied the wool for costumes and flax supplied the linen. Silk was cherished and embroidered, as was silk brocade. Old-time trims were handmade lace, embroidery, and varying lengths of rickrack. Bugle beads and sequins were common. Sometimes real gold or silver thread was used. Lace might be combined with gold braid, brilliant sequins, ribbons and lace.

If a costume originated in the region of old Bohemia, near garnet or silver mines, those valuable minerals might form design and decoration, whereas women from a rural Slovakian farm would wear brightly colored, but more practical and durable folk costumes.

In most districts the marked difference between married and unmarried women was the arrangement of hair and headdress. The custom is still alive today. LaVerne Benda, folk-dance instructor at Yukon, wrote in *Oklahoma Today:* "If a woman is unmarried, she will wear a band of flowers with ribbon streamers. The flowers mean she is 'ripe for plucking.' A man's hat is decorated with feathers. Each long feather stands for a girl-friend. When he is married, the feathers are short. They say he's been 'cropped.'" Married women wear lovely caps of lace and bows, or colorful head kerchiefs. Both then and now, a costume is incomplete without a headdress. The Bohemian costume creators often make a little eyelet cap with a large eyelet bow on the back. The bow is about six inches in length and width and is stiff so that the face appears to be "framed" from the front.

In olden days the young girl's hair might have been braided with ribbons or elaborate headbands. The bride's headdress was an important symbolic ceremony in itself, and the bridegroom wore to his wedding his first longtail coat, which lasted him a lifetime if he didn't eat too much. His embroidered shirt might have been a gift from his bride. A new bride from another village was married in the *kroj* of her village, but had to adopt the *kroj* of her husband's village to be fully accepted.

A white-robed bride changed to apron and bonnet after marriage. Expandable waistbands on women's costumes assured permanence to skirts even through pregnancy or added poundage. Older women, then, having arrived at a more dignified appearance, would still use a skirt from youth but add to it rich embroidered fabrics or designs.

Women's vests were gaily trimmed. Some were cut like boleros, while others were laced down the front. A tightly laced vest made even an ample waist look slender above billowing, lace-trimmed petticoats and skirts. Blouses were lavish, with lace-trimmed necklines and sleeves.

Traditionally, the apron was the most elaborate part of the costume. Perhaps thrift joined the reason here because aprons could always be lengthened with lace or widened with new ties for more years of wear. Again, lace patterns varied from region to region. Some designs were combined with others, and in other instances the women used one symbol exclusively and repeated it to create a motif.

Men's costumes were adapted according to age and status. In some regions, when a young man attained 14 years of age, he received his first real costume, although of a simpler design than an adult male would wear. Certain parts of the costume, then, the boy would "win" by individual personal effort, either from a girl or in contests of some sort.

In general, men's costumes were elaborate and just looked important! Trousers might be scrolled with embroidery. Shirts were tucked and embroidered. Vests were colorful, and hats may have signified prosperity if the wearer tucked a sprig of wheat, flax, or a hop vine into the band of his soft-fabric black mountain hat. Rooster tail, ostrich, or peacock feathers completed the effect of the hatband.

Men's costumes were not as varied as women's, but they differed in the width and length of trousers and shirts, the quality of the material used, and the cut of waistcoat, jacket, and fur coat. Very often the shape of a hat indicated the difference between a costume from one region or another, and a reliable way to distinguish costume origins for men was the type of embroidery on the collar, waist, and trouser legs. Boots had a commanding appearance and were functional as well. The size and intricacy of design of the hand-carved pipe was another way to suggest social status in the community.

The costume of the eighteenth and nineteenth centuries functioned as a national costume. It was a symbol of the struggle to survive as a people with a treasured heritage and culture. The costume said to the conquerors, "This is what we were and still are."

By the middle of the nineteenth century people stopped wearing their typical attire on a regular basis and adopted clothes fashionable to the day. Only the older generations remained true to the national costume. By this time, however, the idea of preservation of costumes was nurtured.

Generations of creative hands fashioned the national costumes. Here in America, in localities where Czechoslovak Americans celebrate their heritage with events, displays, or festivals, traditional attire is preserved, studied, displayed and worn because of its beauty and symbolic meaning.

Interesting Costumes

Left: This costume of the CHOD region, is also known as the "Psohlavci"—Czech border guards. Bas relief on wall: Clay replica of Nemecek Photography Studio as it appeared in Chicago's Pilsen area in the early 1900s. Artist: Zani Jacobsen, Chicago
—CSA Museum, Library, and Archives, Berwyn, Illinois

Bottom left: Vera Kosinova Cousins, who emigrated to the United States from Czechoslovakia in 1969, is wearing a "Prague" city costume, more dignified and "citified" and less folksy than the stereotypical Czech national costumes.

Bottom right: Brenda Buresh models costume from Pilsen (Plzeň) donated to Czech Museum and Library of Cedar Rapids, Iowa, by John and Jeanne Joseff of Manassas, Virginia. The costume dates from about 1900.

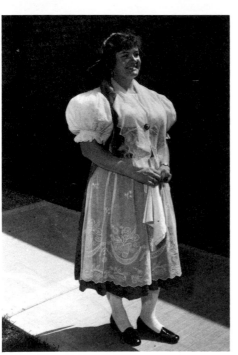

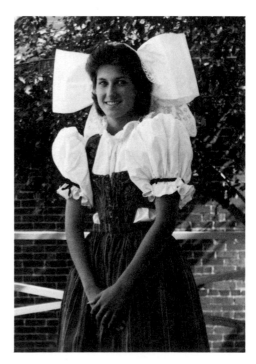

Eggs and Customs

Each Easter after we have finished our family dinner, we pick out the prettiest colored egg, shell it, and then divide this one egg into the number of people (plus our two family dogs!) celebrating our Easter dinner. Sometimes this number includes fifteen nieces, with grandchildren, relatives, or guests. Each individual gets a piece from the hardboiled egg and the tradition is that this practice will keep us from getting lost during the year ahead. We do this every Easter, and Stan remembers it from his early childhood.

—*Dolores (Mrs. Stanley) Travnicek*
Swisher, Iowa

Kraslice (decorated eggs) are mentioned as early as the 14th century in Bohemian and Moravian literature, and it is known that this was a custom long before that time.

Each district uses a different method for decorating eggs and the locality from which an egg has come can readily be identified by the technique used. Millions of them have been decorated with hundreds of different traditional designs.

Eggs are symbols of life and future hope, here and now. Throughout history man has eaten eggs and decorated eggs to celebrate the miracle of life.

The season of spring and, later, the Christian spiritual observances of Easter, both heralding rebirth of life and spirit, are most commonly thought of as times to eat and decorate eggs as a sign of spiritual renewal. However, eggs have been cherished by people from many lands and have been presented as gifts to friends and family on other occasions throughout the year.

Ancient Persians, Egyptians, Greeks, and Romans all exchanged decorated eggs. Mexicans, Bulgarians, Italians, Finns, Hungarians, Greeks, English, Germans, Irish, Belgians, and French all have customs evolving from the egg.

In Czechoslovakia, as in many other countries, no Easter celebration would be complete without eggs. Czechoslovaks often color eggs red or purple, or use red or purple flowers to ornament them, on Maundy or Holy Thursday, to commemorate the Passion of Christ.

In Czechoslovakia, Easter is the most joyous holiday of the year. Friends exchange eggs with the greeting "Christ is risen." and the reply, "He is risen indeed." Flowers and eggs abound in the markets, homes and churches.

In times past, the most beautiful egg painted by the boy or girl was saved for the special best-loved person. It was very often a pre-engagement symbol. Young people on the farm carried their eggs in a basket, delivering them from farm house to farm house.

One story tells of a young man who decorated an egg tree below the window of his loved one. On Easter morning there it was, to her surprise. Trees in the yard or garden were sometimes decorated.

Another old Christian practice occurred on Easter Saturday afternoon, when the village boys collected and stacked wood and placed a straw-covered cross in the center of that stack. After an evening church service, the boys would light lanterns at the Paschal Candle, hurry to the stack of wood, and set fire to the cross. They would chant, "We are burning Judas." The ashes were guarded throughout the night, and in the morning were thrown into a flowing stream. Church ladies would then give decorated eggs to the one boy lucky enough to have lighted the fire in this annual observance.

Villages had egg artists, usually older people who utilized many designs and then taught them to others. Moravians placed pebbles or beads inside dried eggshells to make rattles for children. Long ago such rattles were believed to drive away evil spirits, and only recently have rattles become simply toys for children.

Inscribed eggs, a rarity in egg decorating, were fashioned by Moravians and Slovakians. Moravians threaded eggs with ribbon and displayed them on the traditional Easter Egg Tree. One custom was to adorn the tree with colored eggshells and flowers, and then young girls would parade house to house in their village. In another Moravian technique, cut-out straw pieces were glued to the eggshells to make beautiful designs or patterns. The straw pieces were either dyed or of natural color.

An old Bohemian custom involved "Smrt," an effigy of "Death." Numerous variations of this custom are recorded. One featured the doll burned or thrown into a running stream or river on Palm Sunday. The figure, symbolizing "Old Woman Winter," might be fashioned of straw and dressed in old clothes or decorated with old rags. She might have had a necklace of eggs. As she was tossed into the river, the children would sing a welcome to the arrival of spring.

Another old custom involved making willow switches to "dust away the dreariness of winter when spring arrived." Then decorated eggs were presented to an individual's favorites following the "switching." These customs are as numerous as the villages in Czechoslovakia. All such customs are a part of the joy of living and relate us to the charm of history and tradition.

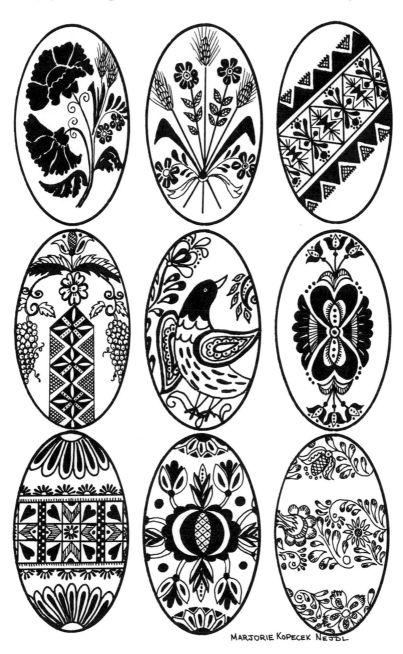

MARJORIE KOPECEK NEJDL

Egg Decorating

Batik is a word that describes a "resist" dyeing process, a form of "printing" that is obtained when hot wax, an effective resist to dye, is applied to the surface being worked. This process of egg decorating is accomplished when wax is applied in intricate and creative ways, after which the egg is dyed, leaving color only on the unwaxed areas.

Batik is an Indonesian word and therefore this art form probably had its beginnings in southeast Asia. Like needlework and other folk art forms, the batik method of decorating is reflected in a number of cultures and religions in southeast India, Africa, Europe, and elsewhere. In Czechoslovakia, eggs are decorated with the batik method, using traditional patterns. The following directions are from Czech egg artist Marj Nejdl of Cedar Rapids, Iowa. Equipment needed for waxing includes:

1. A flat surface covered to protect table.
2. Melted beeswax. Obtain beeswax from hardware store or craft shop.
3. An electric heater of some sort, or a hotplate, standing on fireproof material. Beeswax must be used in liquid form.

Before coloring, mix water with baking soda, wash eggs thoroughly, and dry them. Hot wax may be applied in a variety of ways, the most common of which is an artist's pen. In order to de-wax, hold the egg over a hot flame to melt wax, and then wipe with cloth. Candle flame may not be hot enough and sometimes candle flame leaves a black residue on egg. If this is the case, flame from another heat source should be used. On the other hand, there is only one way to blow out an eggshell, and that is to make two small holes in opposite ends of the egg, place lips to one aperture, and blow!

Marj uses beeswax, melted by an Old World method. In a tablespoon, fixed in a potato, and suspended over a burning candle, she melts a small piece of beeswax. Marj blows her eggs out after decorating, because she needs the extra weight to hold the egg down in the dye.

A small, dental-type rotary grinding tool may be used to cut "lace eggs" to decorate, according to the method employed by Marj. She begins by piercing the egg with a little hole at the middle, enlarging upon that hole carefully. Although Marj fashions designs on chicken eggs, often these eggs are too thin-shelled for success. The method is most often used by Marj on the heavier-shelled goose eggs.

Before cutting into the goose egg with the little grinding tool, decide upon the design you are to create, Marj advises. The easiest method is simply to draw this design on the egg with a lead pencil. There are various attachments for this rotary device, and Marj suggests that the user read the directions carefully and have the dealer demonstrate the tool and its many uses.

Other Methods

You may draw directly onto an egg with oil paints or pen and ink. Or you may wrap the egg in ferns, leaves or flowers, held in place with nylon fabric, and dip the egg in dye. After drying, remove the leaves and see the pattern that remains on the egg.

Zora DuVall's Directions

To create decorative eggs using the batik method, Zora Pauk DuVall, a noted painter living in Lake Forest, Illinois, has developed a simple practical method to use for groups of adults or children. Here is her system:

Materials needed:
1. Hard-cooked eggs (or raw eggs if you want to blow them after decorating).
2. Egg dyes: any type that produces good color and can be used while cool.
3. Finish nail: whatever size head will be best for your design or age (larger nail for small children, smaller nail for more delicate design).
4. Facial tissue, soft toweling or cloth to wipe egg after dipping.
5. Paraffin wax melted in a little pan or small container which can be heated.
6. Hot plate or electric stove to keep paraffin wax melted (something that will keep it at a steady melted temperature).

Method: Wax resist or batik process.
1. Dip tool (nail head) into hot wax and make stroke on egg to produce the design you need for the first color (which would be the white of the shell). Practice on paper or other object until the wax flows into the stroke with one fast motion. Your design will need to be built up of short strokes because the wax solidifies rapidly into a little mound covering the eggshell where you want it to stay white. Do all the areas on the egg you want to remain white, dipping the nail into the hot wax between strokes.

2. Place egg in first color (it is better to proceed from light colors to dark colors). After dye has colored egg to desired brightness, lift egg out of dye and pat it dry. Let it sit in air to dry well (just a minute or two).

3. Repeat first process, covering with wax the parts of the first color you wish to keep.

4. Place egg in second color. Repeat process until design is complete with the number of colors you wish to have on egg. The remaining unworked portion will be a combination of all colors used. If that does not look interesting, dip in final dark color of your choice. Blue or purple is a good finishing color, but remember it will be a combination of all preceding colors, too.

5. Finished egg will have the texture of interesting wax mounds covering each color. If you like that look, keep it that way, or remove wax with hot water or other type of heat. I like the bumpy look, myself.

6. If you are working on a raw egg and want to blow it, tap a tiny hole at each end of egg (with point of paring knife or other sharp object). Carefully and slowly blow with mouth at one hole and the inside of the egg will slowly flow out of the other hole into container. When done, wipe off any moisture at ends and seal holes with paraffin. To hang eggs (on tree, for example) do not seal one end. Tie a thread around the middle of a half-inch length of toothpick. Drop toothpick into the hole and as it straightens out inside the egg it will stay there and hold the egg for hanging by the thread.

Slamenky

(Cut Wheat Goose Eggs)

By Sidonka Wadina-Lee

This technique, particularly popular in Hana, Moravia, is one of the most exacting of all methods of decorating eggs. It requires a great deal of skill and patience. This form of decoration is used on eggs dyed a dark color, most frequently dark red or brown.

Using good pieces of oat, barley, or wheat straw, first remove the joints. The stalks are soaked in hot water about one hour, and then they are split lengthwise and the pith scraped away with a sharp knife. The straw is then smoothed out with an iron and then cut into squares, triangles, diamonds, and narrow strips—in fact, all the elements from which decorations can be composed.

A good, colorless glue can be used to attach the individual pieces. A tweezer and toothpicks are used in the application of the glue (toothpicks) and cut wheat pieces (tweezers).

110

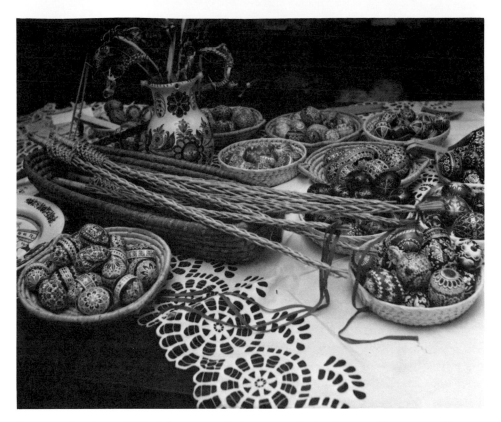

Easter display, CSA Museum, Library and Archives, Berwyn, Illinois. Traditional items include hand-braided whips decorated with colored ribbons. Young men chase girl friends on Easter Sunday, and are rewarded with colorful hand-painted Easter eggs. Pussy willows and palms in traditionally decorated vase are symbols of the new life of spring. Braided palms are a symbol of the scourging of Christ on Good Friday. White embroidered cloth is from Moravia.

Kraslice Folk Artists

The folk artists whose eggs are featured in the color section of this book live in Wisconsin, Iowa, Kansas, and Tennessee. Each of these artists seeks to preserve the traditional folk arts of Czechoslovakia while at the same time developing a personal style.

Marjorie Kopecek Nejdl, for instance, cuts out portions of goose eggs for special effects. Sidonka Wadina-Lee applies cut straw on goose eggs. Kepka Belton and Wash Hornick stress the batik technique in their work.

111

Marjorie Kopecek Nejdl

Marj Nejdl, a master egg painter from Cedar Rapids, Iowa, generally works an eight-hour day in her home, creating beautiful eggs for buyers from Washington, D.C., to California. She also demonstrates and displays her artistry throughout Iowa and sometimes regionally.

Her techniques include batik (or wax resist), pen and ink, hand-painted, "lace eggs," and her newest creation, stained glass eggs.

Marj learned the "Old World" batik method as a child from her uncle, Martin Polehna. Her mother, Helen Kroupa Kopecek, always encouraged folk arts and was, herself, a designer of bobbin lace and Czech embroidery. In fact, Helen was born in this country but was raised in Czechoslovakia because her father, Frank Kroupa, returned to the Old Country with Helen and her brother after their mother died.

According to Marj, in Czechoslovakia it is possible to tell what village a decorated egg comes from by its design and color—as is possible with traditional Czechoslovak costumes. Batik egg decorating flourished, especially among peasant women, because there was always an egg in the hen house on which to practice creative artistry even if they did not have the linens and fine fabrics that women of the nobility used for their batik creations.

Marj dyes, paints, or cuts, just about any egg—whether chicken, goose, quail, or ostrich.

Sidonka Wadina-Lee

"You are the future; you must carry on for me when I am gone. . ."

The words spoken by Johanna Biksadsky to her young granddaughter Sidonka marked the beginning of the young girl's many years of instruction in the folk arts, traditions, and customs of her grandmother's native Slovakia.

Driven by a deep sense of pride for their heritage, the two lectured and demonstrated throughout Wisconsin, and spent many hours decorating intricately detailed eggs to sell at the Milwaukee Holiday Folk Fair, an event the entire family has participated in since the mid-1940s. Sidonka is an expert egg artist, proficient in the wax-dyed, wax-relief, scratched, pen-and-ink, hand-painted, and cut-straw methods of egg decorating. For the past thirteen years she has painted a series of collector plates, each depicting some custom or facet of Czechoslovak folklore. Sidonka is a member of the National Association of Wheat Weavers, and practices Czechoslovak wheat

weaving in its many forms. As an instructor for the International Institute in Milwaukee, she teaches and demonstrates throughout the state, most recently at the John Michael Kohler Art Center, the Cedarburg Cultural Art Center, and the Milwaukee Public Museum.

Sidonka's reputation as one of the state's finest traditional folk artists grew in 1987 when eleven examples of her work were featured in the exhibition "From Hardangers to Harleys—A Survey of Wisconsin Folk Art." The Czechoslovakian Harvest Cross featured in the exhibition is now on permanent display at the national headquarters of the Future Homemakers of America in Reston, Virginia. On Page 81 Sidonka is shown with a similar harvest cross.

"Where the old apple tree once stood, a young tree now stands, blossoming and bearing fruit for all the neighbors in the countryside to share."

My Story, by Wash Hornick

My mother and father, Mary and Visily Hornyak, came here from the Old Country in the early 1900s and settled in the coal fields of southern West Virginia. When I was about eight years old, I would watch my mother and grandmother color eggs and naturally, I had to try my hand at it. Two of my brothers and one sister also learned, but one brother and one sister never got interested.

One day as I was doing my eggs, a thought crossed my mind. My only child, a daughter who is retarded and doesn't have good coordination, will never be able to learn the art, and unless I teach it to someone it will soon die. So I decided to go to schools, church group meetings, senior citizens' meetings, et cetera, and give demonstrations and workshops to teach persons. If only one in a group learns, it is well worth my time. I'm thankful to say that there are many who have learned and the art will go on.

Some of the designs on the eggs in photos were handed down from my mother and grandmother and some are my originals. A year ago I started a Christmas design that caught on and people are using them as ornaments on trees. The most popular is the Cross on one side and Dogwood on the other.

My eggs were displayed at the Fine Arts Center in Kingsport, Tennessee, in May 1985. On Good Friday, Saturday, and Easter Sunday, 1988, the eggs were shown on three local television stations and also on CNN-TV.

Kepka Belton

One of twelve American folk artists who were honored in 1988 by the National Endowment for the Arts, Kepka Belton, a schoolteacher of art, received a one-time award given to a folk artist nominated by peers. She is known as "the egg lady."

Kepka Belton is a fourth-generation American with roots tracing back to a small town north of Prague, Czechoslovakia. She was born in Wilson, Kansas, often called the Czech capital of Kansas. At an early age she learned from her grandmother the craft of *kraslice,* the Czech art of decorating eggs with melted wax and dyes.

Kepka has participated in the Kansas Folk Arts apprenticeship program and has exhibited throughout the Midwest and at the Festival of American Folklife at the Smithsonian Institution in Washington, D.C. Her work has been reviewed in *Les Editions de la Revue Moderne,* Paris, France. She belongs to the Czechoslovak Society of Arts and Sciences.

Kepka Belton is a graduate of Emporia State University at Emporia, Kansas, and Fort Hays State University at Hays, Kansas, and studied art at the Kansas City Art Institute, Kansas City, Missouri.

In addition to her hand-painted Easter eggs and the methods she has painstakingly developed for hardening the shell before it is painted, Kepka is a creator of tree-branch dolls, a lost Czech doll-making technique.

In 1982, Kepka and the Wilson, Kansas, Czechs decorated the Statehouse Christmas tree at Topeka with beautiful handmade traditional Czech decorations of wheat, paper, decorated cookies, foil-covered nuts, and fruit.

Copyrighted folk art designs by Kepka Belton, used with permission.

114

Czechoslovakian Food

Kde se dobře vări,

Tam se dobře dări!

Where there is good cooking there is happiness!
—Anna Petrik

For Czechoslovaks, food means memories. . .

Food helps create special family occasions. . .

Food says much about who and what we are. . .

In the most basic sense, food is any nourishing substance taken into the body to sustain life, provide energy, and promote growth. However, food is so much more than victuals !

What we eat determines what and who we are —especially if we have Czechoslovak ancestry. Food also is determined by where we live and how we live. Many recipes are best described as straightforward, simple, tasty, and nourishing. The essence of Czechoslovak food came from gardens and farms in Europe: pork, cabbage from farms and gardens, fruit from trees. From these staples of nature, for example, comes the popular national dinner menu of pork and dumplings with gravy and sauerkraut. Kolaches with fruit filling emerge naturally and easily. Even the dessert, "divine crullers", is created from the simple ingredients of egg, flour and milk!

The early pioneers in this country ate what they had on hand, and memories attached to those foods are now embodied in memories of "the lean years." In this volume, however, is a collection of special memories of recipes that reflect a legacy from Czechs-Slovaks who survived those lean early years. These contributors, more established and secure with their personal lives and as members of the Czech-Slovak ethnic, also present more fancy foods, more party foods, and more foods for special occasions.

Appetizers, for example, were not customary in Old World. Only in recent years has the appetizer been enjoyed instead of a soup, or just to add variety to a special occasion. Appetizers in this book include mostly mushroom dishes, again particular favorites of Czechoslovaks, especially those who live where gathering mushrooms is a pleasurable pastime. Beverages popular with Czechoslovaks have always included homemade wines. Remember, people of the Old World had their own vineyards. The liquor "kminka" makes

practical use of a popular herb caraway seed.

Soups, popular at midday as well as for supper, are made with staple foods of milk, meat and vegetables. Breads show preference for the old fashioned rye. Many dumplings are truly Czechoslovak specialities. Dumplings are plain as well as made with vegetables and fruits, and are popular side dishes, as are potato and sauerkraut dishes, rice and noodles. Today, in Czechoslovakia, corn is grown only in the most southwestern part of Slovakia.

Main dishes in this collection include the national favorite of pork and gravy with dumplings.

There are few countries that have the variety of desserts the Czechoslovaks boast! Many special desserts are included, such as Lady Locks, which exemplifies the more elaborate baking of modern times. Traditionally, simpler desserts were the rule, such as those made with ginger or poppy seed. (There have always been bakeries in the Old Country.)

Kolaches are so popular that we include seven recipes. Just as there are many ways to spell Kolache, with the one used in this book the preferred English spelling, so too are there many ways to prepare kolaches! The original kolache was the size and shape of a pie and was cut and served accordingly. This dessert, which is also a breakfast, a staple, or whatever you wish, also exemplifies the diversity, creativity and thrifty nature of the Czechoslovak cook. Kolaches are covered or open, they may utilize prunes from plums or cottage cheese that was traditionally economical because there was inadequate refrigeration for milk.

Food, to many Czechoslovaks with a sense of culture, involves a legacy, handed down from past generations and given to future generations. When people enjoy being together, "breaking bread" is a sharing time. In fact, every meal together is a celebration of sorts.

It is in this spirit that our contributors share their favorite recipes with you. In truth, a collection of special memories and celebrations is presented to readers in the form of a collection of recipes! Enjoy!

Harvest Celebrations

There are two harvest celebrations in Czechoslovakia at Thanksgiving-time. "Posviceni" is the church consecration of the harvest and "Obžinky" is the secular celebration.

Wreaths made of rye straw, field flowers, and ears of corn are placed on the heads of pretty girls. After the ceremony, these wreaths are not destroyed, but are saved until the next harvest.

A typical feast includes roast pig, roast goose, kolaches filled with prunes, sweet yellow cottage cheese, poppy seed filling, or apricot jam, beer *(pivo)* and a prune liquor, *(slivovice)*.

Merry Christmas

The merriment of Christmas begins December 6 in Czechoslovak communities, when Sv. Mikuláš, also known as St. Nicholas or Santa Claus, arrives at the appointed place, accompanied by the angel and devil, both in costume.

One by one, the children are asked if they have said their prayers and if they have been good or bad children. The angel busily makes notes; the devil might rattle his chain. The child may be rewarded with candy or cookies from the angel. For everyone, it is a time of celebration and joy, a happy get-together.

The ensuing days are busy times of housecleaning and the baking of Christmas cookies and goodies. The Christmas tree is cut and decorated with sufficient secrecy that small children will find it a Christmas Eve surprise.

The Christmas Eve meal may begin with a prayer of thanks and a sharing of honey and *oplatky,* a thin wafer eaten as a symbol of family love and forgiveness for past quarrels or differences. Soup may be lentil, dumpling or fish. The dinner may include breaded fish, either mashed potatoes or potato salad, peas or variations, followed by fruit, Christmas cookies, kolaches or apple strudel.

Afterward, the gaily lighted and decorated Christmas tree, with the star or dove on top and presents and a creche beneath, is unveiled, a carol may be sung, and presents are unwrapped. The family may attend midnight Mass or Christmas morning services.

The traditional Christmas dinner features roast goose, dumplings, and sauerkraut. It is a time for visiting friends and exchanging Christmas greetings.

Magic of Morels

Peeking around and into decaying leaves, wild flowers, and crumbling logs, countless "houby hunters" are lured to the homes of the delectable morel mushrooms.

Hunting mushrooms, or houby, has always been popular with Czechoslovak people. In fact, it's a sport. There are houby jokes, certain grubbies to be worn while hunting, tales of secret places where houby might be found, and houby stories that are similar to fish stories.

The dedicated morel hunter knows when it is time to search for prizes by the very feel and scent of the moist spring air. It's a good thing he does sense the right time, for this elusive little delicacy has a fruiting period of only a few weeks. The most favorable time involves a soft rain during the night, followed the next morning by the sunshine that warms the damp leaves and dirt.

The city dweller rarely finds the morel in his yard, park, or garden. For serious hunters it's off to thickly carpeted forests of mixed oak, aspen, elm, and maple.

Czech Village in Cedar Rapids, Iowa, holds an annual Houby Days celebration the weekend after Mother's Day. Houby hunters from eastern Iowa vie for trophies presented for the smallest, tallest, most oddly shaped large and small, best display, and best houby in the show.

The most popular mushrooms in eastern Iowa are the common morel, both the round head and the conical head. Also eaten are the false morels, or lorchels, goatsbeard, rooster comb, and grass mushrooms.

Mushrooms are high in minerals and vitamins, are fun to seek, and delicious to eat. Needless to say, if eating is what you have in mind, know what it is that you are looking for and what you're looking at.

Garden, Ducks, and Geese

The town of Malin, Oregon, founded in 1909, was named because the wild horse-radish fields reminded Alois Kalina of the town of Malin in Bohemia, where much horse-radish was produced. Mrs. Elizabeth Paygr wrote of her experiences:

"My father called me a boy because I worked so hard when I was young. Then, with my husband, I came to Malin and I cried because I was so lonesome. We put straw on the floor in the Zumpe house where they let a lot of us newcomers sleep until our houses were ready. The lumber had to be hauled with horses, the same as in the old country. I worked with my husband, clearing sagebrush, stacking hay, and milking cows. We never bought anything except necessities—flour, beans, sugar. I raised a big vegetable garden every year, ducks, chickens, geese, and turkeys. And I cried, too, when I killed a turkey."

Czech display at the University of Texas Institute of Texan Cultures, San Antonio, Texas shows corn shuck basket by John Jurecek, grape masher, kitchen knife, wooden kitchen beater, and sausage pins.

The Story of Beer

Classic brews of England and Ireland are ales and stouts. The Japanese drink Saki. But the medium-bitter beers most popular in America probably originated as Pilsner, which has been brewed since 1292 in Pilsen (Plzen), Bohemia.

Czech beer may be best, but it wasn't the first. The ancient philosopher, Pliny the Elder, whose *Natural History* is one of the most important works of classical Latin literature, wrote about beer: "So exquisite is the cunning of mankind in gratifying their vicious appetites that they have thus invented a method to make water itself produce intoxication."

Pliny the Elder could have been wrong in his intoxication idea. A fact about beer is that it was safe to drink long before water was! And beer had been around a long time before the Greeks. Beer made from malt and red barley is mentioned in Egyptian writings as early as the fourth dynasty.

The Pilsner Urquell brewery's central lager cellar is popular with visitors. It is 45 feet below the ground, where the temperature is only 3 1/2 degrees above freezing. Pilsner Urquell is marketed in the United States by All Brand Importers, Inc., of New York City. Of a dozen or so Czech beers, the only ones exported are Pilsner Urquell and Budweiser Budvar, which licensed its name to Anheuser-Busch in 1910.

Some like to pretend that Czechoslovakians invented beer. Although they did not, the most popular beers of America, Germany, Denmark and the Netherlands are the pale-colored, light brews that are like Pilsner Urquell, for which no equal has been found.

A Room in a Barrel

In Czechoslovakia there is a room that is only 6 1/2 feet high and 8 1/2 feet wide but which contains two beds, chairs, a lamp and a table. This furnished room, created from a large beer barrel, is for rent at $8 a night at Camp Vlahovka, near Prague, from April to September. Amenities include a camp restaurant nearby.

Each of these barrels once held more than 4,000 gallons of beer. The breweries rolled them out when steel vats came in.

Legend of the Frost

Gardeners watch their favorite signals to determine when to plant. A Czech legend warns not to plant before May 12, 13, and 14 because of the "three frozen kings" or "three frost saints."

Pangrac (also Pangras) died May 12, 304 A.D. Servac (also Servais or Servitus) died on a May 13 and Bonifac (or Tarsus) died on a May 14.

Then, on May 15, Sophia (Žofie) brought about a thaw with a kettle of boiling water. Sophia was undoubtedly brought into the legend because her feast day is May 15 and because she was known for her excellent cooking and baking. So, on May 15 or later it's safe to plant.

When May temperatures threaten frost, the legend is especially recalled. In the New World, this legend might apply in parts of Canada and northern United States, but elsewhere gardens are planted in March or April and in some southern areas the climate permits planting year-around.

In Moravia, a five-foot figure representing the death of winter was drowned in a river on the first day of spring.
Illustration by Diane Heusinkveld.

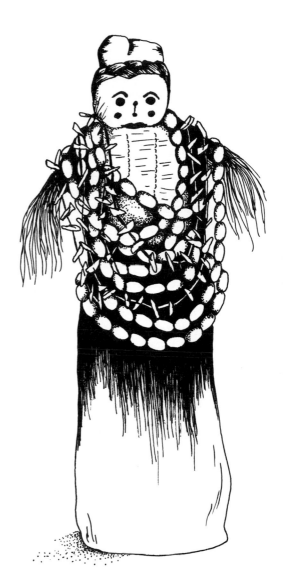

Appetizers and Beverages

Sweet 'n' Sour Mushrooms
Sladké A Kyselé Houby

Vera Krasova Miller

4 cups mushrooms
2 cups water
1 cup sugar
1 cup white vinegar
2 teaspoons salt
2 teaspoons pickling spices
2 bay leaves
sliced onion

Cook mushrooms covered in salt water until tender. Drain and rinse. Combine rest of ingredients in pan to make marinade. Bring marinade to boil, add mushrooms, and boil again. Pack in jars and process 10 minutes.

Stuffed Morels
Nacpané Smrže

2 dozen morels
1 cup fine bread crumbs
1 cup cooked chicken or
 ham, minced
1 small onion, finely chopped
morel stems, chopped
1/3 cup sour cream
1/2 teaspoon salt
pepper, freshly ground

Remove and reserve morel stems. Cut mushrooms lengthwise in half. Rinse in cold water. Place in a bowl and sprinkle lightly with salt. Cover with cold water and let soak 10 to 15 minutes. Remove, pat dry with towel, set aside.

In a bowl, combine bread crumbs, minced chicken or ham, onion, morel stems, sour cream, salt, and pepper. Stuff each morel half with filling. Arrange in a buttered oven dish and bake at 400° for 15 to 18 minutes.

Hot Mushroom Dip

2 pounds fresh mushrooms
6 tablespoons butter
1 tablespoon lemon juice
2 tablespoons minced onion
3/4 to 1 cup sour cream
4 tablespoons parsley, chopped
salt
pepper
2 teaspoons bouillon granules
 (or 2 bouillon cubes)
1 tablespoon butter, softened
1 tablespoon flour

Chop mushrooms fine. Place in pan with butter; add lemon juice and simmer 10 minutes. Add onions, sour cream, and parsley. Season with salt and pepper and add bouillon granules or cubes. Simmer 10 minutes more. Make a paste of 1 tablespoon soft butter and 1 tablespoon flour. Add to mixture and stir until thickened. Serve hot.

Note : Parsley may be added to dip or used as garnish.

Mushroom Fondue

1 cup mushrooms
butter
1/4 cup sherry
1 cup grated Monterey Jack cheese
 or
1 cup morels
butter
1/4 cup sauterne
1 cup grated mild Colby cheese

Sauté mushrooms in butter until liquid is absorbed. Place in blender at high speed until puréed. Place mushroom purée in a fondue pot, add sauterne, or sherry, and heat until bubbly. Add cheese by handfuls and stir until melted. Serve with cubes of French bread.

Pickled Mushrooms
Goats' Beard or Cottage Cheese Mushrooms
Kozi Brada

Mrs. Lumir J. (Norma) Newmeister,
Cedar Rapids, Iowa

Gathering spring and fall mushrooms and flowers is a favorite pastime of Mr. and Mrs. Newmeister. Ardent nature lovers, they are bird-watchers and they fish. Mrs. Newmeister harvests an herb garden and uses the dried herbs in her cooking. She created this recipe by experimenting with other recipes. Norma says she is sorry so many Czech traditions are "going by the wayside," though she has tried to maintain a few in her family.

1 quart mushrooms
2 cups cider vinegar
2 cups sugar
1 cup water
1 large onion, diced
1 teaspoon canning salt
1 tablespoon pickling spices

Wash mushrooms and cut into small pieces. Cover with water, bring to a boil, and simmer for 15 minutes. Drain and rinse well in cold water.

For pickling syrup, combine vinegar, sugar, water, onion, salt, and pickling spices. Cook. Add mushrooms and simmer 10 to 15 minutes.

Seal at once in sterilized pint jars. Makes about 4 pints.

Embroidery: counted work

Pickled Mushrooms
Naložené Houby

Emily Polacek,
Brookfield, Illinois

1/3 cup vinegar
1 cup water
1 teaspoon sugar
1 onion, small and thinly sliced
3 peppercorns
pinch of mustard seed
1 bay leaf, small
2 cups mushroom caps, drained

Combine all ingredients, except mushrooms, in a small saucepan. Bring to a boil. Simmer 5 to 6 minutes. Strain and pour hot mixture over mushrooms. Chill overnight. Drain. Serve with cocktail toothpicks.
If using fresh mushrooms, simmer in salted water for 3 minutes and drain before adding pickling mixture.

Marinated Mushrooms
Nakladané Houby

Mildred Stejskal,
Yukon, Oklahoma

This recipe is from a friend in Prague, Czechoslovakia, says Mildred. She serves these on a relish tray, and provides toothpicks.

2 8-ounce cans mushroom caps,
 drained
1/2 cup olive oil
3 small green onions,
 sliced in rings
1/3 cup wine vinegar
2 bay leaves

Put drained mushrooms into a bowl and combine with remaining ingredients. Cover and refrigerate overnight.

East European Milk and Egg Cheese
Cereck

Andy and Elda Sokol,
Elora, Tennessee

"From about 1919 to the 1930s," writes Andy, *"when the union broke the stranglehold of the coal companies in Nemacolin, Pennsylvania, times were hard, and Slovenians, Bohemians, Moravians, Slovakians, Poles, Hungarians, and Croatians relied on nature to feed their families. We would fish the streams and roam the fields and woods for herbs, fruits, mushrooms, and vegetables. The wild grapes and berries were gathered for wine and jams. People would go and help a farmer in return for some meat and milk. We all had our ups and downs, but we were happy.*

"I remember the weekends when we would roast a pig, calf or sheep and sip on wine. We played instruments and danced on the ground until the wee hours of the morning. In search of jobs, people headed to the cities. The change was rapid and times were never the same."

This cheese is traditionally made at Christmas and Easter.

1 dozen eggs, slightly beaten
1 quart milk
salt (optional)
sugar (optional)
nutmeg (optional)
cinnamon (optional)

In a large pan, stirring constantly, slowly cook the eggs and milk just under the boiling point until the mixture curdles, about 10 to 20 minutes. Have ready one square yard of cheesecloth spread over a colander. At this point you may add salt, sugar, nutmeg, or cinnamon if desired. When the egg and milk mixture is well curdled, pour it in the colander to strain. Lift the 4 corners of the cheesecloth up and twist to get as much whey out of the mixture as possible. Then hang it up over the sink or the pan and let the mixture drain for about 8 hours or overnight. The cheese is ready to eat the next day. Serve with pickled beets and prepared horseradish.

Stuffed Dried Fruits
Nacpané Sušene Ovoce

Ann E. Svoboda,
Cedar Rapids, Iowa

1 6-ounce package dried prunes
1 6-ounce package dried figs
1 6-ounce package dried apricots
1 6-ounce package dried dates
6 ounces cream cheese, softened
1 small can crushed pineapple,
 well-drained
1/4 cup nut meats, finely chopped
3 ounces mild cheese spread

Steam the dried fruits. Chill. Combine cream cheese and pineapple. Set aside. Combine nut meats and cheese. Stuff each fruit with either the cream cheese and pineapple mixture or nut and cheese mixture.

Counted embroidery, consisting of cross-stitch, four-sided stitch, upright Gobelin, slanted Gobelin, and straight stitches.

Mounds
Homolky

Mrs. Joseph A. Zikmund,
Pisek, North Dakota

Lucy Zikmund writes "My mother, Victoria Kouba, prepared Mounds for our family in the 1920s and 1930s. It was a real treat. She heated the milk on the back of a coalwood stove. She hung the bag of curds and whey out on the clothesline to drain."

2 gallons milk
1/2 cup sweet cream
1 teaspoon salt
1/2 teaspoon caraway seeds

Heat milk until it turns into curds and whey. Place the curds in a cloth bag and hang to drain. Place curds in a bowl. Add sweet cream to moisten so it mixes easily and has a creamy texture. Add salt and caraway seeds to taste. Mix thoroughly.

Shape into peaks or mounds about 3 inches high to look like haystacks. Place on a platter. Store at room temperature up to one week. They are best when sticky and are suitable as either appetizers or as a main dish.

Just Like Pickled Beets
Naložená Řipa

Dorothy Snitil,
Cedar Rapids, Iowa

sweet pickle juice from a quart of sweet pickles
beets, fresh cooked or canned, drained and sliced
6 whole cloves (optional)
2 onion slices (optional)

Use equal amounts of pickle juice and beets. Add beets to juice until juice barely covers them in jar. Refrigerate for two days before serving. If juice needs more flavor, add cloves and onion.

Chokecherry Wine
Višnové Vino

Mrs. Ben Greicar,
Pisek, North Dakota

Chokecherry wine was one of the best wines her grandmother made, says Mrs. Greicar. Her mother, who claimed these wines were as good as store-bought, later took over as family wine-maker. Wheat and beet wines were also made.

1 gallon chokecherries
sliced lemons and oranges (optional)
2 gallons water
1 cake yeast
1 gallon sugar

Clean cherries and run them through food grinder, including stones. Add lemon and orange slices. Mix cherries, water, and yeast. Let mixture stand in a warm place for 3 to 5 days.

Strain through a flour sack or cloth bag. Add 1 gallon sugar for every gallon of chokecherry liquid. Bottle and cork.

If using larger quantities of cherries, add 2 gallons water to every gallon of cherries. Add 1 gallon sugar to every gallon of cherry liquid.

Kminka (Kimmel)

Mrs. Emma Novotny,
Pisek, North Dakota

*The "min" is pronounced like "mean"
and "kminka" is the Czech word for
caraway seed, says Mrs. Novotny.*

1/2 cup sugar
1 cup vodka
1 cup water
1 teaspoon caraway seed

Brown sugar in skillet, stirring con-
stantly to prevent scorching. When it
turns dark brown add remaining ingre-
dients. Set aside, allowing caraway seed
to flavor the liquid. Makes 1 pint.

Homemade Wine
Domáci Vino

Evelyn Rainosek Vecera,
Bellaire, Texas

8 cups grapes
4 cups sugar
1 gallon boiling water

Take a clean 1 gallon jar with a good lid.
Use ripe wild grapes or grapes you have
in your area. Wash well. Fill jar with
grapes and sugar. Add boiling water to
within 1 inch of the top. Tighten lid and
leave to ferment till grape seeds, skins,
etc. drop to the bottom. Then it is ready.

Rhubarb Wine
Rebarborovy Vino

Mrs. Ben Greicar,
Pisek, North Dakota

*This recipe has been handed down in
Marie Greicar's family.*

7 pounds rhubarb, cubed
1 gallon water
3 1/2 pounds sugar (use this
 amount of sugar for every
 1 gallon water)
1 citron with peel, finely cut

Place rhubarb and water in a clean,
open barrel. Mix it 3 times daily for 3
weeks. Press water out of rhubarb.
Discard rhubarb mash. Place rhubarb
juice and water in a clean vessel. Add
sugar and citron.

When sugar has dissolved, pour into a
wine barrel with a lid. Barrel must be
full for foam to pour away (pipe hole
remains uncovered). Set aside for 14 to
20 days in moderately warm room. A
"purring" sound can be heard from ris-
ing wine. When it no longer purrs, cork
the barrel and place in cold cellar. Wine
is ready to drink in 2 to 3 months.
Tastes better with age. Makes 1 gallon.

Note: For 20 gallons of water (wine)
use 140 pounds of rhubarb.

*Counted embroidery, consisting of cross-stitch, four-sided stitch,
upright Gobelin, slanted Gobelin, and straight stitches.*

Soups

Old-Fashioned Goose Barley Soup

Starodávní Husová Ječmenová Polévka

Libbie Urban,
Fort Dodge, Iowa

2 tablespoons rendered goose fat
(drippings from roasting goose)
or butter
1 cup sliced onion
goose giblets, neck, wings, and
carcass
water
1 teaspoon salt
1/2 teaspoon celery salt
1 pound tomatoes, cut up
1 cup pearl barley
1 teaspoon beef stock base (optional)
1/2 teaspoon thyme

Melt fat in Dutch oven or large soup kettle. Sauté onions until limp, but not brown. Add giblets, neck, wings, water, carcass, salt, and celery salt. Cover and simmer for 1 hour.

Remove meat and bones with slotted spoon. Cut meat off neck and bones and finely chop giblets. Return meat to kettle. If you wish, add cut-up, left-over roast goose. Add tomatoes, barley, beef stock base, and thyme. Return to a boil, cover, and simmer 1 additional hour. Makes 2 quarts.

Note: Cook decides how much water to use, depending on consistency desired.

A sampler by Mary Laznička Lacina. It was once customary for young girls to learn stitches on samplers. This sampler is now in the collection of the Czech Museum and Library, Cedar Rapids, Iowa.

Bean Soup

Fazolová Polévka

Dorothy Snitil,
Cedar Rapids, Iowa

"If you like baked beans," writes Dorothy, "you will like this soup. Mrs. Stan Kuta gave me the recipe about 25 years ago. It has been our favorite bean soup all these years."

1 pound northern beans
2 cups ham, cubed (or part ham and
part bacon, raw and chopped)
1 quart canned tomatoes
2 onions, diced
1/2 cup brown sugar
2 cups raw potatoes, cubed
salt to taste (optional)

Soak beans in cold water and cover overnight. In the morning, drain and add enough water in a soup kettle to cover beans. Add ham and cook until beans are almost done, about one hour. Add tomatoes, onions, brown sugar, and potatoes. Cook slowly until potatoes are done. If desired, add salt.

To give soup a smoky flavor, bacon (raw and chopped) can be substituted for part of the ham. This soup freezes well.

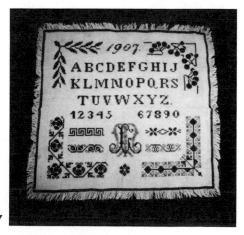

Potato Soup
Bramborová Polévka

Dr. Vera A. McKenna,
Crookston, Minnesota

10 1/2 cups water
1 pound potatoes
3 1/2 ounces mushrooms, sliced
3 1/2 ounces vegetables (carrots,
 turnips and parsley) shredded
3 ounces butter
1 3/4 ounces flour
salt
1 clove of garlic

Peel the potatoes, cut into small cubes, and boil in hot salty water until tender. Add sliced mushrooms and shredded vegetables fried in a spoonful of butter. Then fry the flour and when light brown mix with 2 cups of soup and add to the soup. Add salt and garlic to taste.

Slovakian Caraway Soup

Pittsburgh Folk Festival

3 tablespoons butter
3 tablespoons flour
3 cups boiling water
1/2 teaspoon salt
2 teaspoons caraway seed
1 egg, beaten

Melt butter in heavy pan, add flour and cook over low heat until dark brown, stirring constantly, about 5 minutes, add hot water slowly, salt and caraway seed, cook and stir until soup comes to a boil, remove from heat. Continue stirring, add beaten egg, pouring slowly, egg will look like scrambled eggs. Remove and enjoy. Serves 2.

Heart Soup
Polévka ze Srdíček

Irma Mouchka Kelly,
Cedar Rapids, Iowa

1 beef or pork heart, cut into quarters
1 teaspoon salt
dash of pepper
1/2 teaspoon caraway seed
1 medium-sized onion, chopped
1/2 cup flour

Cover heart with water, add salt, pepper, caraway seed, and onion, and bring to a boil. Simmer for about 1 1/2 hours or until fork comes out easily and heart is tender to touch. Remove heart and dice. Thicken liquid with flour. Add heart and serve at once.

Mother Vondracek's Tomato Soup
"Rajská Polévka" Dle Matky Vondráčkové

Vlasta V. Kosek,
Cedar Rapids, Iowa

16 ounces milk
16 ounces puréed tomatoes
1/2 teaspoon baking soda, divided
 (prevents curdling)
salt and pepper to taste, only if using
 fresh tomatoes

Heat milk and 1/4 teaspoon baking soda in a small sauce pan. In a medium-sized saucepan heat tomatoes and 1/4 teaspoon baking soda. When both liquids reach boiling point pour together. Do not boil. Soup is ready to serve. Minute Rice can be added to the soup if desired, or cooked vegetables such as carrots, celery, etc.

Breads and Dumplings

Bishop's Bread
Biskupský Chlebíček

Emily Polacek,
Brookfield, Illinois

"I remember my mother preparing this recipe. She would sit with the bowl in her lap and beat the dough with a wire whisk for half an hour."

3 eggs
1 cup sugar
1 cup flour
1 teaspoon baking powder
1/2 teaspoon salt
1 cup raisins, washed in warm water
1 cup almonds, coarsely chopped

Beat eggs and sugar at low speed until very thick, about 20 minutes. Sift together flour, baking powder, and salt. Add to egg mixture. Shake or sprinkle raisins and almonds in flour, then fold with other ingredients. Pour into a greased and floured 4 1/2 x 8 1/2-inch loaf pan. Bake at 350˚ for 30 minutes. Cool slightly. Remove from pan while warm. Delicious with ice cream. Serves 16 people.

Dad's Favorite Rye Bread
Tatinkovo Žitný Chléb

Mrs. Francis C. Bouska,
Fort Atkinson, Iowa

2 cakes yeast
1 1/2 cups potato water, lukewarm
2 1/2 cups water, lukewarm
2 1/2 tablespoons sugar
1/2 cup potatoes, mashed
2 eggs
1 tablespoon salt
2 tablespoons lard
1 cup rye flour
1/2 cup graham flour
7 cups all-purpose flour

Dissolve yeast and sugar in water. Combine all ingredients. Knead well. Cover with cloth, let rise in warm place until dough doubles. Punch down and let rise until it doubles again. Shape into loaves and place in greased loaf pans. Let rise until doubled. Bake at 350˚ for 45 minutes. This bread freezes well after it is cool.

Bread sculpture, below, is by Lester Sykora.

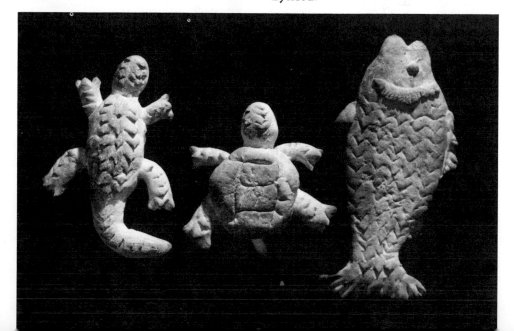

Christmas Bread
Vánočka

Lester Sykora
Sykora's Bakery
Czech Village
Cedar Rapids, Iowa

1 cake compressed yeast or
 1 package active dry yeast
1/4 cup warm water (105° to 115°)
1/2 cup sugar
1/4 cup margarine
2 teaspoons salt
2 eggs
5 1/2 to 6 cups all-purpose flour
1 cup warm milk (105° to 115°)
1 teaspoon finely shredded lemon peel
1/4 teaspoon ground mace
1 cup light raisins
1/2 cup chopped nuts
1 beaten egg yolk

Soften yeast in warm water. In a mixer bowl, beat together sugar, margarine, and salt. Add eggs; beat well. Beat in 1 cup of the flour. Beat in milk, peel, mace, and yeast mixture. Stir in as much remaining flour as you can with a spoon. Stir in raisins and nuts. Turn out onto floured surface. Knead in enough of the remaining flour to make a moderate soft dough that is smooth and elastic (3 to 5 minutes total). Place in a lightly greased bowl; turn once to grease surface. Cover; let rise in warm place till double (1 1/2 hours). Punch the dough down; divide in half. Divide 1 portion of the dough into fourths for the bottom braid. Cover and let rest for 10 minutes. Meanwhile, divide the remaining dough into 5 portions for the other 2 layers of the dough. Cover those portions and set aside. On a lightly floured surface, form each of the first 4 portions into 16-inch-long ropes. On a greased baking sheet, arrange the 4 ropes, 1 inch apart. Beginning in the middle of the ropes, braid loosely together toward each end. To braid 4 ropes, overlap the center 2 ropes to form an X. Take the outside left rope and cross over the closest middle rope. Then, take the outside right rope and cross under the closest middle rope. Repeat braiding until you reach the end. Pinch ends together; tuck under. Turn baking sheet and braid on opposite end. Gently pull width of braid out slightly. Form remaining 5 portions into 16-inch-long ropes. Braid 3 of the ropes together. Brush the 4 strand braid with water and center the second braid on top; gently pull width of top braid out. Twist the remaining 2 strands of dough together. Brush the top braid with water; place the twist on top of the second braid. Cover the shaped dough and let rise till nearly double. Brush surface of the shaped dough with egg yolk. Bake in a 350° oven for 35 to 40 minutes. Cover the loaf with foil during the last 10 minutes of baking. Remove from the baking sheet and cool on a wire rack. Makes 1 loaf.

Christmas Cookies by Lester Sykora

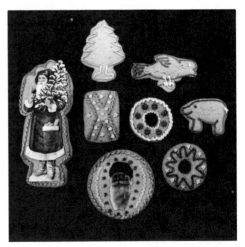

Crescent Rolls
Rohliky

Cherryl Benesh Bartunek,
Cedar Rapids, Iowa

*This recipe came from the late Mrs.
Harold Fliehler and was submitted by
Cherryl. Mrs. Fliehler was proud of
her strong Czech heritage. She was
well-known for her baked items,
dumplings, and candy, which she made
as Christmas treats for friends and
family.*

2 packages dry yeast
1 teaspoon sugar
3/4 cup warm water
1 cup hot water
1/2 cup sugar
1 egg
2 teaspoons salt
3 tablespoons butter
5 1/4 cups flour
1 egg, beaten with 1 1/2 tablespoons
 water
poppyseed or caraway seed
salt

Dissolve yeast and 1 teaspoon sugar in
the 3/4 cup warm water. Combine hot
water, sugar, egg, salt, and butter in a
large mixing bowl. Add 3 1/2 cups of
the flour. Cool flour mixture to luke-
warm, then add the yeast mixture.
Gradually add remaining flour until all
ingredients are blended. Knead the
dough 10 minutes. Let rise in a greased
bowl until doubled. Cut off 1 table-
spoon of dough for each roll and form
into a crescent shape. Place on well-
greased cookie sheets. Brush the tops
with the egg-and-water mixture.
Sprinkle with poppyseeds or caraway
seeds and salt to taste. Let rise until
double. Bake at 375° for 15 to 20 min-
utes.

Rye Bread
Žitný Chléb

Libbie Urban,
Fort Dodge, Iowa

*An active member of the Fort Dodge
Czech Heritage group, Libbie taught
Czech cooking. She learned many
dishes when she was a girl. Now in her
late 70s, Libbie still enjoys sewing,
quilting, cooking, and baking. She bakes
this bread often.*

1 quart lukewarm water
1 tablespoon salt
1/2 cup lard or shortening
2 packages yeast
1/2 cup sugar (or 1/4 cup sugar and
 1/4 cup sorghum)
2 1/2 cups medium rye flour
2 1/2 cups all-purpose flour
6 cups all-purpose flour
1 tablespoon caraway seed

Mix warm water, salt, and lard in large
bowl. Sprinkle yeast on top, then
sprinkle sugar. Stir well. Add rye flour
and 2 1/2 cups all-purpose flour, beat
well with wooden spoon. Add caraway
seeds. Cover and let rise in a warm place
until double in size.

Put 6 cups all-purpose flour in large
bowl and add dough slowly to the flour,
beating well. When dough takes shape,
put on a floured board and knead for
about 5 minutes. Place in bowl and let
rise again. When double, shape into
loaves and place in greased bread pans.
Let rise until double. Bake at 325°, about
1 hour, until brown. Makes 4 large
loaves or 6 small loaves. Freezes well.

Potato Dumplings
Bramborové Knedliky

Mrs. Frank R. Studnicka,
Clarkson, Nebraska

Mrs. Studnicka's husband plays accordion with a Czech band at festivals. Their grandson Tom joins "grandpa" for accordion concerts at nursing homes. Potato dumplings, says Helen, are a must for Czechs during the holidays and should be served with duck and "kraut."

3 cups potatoes, boiled
2 eggs
1/3 cup farina
1 tablespoon salt
2 cups all-purpose flour

Put cooked potatoes through food grinder or rice them. Let stand until cooled. Mix potatoes with remaining ingredients, in order shown. Knead dough on a floured board. If dough is too soft, add more flour. Cut off 2-inch pieces of dough. On a board, roll pieces into balls and shape into 3-inch-long dumplings.

Put dumplings in large kettle of boiling water (with 1 teaspoon salt). Stir dumplings with wooden spoon so they don't stick to the bottom of the kettle. Cover pot and let boil for 8 to 10 minutes. Test by taking one dumpling out of water and cutting in half. If center is raw, boil a few minutes longer. Nine or ten dumplings will fit into a large kettle, but don't crowd them. Best served with roast duck and sauerkraut.
For freezing, place cooked dumplings on greased cookie sheets and place in freezer. When frozen, place them in covered containers and freeze until used. Heat to serve.

Quick Czech Bread Dumplings
Knedliky Chlébové

Lynn Kosmak, Bedford, Texas

Raised in Czech-oriented Berwyn, Illinois, Lynn participated in activities sponsored by the Czechoslovak Society of America when she was a child. She obtained this recipe from her mother and says the dumplings taste exactly like raised dumplings which take more preparation.

1/2 cup flour
1/2 cup buttermilk baking mix
1/4 cup milk
1 egg
1 1/2 slices of bread, torn into small pieces

Combine ingredients. Dough will be sticky. Roll the mixture in flour until it loses stickiness. Form into ball and flatten slightly. Bring 3 quarts water to boil and add dumpling. Cover pot. Bring water to boil again for 16 minutes. Remove dumpling with slotted spoon and slice. Makes one dumpling. Cut into 5, 6 or 7 slices. Recipe may be doubled as necessary, but each dumpling should be the size of single recipe.

Wood carving by the Bily brothers, Bily Clocks Museum, Spillville, Iowa.

Dumplings with Blue Plums
Švestkové Knedlíky

Camilla Budke,
Manhattan, Kansas

Camilla's grandparents were born in Czechoslovakia. A school teacher, she has corresponded with a relative in Skasov, Czechoslovakia for 30 years. Camilla's daughter, Laurie, visited her Czechoslovakian relatives in 1983. This recipe was handed down to Camilla by her mother, Abbie Hubka of Odell, Nebraska.

2 cups flour
2 teaspoons baking powder
1/2 teaspoon salt
1 egg, beaten lightly
2/3 cup milk
butter, melted
1 can blue plums, pitted
 and thickened

Sift dry ingredients. Add egg and milk. Blend. Drop dough by spoonfuls into hot water. Cover and boil 15 to 20 minutes or until done in center. Lift dumplings out carefully and break into halves with two forks. Drizzle with melted butter and pour plums over dumplings. Serve warm. Serves 6.

These dumplings can also be formed into 6 balls, boiled in broth, and served with meat or gravy.

Goose feather wreath made in 1887 belonged to Mary Skulina Karnik, who was born in 1865 at Květova, Mileuska, Czechoslovakia. She lived in Crete, Nebraska. Donated by her daughter Rose L. Karnik, to the Wilber Czech Museum, Wilber, Nebraska.

Mrs. Jelinek's Bread Dumplings
P. Jelinkové Chlebové Knedlíky

Mrs. Joseph A. Zikmund,
Pisek, North Dakota

The Czech church in Pisek features a large painting by the art nouveau artist Alphonse Mucha. This recipe came from Julia Jelinek, a former Pisek resident who now lives in a Chicago suburb.

1/8 pound butter, melted
1/2 loaf of bread, cubed (dried or
 fresh)
4 eggs, lightly beaten
1 cup milk
1 teaspoon salt
flour for thickening

Pour melted butter over bread cubes. Combine eggs, milk, and salt. Add flour to create a medium thickness. Add bread. With hands dipped in water, shape dough into individual dumplings. Place in kettle of boiling water and boil for 30 minutes. Dumplings are good warmed over.

Noodles
Nudle

Helen Horak Nemec,
Cedar Rapids, Iowa

2 cups flour
3 egg yolks
1 whole egg
1 1/2 teaspoon salt
1/4 teaspoon baking powder
1/4 teaspoon vegetable oil
1/4 to 1/2 cup water

Measure flour into a bowl. Make a well in center and add egg yolks, whole egg, salt, baking powder, and oil. Mix well. Add water 1 tablespoon at a time, mixing thoroughly. (Add only enough water to form dough into a ball.) Turn dough onto well-floured cloth. Knead until smooth and elastic (about 10 minutes). Cover and let rest 10 minutes. Divide dough into 4 equal parts. Roll dough paper thin. Let dry about 20 minutes on tea towels. Then cut into noodles as desired. Let dry about 2 hours. Makes about 6 cups (10 ounces).

Dumplings
Knedliky

2 cups water
1 teaspoon salt
1/2 cup grits
3 cups potato flakes
2 tablespoons butter
2 eggs

In a large bowl mix water, salt, grits, potato flakes, butter, and eggs until smooth. Divide into small balls. Drop into boiling water in a large kettle. cover and let boil for fifteen minutes. Remove and serve.

Slovak folk artist Maryann Brahm in her Prestany costume, demonstrated wood curl crafts at the Holiday Folk Fair, Milwaukee, Wisconsin.

Slovakian Menu

The following Slovakian menu reprinted from a program delighted festival-goers during the Pittsburgh Folk Festival. This event draws 30,000 to 40,000 annually.

Bandurka halusky
Fried sweet cabbage and
potato dumpling
Pirohy
Potato and cheese filled dumplings
Klobasy i kysla kapusta
Sausage and sauerkraut
Holubky
Stuffed cabbage
Halusky
Sweet cabbage and noodles
Orehovnik kolacky
Nut roll
Makovnik kolacky
Poppyseed roll
Rozky
Nut and apricot crescents
Slivka alebo jablka siska
Prune or apple fritter
Paska
Sweet bread
Pagac
Unsweetened cake

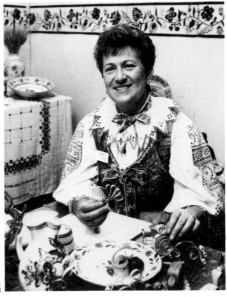

Vegetables and Side Dishes

Suska
Bramborové Škubanky

Mrs. Emma Novotny,
Pisek, North Dakota

2 pounds peeled, cooked potatoes
1 cup all-purpose flour
ground poppyseed
sugar
butter, melted

In a large bowl, mash potatoes and flour together. Serve on plates. Combine poppyseed and sugar and sprinkle generously on potatoes. Top with melted butter.

Rice with Mushrooms
Rýže S Houbamy

Mrs. Lumir Kopecky,
Cedar Rapids, Iowa

1 onion, diced
2 ounces butter or margarine
8 ounces mushrooms, sliced
1 cup rice, rinsed
2 cups stock (beef or vegetable)
salt and pepper

Sauté the onion in the butter. Add the mushrooms and rinsed rice. Cover with the stock and season to taste with salt and pepper. Bake at 325˚ to 350˚ for 20 to 30 minutes, until rice is done.

The Floyd Hermans of Wilber, Nebraska cherish the corn husk dolls created by Mr. Herman's elderly mother, Olie D. Herman.

Wild Rice Casserole

Pat Martin,
Cedar Rapids, Iowa

Pat is also the compiler of The Czech Book, Recipes and Traditions.

1 cup wild rice, soaked overnight
 in cold water
2 cups fresh mushrooms, sliced
1/2 cup butter or margarine
2 tablespoons flour
2/3 cup milk
1 bay leaf
1 onion, sliced
salt, pepper, thyme, nutmeg
1/2 cup buttered crumbs

Drain soaked rice. Cover with boiling salted water and let stand for 20 minutes. Drain again and set aside.

In skillet, brown mushrooms in butter. Sprinkle with flour and blend well. Scald milk with bay leaf and onion. Strain and add to mushroom mixture. Stir constantly until thickened. Add drained rice and season to taste with salt, pepper, nutmeg, and a pinch of powdered thyme. Transfer to a generously buttered casserole dish. Sprinkle top with buttered crumbs and bake at 350˚ for 15 to 20 minutes.

Sautéed Mushrooms
Smažené Houby

Joe Vondracek,
Cedar Rapids, Iowa

Owner of Vondracek's Meat Market in Cedar Rapids, Joe is the Czech Village's "Czech Joe" ambassador every March 19, when St. Joseph's Day is celebrated.

1 pound fresh mushrooms
1/4 cup butter
toast
drawn butter

Remove stems of mushrooms, wash, and peel. Melt butter in frying pan and saute mushroom caps lightly on both sides for 10 to 15 minutes. Serve on trimmed slices of toast with 1 tablespoon drawn butter over each serving.

Pork Cheeks with Sauerkraut
Vepřové Tváričky Se Zelim

Julia and Floyd Davis,
Cedar Rapids, Iowa

Julia and Floyd own a barbershop in their city's Czech Village.

1 onion, chopped
2 pounds pork cheeks
3 tablespoons butter
water to cover
sauerkraut
1 medium potato, grated
salt to taste

Sauté the onion and pork cheeks in butter. Add water and simmer until nearly tender. Add sauerkraut and continue cooking until meat is done. Add grated potato (potato thickens the kraut) and cook about 10 minutes longer.

Sour Cream Dill Gravy
Koprová Omáčka

Marilyn Stoysich,
Omaha, Nebraska

This gravy is delicious served with pork and hot buttered noodles.

1/3 cup pan drippings, reserved
1 small can chicken broth
1/2 teaspoon dried dillweed
1/4 teaspoon black pepper
1 cup sour cream

Using the skillet that meat was browned in, combine pan drippings and chicken broth over medium to high heat. Add spices and turn heat to low. Add sour cream, stirring until smooth. Serve immediately with meat. Serves 6 to 8.

Bohemian Sauerkraut
České Kyselé Zeli

Barbara Polulach Sovern,
Cedar Rapids, Iowa.

1 pound sauerkraut
caraway seeds
1 medium onion, chopped
2 tablespoons lard or shortening
3 teaspoons sugar
1 potato, grated (for thickening)

Place kraut in pot and cover with water. Cook for 30 minutes. Add caraway seeds. In a skillet, saute onion in lard. Mix in sugar and potato. Add cooked kraut and bring to a boil. The dish is now ready to serve.

Black Jack
Černá Kuba

Mrs. Emma Novotny,
Pisek, North Dakota

This is a traditional Christmas Eve supper brought from Czechoslovakia in 1888 by Mrs. Novotny's mother, Mrs. Thomas Blazek. For more flavor, prepare one day before serving. This can be frozen and reheated easily.

1 pound pearl barley, quick-cooking
1 teaspoon salt
1/4 pound dried mushrooms
 (or canned mushrooms)
2 to 3 tablespoons butter

Cook barley in enough salted water to cover until tender. A little more water may be added while cooking if necessary to prevent scorching. Mix often. In a large pan, cook dried mushrooms covered with water for 45 minutes. Add barley and butter to the mushrooms. Drain any excess water.

Breakfast Mushrooms

Zora DuVall,
Lake Forest, Illinois

Born in Czechoslovakia and raised in Slovak and Czech-American communities, Zora has used this recipe often. While traveling in Czechoslovakia, she discovered that this recipe is served by relatives there as a special treat. Wild mushrooms are used in the "old country" as well as here, though button mushrooms from the grocery store also will do.

1/2 onion, finely chopped
1 tablespoon butter (or margarine)
1 pound mushrooms, finely
 chopped
salt and pepper to taste
2 eggs (more if desired), slightly
 beaten
caraway seeds (optional)

In frying pan, sauté onion in butter until tender. Add mushrooms, salt, and pepper. Sauté until moisture has cooked away. Add eggs. Mix well. Continue cooking and stirring until eggs are not liquid. Add a few caraway seeds. Serve with rye bread and butter or on rye bread toast.

Sauerkraut Krisps

Florence Dvorak,
Cedar Rapids, Iowa

Florence has always made her own sauerkraut.

2 cups flour
1/2 teaspoon salt
1/2 cup cold lard
1 1/2 cups sauerkraut, drained
6 to 8 teaspoons water
egg (optional)
milk (optional)
caraway seeds (optional)
poppyseeds (optional)
salt (optional)

Combine flour and salt. Work lard into flour mixture. Add sauerkraut and mix well. Add water until mixture forms a ball. Divide dough into 2 parts and roll out on a floured board. Roll very thin: 1/4 inch for a crisp dough or 3/8 inch for a chewy dough. Cut into strips or squares. If desired, krisps' tops may be brushed lightly with egg or milk and sprinkled with caraway seeds, poppyseeds, or salt. Place on ungreased pan and bake at 425° for 10-15 minutes until light tan, not brown.

Homemade Sauerkraut
Nakládané Zelí

Leona Netolicky Kaplan,
Solon, Iowa

40 pound of cabbage
scant cup sugar
scant cup salt
handful of caraway seed

Remove the outer leaves from cabbage, halve heads and remove hearts. Shred the cabbage with a kraut cutter over a large washtub. Add sugar, salt and caraway seed. Mix with hands until juicy. Pack loosely into glass jars, adding juice about level with top. Add one or two hearts to each jar. Put lids on jars as tightly as possible. Store in basement or similar area. To protect storage area set jars on newspaper and cover with same, in case juice leaks out while the sauerkraut is working. Do not disturb the jars if they leak, sauerkraut will be all right. Allow to work 4 to 5 weeks. Makes about 15 quarts. One rule of thumb states that 10 pounds of cabbage makes about 1 gallon of sauerkraut.

Dvořák Clock by the Bily brothers, Bily Clocks Museum, Spillville, Iowa.

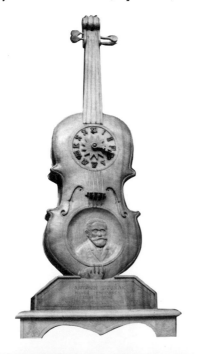

Cottage Cheese
Jak Dělat Tvaroh

Mrs. Charles E. Krejci,
Cedar Rapids, Iowa

Mrs. Krejci submits her cottage cheese recipe. "We ate the dry curds softened with rich milk or cream. Sometimes we added chives or onion tops. The pigs got the whey."

Whole milk was allowed to set for 6 or 8 hours, then the cream was skimmed off and the milk used for cottage cheese. A two gallon stoneware crock was filled and set on the back of the cookstove very little heat. The crock was covered with just any old lid. It remained there until curds developed, maybe 8 hours, maybe 24. We used a wooden spoon to stir and test. When it was ready, it was poured into a white flour sack. The whey drained off and the curds were forced into a corner of the sack and hung on the clothes line to dry, 6 to 8 hour.

Tomato Gravy
Rajská Omáčka

Mrs. Julia Davis,
Cedar Rapids, Iowa

5 small tomatoes
1 cup beef broth or water
3 tablespoons sugar
1/2 teaspoon salt
1 teaspoon cinnamon
1/4 teaspoon allspice
1/4 teaspoon cloves
3 tablespoons butter
3 tablespoons flour

Peel tomatoes and cook. Then strain to remove the seeds or put through a blender to purée. Add the broth or water and rest of the ingredients, except the flour and butter. Make a brown roux of the flour and butter, then add the tomato mixture.

138

Main Dishes

Czech Pork Loin
(With Dumplings and Cabbage)
České Vepřovy A Knedlíky

Marilyn Stoysich,
Omaha, Nebraska

Marilyn and her husband Frank own and operate Frank Stoysich Meats, a meat market which features homemade sausages, including the Czech jaternice and jelita sausages. Marilyn's paternal grandfather came from Czechoslovakia in the late 1800s. Her mother's side is Polish. Her husband's parents came from Austria-Hungary in the early 1900s. This pork recipe won first place in the pork category in the Nebraska Association of Meat Processors' Competition.

1 5-pound pork loin roast, boneless
1 1/2 pounds bulk pork sausage
 or ground pork
1 1/2 cups bread crumbs
bamboo skewers, 4 to 5 inches
 long
heavy string or butcher twine
caraway seed
black pepper

Sweet Sour Cabbage:
1 medium-sized head cabbage,
 cored and coarsely cut
1 small onion, chopped
pepper to taste
2 teaspoons sugar
2 tablespoons butter
1 tablespoon all-purpose flour
1 to 2 tablespoons white vinegar

Bread Dumplings:
3 cups all-purpose flour
3 1/4 teaspoons baking powder
3 slices dried, crustless white
 bread, crumbled
1/2 teaspoon salt
3 eggs, well beaten
3/4 cups milk

Split roast lengthwise, not cutting completely through. Open and pound flat. Brown sausage or pork in skillet over medium heat. Drain fat and mix the meat with bread crumbs. Sausage mixture may be prepared a day ahead. Mixture should be covered well and refrigerated. Bring to room temperature before assembling roast.

Sweet Sour Cabbage: Cook cabbage and onion in boiling water for 5 minutes or until barely tender. Drain. Add pepper, sugar, butter, flour, and vinegar. Set aside. This step may be done one day ahead. Cover and refrigerate. Bring to room temperature before assembling roast.

Bread Dumplings: Combine dry ingredients with egg and milk and form into a soft dough on floured board. Split the dough into 3 or 4 rolls. Allow to rise under a covered dish for at least 30 minutes. Place into boiling water or stock and cook for 5 to 8 minutes. When dumplings come to the top, turn and cook an additional 5 to 8 minutes. Remove from boiling water onto a rack or platter and allow to cool. Cover with plastic to prevent drying. Bread dumplings cannot be prepared a day ahead. (This recipe is tripled, as my family loves the extra dumplings served with gravy.) About half the dumplings are used with the roast. Serve the rest as a side dish.

To assemble roast, place the flattened loin on cutting board or work area, fat side down. Spread the cooked ground pork mixture to within 3/4 inch of the edges. Next, place dumpling rolls down the center. As a rule, two rolls, placed end to end, will be needed. On either side of the dumplings, spoon generous amounts of the cabbage.

139

Now, beginning with the short side of the loin, roll the roast, jellyroll fashion, applying pressure on the roast as you proceed. Continue until opposite end is reached. Skewer this end to fasten it at intervals and then tie roll with twine at one inch intervals. To do so, slide the twine under the roast, bring up and around and tie, cutting away excess each time. Twine should be taut. Remove any filling which has pushed out of the rolled roast. Smooth ends. Remove skewers. Roll the roast in caraway seed on waxed paper, pressing in as much as possible.

Use a roaster with a lid. Spray the bottom of roaster pan with vegetable coating and place the roast in, seam-side down. Sprinkle with a little black pepper and add 1/2 cup water to pan. Bake uncovered at 350° for 15 to 20 minutes. Cover pan and continue baking at 300° for 1 1/2 to 2 hours. Baste occasionally with meat juices. Add more water if needed. Use meat thermometer to determine when loin reaches 170°-175°. Serve with gravy made from pan drippings.
Serves 8 to 10.

Mushroom and Sour Cream Casserole

Kyselá Smetana A Houby

Mrs. Vera Miller,
Cedar Rapids, Iowa

4 cups mushrooms, chopped
1 tablespoon minced onion (optional)
2/3 cup butter
2 cups bread crumbs
1 cup parsley, chopped
1 cup sour cream
salt and pepper to taste

If desired, mix mushrooms and onions. In a well-buttered casserole dish, sprinkle bread crumbs and parsley. Add a layer of mushrooms and dot with butter. Add a layer of crumbs and parsley. Repeat, ending with bread crumbs dotted with butter. Bake at 350°. After 20 minutes of baking, top with sour cream and return to oven for an additional 10 minutes.

Hash

Kaše

Mrs. J.V. Collogan,
Cedar Rapids, Iowa

1 pig snout
1 cup regular farina
2 potatoes, boiled and mashed,
 and cooking water
1 clove garlic, minced
salt

Boil the pig snout in enough water to cover until cooked. Remove the snout and grind up, saving the water. To the ground snout, add cooking water, farina, mashed potatoes, potato water, garlic, and salt. Stir well and put into shallow pan (a pie pan is good). Bake at 350° until brown.

Embroidery: counted work

Sauerbraten
Svíčková

Pat Martin,
Cedar Rapids, Iowa

Pat says this is a favorite Czech gourmet recipe. It will serve 25 easily, and you may substitute trimmed top rounds or rump roast for more economy. Pat has given this recipe to individuals in gourmet dinner groups and it always receives rave reviews.

11 to 12 pounds lean, trimmed top
 round of beef, in 1 piece
salt
8 bacon strips, cut for larding
4 to 5 carrots, chopped
6 to 7 ribs of celery, chopped
1 onion, chopped
4 to 5 bay leaves
12 to 15 peppercorns
1/4 teaspoon thyme
1/4 teaspoon allspice
1 cup water
4 tablespoons vinegar
1/4 pound butter, melted
cornstarch
1 pint or more of sour cream
pinch of sugar
2 to 3 tablespoons lemon juice
salt to taste

Rub top round of beef with a little salt and lard with strips of bacon. (To lard beef, use a sharp knife, cut with point into beef, and push in a strip of bacon.) Mix all of the chopped vegetables with spices, water, vinegar, and melted butter. Cover meat with this mixture, put into turkey-sized roasting bag or stoneware crock, and refrigerate for 2 days, carefully turning meat in the container occasionally.

Set oven temperature at 350°. Place meat and juices in roasting pan; if using a roasting bag, tie end shut. Cut about 6 small slits at top of bag for escaping steam. Bake for 3 hours.

Remove from oven and let cool awhile, then remove meat from liquid and let cool further before carefully cutting into slices a little more than 1/4 inch thick. Press all the sauce in the roasting pan through a sieve. Mix cornstarch in a small amount of water and add to the sauce. Amount of cornstarch depends on amount of sauce, about 1 tablespoon to 1 cup of sauce. Simmer this in a pan until thickened, then add sour cream, sugar, lemon juice, and salt to taste. Pour over the sliced beef. Serve with dumplings.

Baked Mushroom Toast (and Chicken)
*Opečené Houbové Topinky
(A Kuřetem)*

Vera Krasova Miller,
Cedar Rapids, Iowa

8 tablespoons butter
6 slices French bread
3 cups mushrooms, sliced
1/2 cup onion, chopped
1 cup cooked chicken, diced
 (optional)
2 tablespoons flour
1 cup sour cream
salt and pepper to taste
6 slices Swiss cheese

Butter a shallow casserole or baking dish. In a medium-sized skillet, melt 4 tablespoons butter and add bread slices. Brown on both sides and lay in casserole. Add 2 tablespoons butter to skillet, along with mushrooms. Cook until liquid evaporates. Add onions, cooking until transparent. Spread over bread. (The cooked chicken may be added at this point.) Melt remaining butter in skillet. Add flour, stirring until bubbly. Add sour cream, salt, and pepper. Immediately pour over bread and mushroom mixture. Cover with Swiss cheese slices. Bake at 375° until cheese is brown and bubbly.

Jellied Pork

Vepřové V Rosolu
(Huspenina or Sulc)

Dorothy Snitil,
Cedar Rapids, Iowa

An active folk artist in the Czech
community, Dorothy usually spoons
this recipe out of the jars in chunks
onto the plate and puts a teaspoon of
vinegar over it. It tastes as good this
way as in slices. "Huspenina" means
jelly in Czech, says Dorothy. Some-
times it is called "sulc," said to be a
German word for the same dish.

2 or 3 pounds pork skins
1 pork heart
1 pork tongue
2 pounds trimmings or pork roast
 or 8 pig tails

Marinade :
2 1/2 quarts vinegar
2 1/2 quarts broth
2 tablespoons salt
3 bay leaves

Cover pork with boiling water and cook
until tender. Cook tails separately be-
cause of the small bones. Save the
broth. Cut skins into 3 or 4-inch
lengths. Debone pig tails. Dice rest of
meat into 1-inch cubes.

Marinade : Bring to a boil, add meat,
and bring to a boil again. Pour into 6 to
8 loaf pans, 1 to 1 1/2 quart capacity.
Refrigerate. It will keep 2 to 3 weeks. If
you want to keep it longer, pour boiling
hot into hot sterilized jars and seal. To
serve, reheat, add more vinegar if nec-
essary, pour into a loaf pan, and chill
until set.

Cut thick slices for a meat dish or thin
slices for sandwiches.

Bohemian Beef Dinner

Český Hovězí Oběd

Mrs. Jackie Kourim,
Riverside, Illinois

*This recipe is from the cookbook of
the St. Mary's Altar and Rosary Soci-
ety, Riverside, Illinois.*

1 cup flour for dredging
1 teaspoon salt
1/4 teaspoon pepper
2 pounds stewing beef
2 tablespoons oil
2 medium onions, chopped
1 clove garlic, minced
1 teaspoon dill weed
1 teaspoon caraway seed
1 teaspoon paprika
1/2 cup water
1 cup sour cream
1 27-ounce can sauerkraut
paprika for sprinkling

Combine flour, salt, and pepper. Dredge
beef in mixture. Brown beef in oil.
Pour off drippings. Add onion, garlic,
dill weed, caraway seed, paprika, and
water. Cover lightly and cook slowly
for two hours or until meat is tender.
Stir in sour cream and heat through. In
a saucepan, heat sauerkraut, drain and
place on platter. Serve meat mixture
over sauerkraut. Sprinkle with pa-
prika. Serves 6 to 8.

*Slovak wood curl art by Maryann Brahn
of Milwaukee, Wisconsin.*

142

Sweet-Sour Cabbage and Pork

Sladké-Kyselé Zeli A Vepřovy

Marilyn Stoysich,
Omaha, Nebraska

Pork Chops :
8 pork chops, center cut,
 1 inch thick
salt
pepper
flour for dredging
oil

Cabbage:
2 medium heads of cabbage,
 cored and coarsely cut
1 large onion, chopped
1/4 teaspoon salt
3 tablespoons flour
3 tablespoons sugar
1 1/2 cups water
3 tablespoons vinegar
1/4 to 1/2 teaspoon caraway seeds

Season and flour the pork chops. Heat a small amount of oil in a heavy skillet and brown the chops on both sides. Transfer the chops to a platter and keep warm.

Place cabbage and chopped onion in a roaster pan. Combine salt, flour, and sugar with cabbage and onion and mix well. Combine water and vinegar and pour over the cabbage mixture. Sprinkle with caraway seeds. Arrange browned pork chops on top of the cabbage mixture. Cover roaster pan and bake at 325° for 20 minutes. Remove lid and gently stir cabbage away from sides of roaster. Replace lid, return to oven, and lower heat to 275°. There should be sufficient liquid to cook the cabbage. If there is too much liquid, flour may be added for thickening. Continue cooking for about 30 minutes, until pork is thoroughly done. Serves 6 to 8.

Goulash
Guláš

Rose Vondracek,
Cedar Rapids, Iowa

2 large onions, chopped
1 cup celery, chopped
2 tablespoons margarine or lard
2 pounds pork, cubed (pork
 cheeks are excellent)
2 pounds beef, cubed
1 tablespoon salt
1/4 teaspoon red pepper
1/2 teaspoon black pepper
1 tablespoon paprika
1/2 cup catsup
2 or 3 peppercorns
1 bay leaf
flour or cornstarch

Saute onion and celery in margarine or lard until golden. Add meat and brown. Add enough water to cover and simmer covered until tender (about 45 minutes). Add spices and thicken gravy with a little flour or cornstarch mixed with cold water. Simmer for a few minutes to blend flavorings and serve.

A photograph of Antonin Dvořák sits on the organ used by the composer during the summer of 1893 at the Bily Clocks Museum, Spillville, Iowa.

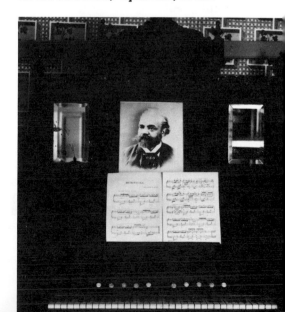

Fish in Dark, Sweet Gravy
Ryba Na Černo

Mrs. Emma Novotny,
Pisek, North Dakota

Over 90 years old, Mrs. Novotny still loves to bake and cook. She says this fish recipe is even better on the second day. It can be frozen and reheated easily.

fish, raw and scaled
1/2 cup raisins
1/2 cup prunes
dried apples and peaches
crushed gingersnaps or flour

Place fruits in a kettle, with water to cover. Add a pinch of salt and boil until fruit softens. Add fish to the fruit mixture and cook until fish is tender. For gravy, thicken juices with gingersnaps or flour. Can be served hot or cold.

Fried-Down Pork
Smažené Vepřovy

Bonnie Benesh Samuels,
Morning Sun, Iowa

pork chops 1 1/2 inches thick,
 boneless
canning salt
freshly rendered lard

Rub each pork chop well with canning salt on both sides and place in large roasting pan. Bake in preheated 325° to 350° oven until brown, turn over, and continue roasting until golden brown. (About 1 hour or longer on each side.) Place chops in 3-gallon crocks to about 3/4 full. Pour hot rendered lard over chops to within 1 inch of the top. These will keep several months in a cool, dry place. To serve, warm slowly in oven and serve with sauerkraut and potato dumplings.

Chicken Paprika
Kuře na Paprice

Sylvia Benesh Courtney
Iowa City, Iowa

1 stewing chicken, about 4 pounds
1 medium-sized onion, chopped
1/4 cup butter
1/2 teaspoon paprika
salt to taste
dash cayenne pepper
1 1/2 cups water
1/2 cup sour cream
2 tablespoons flour

Cut chicken in small pieces. Sauté onion in butter; add paprika, salt, cayenne pepper, and chicken. Brown chicken on both sides; then add water. Cover and simmer until chicken is tender, 45 minutes to 1 hour. Remove chicken to serving platter. Mix sour cream and flour, then stir carefully into pan. Simmer gravy 5 minutes; do NOT boil because the sour cream curdles. Pour gravy over chicken. Serves 4 to 5.

Rev. Frank J. Zavodsky cherished this Bohemian Bible, printed in 1535. This Bible was baked in a large loaf of bread and hidden in Czechoslovakia after 1620 when families discovered possessing religious books were killed for that offense. Rev. Zavodsky served Jan Hus Methodist congregations of Illinois, Iowa and Minnesota.

Rabbit with Prune Gravy

Králičí Pečene Se
Švestkovou Omáčku

Fern Fackler,
Cedar Rapids, Iowa

1 rabbit
1 large onion, quartered
1 bay leaf
2 cloves
2 whole allspice
1 tablespoon salt
12 prunes
1/4 cup raisins
flour
1/4 cup vinegar

Boil the rabbit with the onion, bay leaf, cloves, allspice, and salt. When tender, cut rabbit in small pieces. Cook prunes and raisins in enought water to cover them until tender; drain, saving liquid. Pit prunes and cut up fine. Using reserved liquid, add enough flour to make a nice thick gravy. Add prunes, raisins, vinegar, and rabbit, and reheat if necessary. Serve over dumplings.

Roast Goose or Duck

Pečená Husa anebo Kačena

Virgil and Jitka Schaffer and son Bob own and operate the Czech Cottage in Czech Village, Cedar Rapids, Iowa.

1 goose or duck
salt
1 or 2 cloves garlic or garlic salt
dressing, optional —3/4 cup per
 pound of bird

Clean, wash, and dry goose or duck. Rub inside cavity and outside of bird with salt and minced garlic or garlic salt. (If using garlic salt, use less of the regular salt.) Stuff loosely with your favorite stuffing, or leave unstuffed. (Czech cooks usually leave bird unstuffed and make dressing in another pan.) Place on rack in uncovered roaster, breast side up. Do not cover pan. Roast at 325° for 40 to 45 minutes per pound for duck or 25 to 30 minutes per pound for goose. During roasting, pour off accumulated fat in pan. Test for doneness by moving drumstick. If it separates easily from the body in the joint, the bird is done. If browning is too fast, cover loosely with foil so steam can escape. However, a crisp, brown skin is desired. A 4 to 5 pound duck serves 4. An 8 pound goose serves 5 to 6.

This illustration is by Bertha M. Horack Shambaugh (1871-1953) author and artist, Iowa City, Iowa.

145

Raw Potato Pancakes
Bramborové Livance

Richard Mengler,
Corvallis, Oregon

"I recently retired after 22 years as a state court judge, including a short period on the state supreme court", writes Judge Mengler. *"I reflect frequently on my humble ancestry, of which I am proud. I am also mindful of the hardships my ancestors endured so I could live 'the good life' in a free society. My family name is German, but my father was a full-blooded, loyal Czech. This recipe will be particularly appreciated by Czechs who remember eating potatoes only as fried, boiled, or occasionally mashed if milk and butter were available. The leftovers were taken to school in a lunch pail. It was most embarrassing to eat this 'foreign stuff' in the presence of the 'American' kids."*
This recipe was handed down by Judge Mengler's mother, a Moravian peasant who homesteaded in a sod house in Nebraska in the 1870s. The potato dish was baked in a corncob-burning stove.

4 medium-sized potatoes, peeled
1 egg, beaten
1 tablespoon flour
1 teaspoon salt
1/8 teaspoon allspice
1/4 teaspoon pepper
1 cup milk
1 small clove of garlic, finely grated,
 or 2 tablespoons grated onion
4 tablespoons shortening or
 butter

Grate potatoes into medium-sized mixing bowl. In a separate bowl, mix egg, flour, salt, allspice, pepper, and milk. Add garlic or onion. Combine mixture with potatoes and place in a 7x11-inch baking dish. Spread so it is about 1 1/2 inches thick. Drizzle with melted butter. Bake at 375° for 1 hour, until brown.

Christmas Eve Fish
Halibut or Codfish in Gravy
Vánoční Ryba

Mrs. Adolph Vyhlidal,
Morse Bluff, Nebraska

A homemaker, Mrs. Vyhlidal also works part-time as a painter, paper hanger, and woodwork finisher. Mrs. Vyhlidal's youngest son leads a traditional Czech orchestra in Fremont, Nebraska. She credits this traditional Christmas Eve dish to her mother's ancestors.

halibut, black codfish, or carp
1 large onion, chopped
2 tablespoons butter
1/2 teaspoon salt
1/2 teaspoon allspice, whole
1 large bay leaf or 2 small leaves
1 tablespoon butter
2 tablespoons flour

Cut fish across into 2-inch chunks. Set aside. Sauté onion in butter. In a medium-sized pot, bring 1 to 1 1/4 quarts water to boil. Add onion, salt, allspice, and bay leaves. Boil for 10 minutes.

In a pan, brown 2 tablespoons of flour in 1 tablespoon butter. Pour cold water over the mixture and stir into a paste. Set aside.

After 10 minutes immerse fish in water mixture. Bring to a boil and quickly pour in browned flour mixture to thicken. Do not cook too long or fish will fall apart. This makes a thin gravy. Serve with mashed potatoes and houska.

Slovakian Cabbage Rolls
Holubky

Andy and Elda Sokol,
Elora, Tennessee

"One time my wife took cabbage rolls to a wake," Andy writes. *"A woman attending said that my wife should bring the cabbage rolls to her wake one day because she wanted her husband to have a smile on his face. She pointed to her husband, who was hungrily eating the cabbage rolls."*

2 1/2 pounds lean hamburger
1/2 pound whole pork sausage
1/4 teaspoon garlic powder
3/4 teaspoon salt
3/4 cup onion, minced
2 tablespoons parsley, crushed
3 cups rice, uncooked
2 small to medium heads cabbage
water for cooking
2 cups tomato juice
3 jalapeno peppers
3 chicken or beef bouillon cubes
flour or arrowroot for thickening

In a large bowl, combine hamburger, pork sausage, garlic powder, salt, onion, parsley, and rice. Refrigerate while preparing cabbage. Boil the cabbage in a large kettle until soft and pliable. Gradually remove the leaves. For easier rolling, trim the thick part of the stem to about the thickness of the leaves. When all the leaves have been removed from the kettle, add tomato juice, jalapeno peppers, and bouillon cubes. Let mixture cook while preparing cabbage rolls. Put about 2 tablespoons of the hamburger mixture on a cabbage leaf. Roll up tightly and tuck ends in. When all the rolls are made, cover the bottom of the kettle with leftover cabbage leaves. Place cabbage rolls in the kettle and cook for about 1 hour or until rice is done. There should be enough liquid to cover the cabbage rolls.

Remove rolls and set aside in a warm place. Continue to cook the broth slowly. Remove 2 cups of the broth and pour into a smaller pan. Thicken with some flour or arrowroot. When thickening is smooth, pour into the kettle of broth. When mixture is smooth, return cabbage rolls to the kettle and cook for 15 minutes.

Makes about 15 cabbage rolls. Uncooked rolls may be frozen and cooked later.

Old World Sauerkraut Supper

Old World Inn
Spillville, Iowa

3 strips bacon, cut into small pieces
1 to 2 pounds sausage links or pieces
1 to 1 1/2 tablespoons flour
1/2 to 1 cup water
2 apples, cubed or 1 cup applesauce
3 tablespoons white sugar
1 to 1 1/2 teaspoon caraway seed
2 1-pound cans sauerkraut
2 potatoes, cubed or broken

Fry bacon and sausage; remove meat from pan and drain off some of the fat. Add flour and water to the drippings to make a gravy. Combine meat, apples, sugar, caraway and sauerkraut. In a 9x13-inch glass pan layer half the meat mixture. Place all the potatoes over the mixture and cover them with the gravy. Cover with the remaining meat mixture. Cover with foil and bake at 350° for one hour, remove the foil for the last 10 minutes to brown the top.
Note: Leftover pork gravy can be used instead of the drippings, flour and water. Dumplings can be substituted for potatoes.

Liver Loaf

Játrova Nádivka

Andy Sokol,
Elora, Tennessee

1 pound ground liver
1 medium onion, minced
1/2 teaspoon garlic salt
1/4 teaspoon pepper
1 egg, beaten
1 cup flour
1 cup cracker crumbs

In a large bowl, mix liver, onion, garlic salt, pepper, and egg. Combine flour and cracker crumbs, then add to the liver mixture, making a solid mixture. Shape into loaf and gently lower into a boiling kettle of soup. Cook for 1 1/2 hours. If a soft crust is desired, turn the loaf over during cooking.

If you're not having soup, you may cook the liver loaf in the following broth:

2 cans beef broth
1 onion, minced
2 cloves garlic, minced
1 tablespoon ketchup
1/2 teaspoon salt

Combine ingredients in a kettle and bring to a boil.

Variation: Liver Dumplings
1 pound ground liver
1 teaspoon crushed parsley
1/2 teaspoon garlic salt
flour

Combine ingredients, making mixture not quite as stiff as the liver loaf. On a flat saucer, form dumplings about the size of a baseball. Flatten to 1/4-inch thickness. Dip spoon into boiling broth or soup. Push the the dumplings with a spoon into the broth, dipping spoon after each dumpling to avoid dough build-up. Cook dumplings about 20 minutes. Do not turn them over.

Slovak folk artists demonstrate Christmas crafts. They are at the Holiday Folk Fair, Milwaukee, Wisconsin, making beads of mountain ash berries, and painting walnuts to look like strawberries. From the left are Kenneth and Charlotte Kovac and their daughter Carolyn.

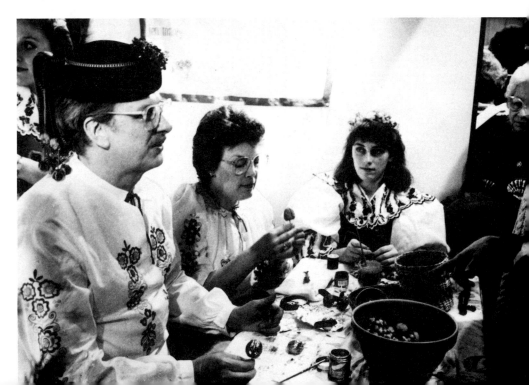

Desserts

Poppyseed Cake
Mákový Dort

Kepka Belton,
Ellsworth, Kansas

Kepka's grandmother, Barbara Kepka, used to grind the poppyseed for this cake in a 9-inch-high brass mortar and pestle brought by her family from Czechoslovakia. The family still has it. Hand-ground poppyseed is the most flavorful, but ground poppyseed in the can may be used, says Kepka. She says this is her favorite birthday cake.

Cake :
3/4 cup ground poppyseed
1/2 cup milk
1/2 cup water
1/2 cup shortening
1 1/2 cups sugar
2 eggs
2 teaspoons baking powder
1 teaspoon salt
2 cups flour

Frosting :
powdered sugar
margarine
3 tablespoons cocoa
milk
walnuts

Soak ground poppyseed in milk for 1 hour. Add water. In a separate bowl blend shortening and sugar. Add eggs. In another bowl combine baking powder, salt, and flour. Alternately blend a little flour mixture and poppyseed to the shortening and sugar mixture. Pour into 2 8-inch rounds or 1 9x13-inch loaf pan, greased and floured. Bake at 375˚ for 35 minutes for a layer cake. If using a loaf pan, bake at 350˚. Frost with your favorite powdered sugar frosting.

Small Houska
Malá Houska

Helen Secl,
Cedar Rapids, Iowa

A beautician for more than 52 years, Helen keeps Czech traditions, customs, and cookery alive in her home for her husband, two daughters, son-in-law, and grandchildren.

1 cake yeast
2 tablespoons warm milk
1 tablespoon sugar
1/2 cup milk
1/2 cup butter
1/4 cup sugar
1 egg, beaten
1 3/4 to 2 cups flour
1 teaspoon salt
1 lemon rind, grated
1/2 cup raisins, softened in hot
 water, drained
1/2 cup nuts, chopped

Soften yeast in 2 tablespoons warm milk and 1 tablespoon sugar. Scald milk, add butter and sugar, and mix. Cool mixture to lukewarm. Add yeast mixture, egg, flour, and salt gradually. Combine lemon rind, raisins, and nuts. Add to dough. Knead dough on a floured board until elastic. Let dough rise until doubled. Form dough into a twist or a round coffeecake. Let the formed dough rise again. Bake at 375˚ for 50 to 60 minutes. Houska may be glazed with frosting and decorated if desired.

Embroidery: counted work

149

Apple Strudel
Jablkový Štrudl

Marguerite Hejtmanek,
Spirit Lake, Iowa

Marguerite and her husband were both born and raised in the Czech community of Clarkson, Nebraska. Her grandfather owned a saloon and dancehall there. This recipe is made especially for Clarkson Czech Days, which are held the weekend before Independence Day. The strudel freezes well. It's best served warm and topped with whipped cream or ice cream.

Dough :
1 cup sweet cream
1/4 pound butter
1/2 teaspoon salt
1 teaspoon vanilla
3 egg yolks
1/3 cup sugar
3 cups flour

Filling:
1/4 cup butter, melted
2 quarts apples, peeled
 and sliced
1 to 1 1/4 cups sugar
2 teaspoons cinnamon
1 cup nuts, chopped
1 cup raisins
3/4 cup coconut
1 1/2 cups bread crumbs, lightly
 browned in butter
1 cup rich milk

For dough, warm cream and butter until butter melts. Add remaining ingredients. Knead dough and place in a warm bowl (set bowl in warm water). Let rise while preparing filling. While dough is warm, stretch it over a floured cloth until paper-thin. Trim hard edges. Spread part of melted butter over dough. Arrange apple slices over dough.

Combine sugar and cinnamon and sprinkle over apples. Sprinkle with nuts, raisins, coconut, and bread crumbs. Drizzle on remaining melted butter. Roll like a jelly roll. Place in a greased 15x18-inch pan. Bake at 350° for 1 hour. While baking, brush often with 1 cup rich milk.

Rice Krispies or crushed cornflake cereal can be substituted for bread crumbs.

Prune Pie
Švestková Pastika

Mrs. Emma Novotny,
Pisek, North Dakota

kolach (sweet roll) dough, from
 your favorite recipe
1/2 pint cottage cheese
2 egg yolks
sugar
1 tablespoon butter
2 cups prunes, cooked, mashed
 and sweetened
cinnamon

Roll a piece of sweet kolach dough to 1/2 inch thickness and put in 8-inch pie plate so that 1/2 inch overlaps edge of plate.

Cottage cheese filling : Combine cottage cheese, egg yolks. Add sugar and butter to taste.

Spread a layer of cooked, mashed prunes over dough. Spread a layer of cottage cheese mixture over prune layer. Bring dough edges over the filling. Let rise. Sprinkle with cinnamon and bake at 350° until golden. (Oven temperature may vary from oven to oven; watch closely to avoid scorching.)

Poppyseed Cake
Mákový Dort

Mary Dworak Eames,
Rio Rancho, New Mexico

Mary writes:"I've been eating this cake most of my life and am 61 years young. This recipe came from distant relatives who lived on a farm in Wahoo, Nebraska. Since I have trouble finding ground poppyseed, my 88-year-old father, Ad J. Dworak, sends it to me from Omaha, Nebraska."

Cake :
3/4 cup ground poppyseed
1 cup milk
1/2 cup butter
1 1/2 cups sugar
4 egg whites
2 cups all-purpose flour
2 teaspoons baking powder
pinch of salt
1 teaspoon vanilla

Filling:
3/4 cup sugar
1 heaping tablespoon cornstarch
1 cup milk
4 egg yolks, beaten
1/4 teaspoon salt
1 teaspoon vanilla

Frosting :
1 1-pound box powdered sugar
1 stick butter
milk
1 teaspoon vanilla
shredded coconut

Cake: Place poppyseed and milk in small bowl and let stand for 30 minutes. Cream butter and add sugar gradually. Beat egg whites until stiff and add to creamed mixture. Combine flour, baking powder, and salt in bowl. Alternately add dry ingredients and poppyseed mixture to creamed ingredients. Add vanilla. Pour equal amounts of batter into two 8 1/2 x 1 1/2-inch round cake pans. Bake at 375° for 30 minutes. Cool layers.

Filling: Combine sugar and cornstarch. In 2-quart saucepan, add milk, beaten egg yolks, and salt. Cook over low heat and stir frequently. When thickened; add vanilla. Cool and spread between cake layers.

Frosting: Combine powdered sugar, butter, and enough milk until creamy. Add vanilla. Frost cake. Sprinkle with shredded coconut.

Klas Restaurant, Cermak Road, Cicero, Illinois.

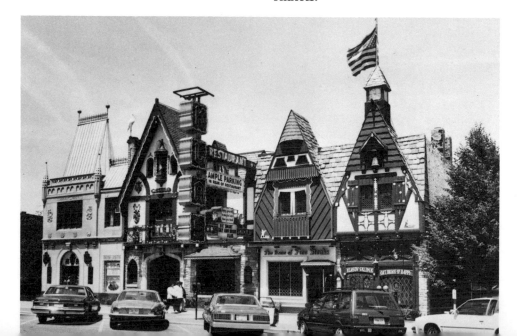

Breakfast Pudding
Krupičný Svítek

Mildred Stejskal,
Yukon, Oklahoma

Mildred says this is not really a pudding, but something like a breakfast cereal when the squares swell up a little in the milk. This can be served cold in the summer as a dessert, or warm for breakfast. It reheats nicely. Mildred's grandmother and mother used to serve this to their families on cold winter days.

2 eggs, separated
2 teaspoons sugar
pinch of salt
1/3 cup farina
4 cup milk
sugar or honey
cinnamon

Beat egg whites until stiff. Beat yolks and fold into the whites. Gradually fold in sugar, salt, and farina. Pour into greased 8-inch pie pan. Bake at 375° until golden brown (about 15 minutes). Heat four cups of milk, sweeten to taste, and sprinkle with a little cinnamon. Cut *svitek* into 1 1/4-inch squares while hot and add to heated milk. Serve immediately.

Nursery Rhyme

Vařila miška kašišku
Na Zeleznau randličku
Tomu dala
Tomu dala
Tomu dala
Tomu dala nic, nic, nic, nic.

A mother mouse cooked some mush in an iron pan (Stir baby's palm with your finger)
She gave some to this one (shake baby's thumb)
And some to another (shake index finger)
And to one more (shake middle finger)
And to one other (shake next finger)
But to this one (shake little finger) she gave none, none, none, none, none.

*Old Prague Restaurant,
Cicero, Illinois.*

Apple Strudel
Jablkový Štrudl

Geraldine Smola,
Ross, North Dakota

In 1905, says Geraldine, Ed Texel left his Nebraska home and homesteaded southwest of Ross, North Dakota. Word got back to his Bohemian friends in Nebraska and many moved to Ross, which now has a large Bohemian population.

1 cup warm water
1 1/2 tablespoons butter
1 egg
1/4 cup sugar
pinch of salt
2 cups flour
3 apples, sliced
1 teaspoon cinnamon
3 tablespoons butter
1/2 cup sugar
3 crackers, crushed

Combine water, butter, egg, sugar, and salt. Beat slightly. Place 2 cups flour in bowl and work in the liquid mixture to form a smooth dough. Place in a warm area for 1 hour. Prepare apples. Roll out dough and stretch very thin. Cover dough with apples, then sprinkle with cinnamon, butter, sugar, and crackers. Roll as a jelly roll. Bake at 350˚ for 1 hour.

Grandma Wachovec's Baked Ammonia Cookies

Frank J. Wachovec Sr.,
Kingston, Ohio

"This recipe was brought from Bohemia in 1910 when my mother came to America," Frank says. "She was born near Pilsen (Plzeň) in 1893."

1 pound butter
2 cups sugar
6 eggs
rind from 2 lemons, grated
2 teaspoons baking ammonia
4 cups all-purpose flour
1 egg, beaten

Combine all ingredients and mix well. Roll out dough 1/8 to 1/4 inch thick and cut into squares. Brush each cutout with beaten egg. Bake at 350˚ for 12 minutes.

Fruit Dumplings
Ovocné Knedlíky

Emily Polacek,
Brookfield, Illinois

1 cup milk
1 tablespoon butter
1/2 teaspoon salt
1/2 cup flour
1 egg
2 cups flour
11 peaches (or 15 plums), whole
 with pits

Bring milk, butter, and salt to a boil. Stir in 1/2 cup flour, mixing until it leaves sides of pan. Remove pan from burner. Add egg. Mix well. Add 1 cup flour and mix. Use remaining 1 cup flour for board. Turn dough out on board and knead until dough forms a ball.

While keeping hands floured, tear off pieces of dough and wrap around fruit. Place dumplings into boiling water. When dumplings rise to top, boil for 20 minutes. (Plum dumplings cook in only 10 minutes).

Serve dumplings with sugar, sour cream, cottage cheese, or melted butter. Sprinkle with vanilla cookie crumbs.

Ginger Cookies
Zázvorové Kukesy

Mrs. John Nosewick,
Minnetonka, Minnesota

The daughter of Czechoslovakian immigrants, Mrs. Nosewick says these cookies are traditional at Czech Christmas, Easter, and wedding celebrations. She remembers her catered wedding reception was followed by zázvorové and kolačky made by Czech friends and neighbors. Mrs. Nosewick speaks Slovak fluently and writes Slovak to her parents, 94 and 91 years old, who still live in their own home in New York. Her parents met and married in New York state, although they came from villages less than ten miles apart in Slovakia.

1/2 pound butter
1 pound minus 1/2 cup powdered sugar, sifted
8 egg yolks, well beaten
4 egg whites, stiffly beaten
1 heaping tablespoon baking powder
2 heaping teaspoons ground ginger
dash of salt
4 1/2 cups all-purpose flour

In a large bowl, cream butter and sugar well. Add egg yolks, then egg whites. Mix well after each addition. Add sifted dry ingredients. Mix and knead well. If dough is too soft for kneading, add more flour. Section dough and roll out on floured board to 1/4 inch thickness. Cut with various small cookie cutters. Let stand overnight on greased cookie sheets in a warm room. (Cookies can be placed on floured dish towels if not enough cookie sheets. Transfer to cookie sheets later). Bake the following morning at 375° for 10 minutes. Store in tight container or freeze. Best when eaten 3 or 4 days after baking.
Note: For stronger taste of ginger, use 4 teaspoons instead of 2.

Raised Bohemian Fruit Dumplings

Lillian K. Chorvat,
Berwyn, Illinois

3 cups flour
salt to taste
sugar to taste
1 ounce yeast
3/4 cup lukewarm milk with sugar added, (amount as desired)
1 egg yolk
2 tablespoons butter
15 plums, with pits or other fruit
dry cottage cheese
butter

Mix the first 7 ingredients until smooth and let rise. When dough is doubled in size, punch down and begin spooning out desired amounts onto a floured board, (amounts vary with the type of fruit you are using, i.e. a fresh plum takes about 2 tablespoons of dough.) Flatten out the clumps of dough and fill each with fruit. Roll into dumplings, making certain edges are secure so they will not leak. Place in at least four quarts of boiling salted water. Boil approximately 5 to 8 minutes, depending on size of dumpling. When dumplings are about half cooked, turn them over and allow to boil another 3 to 4 minutes. Gently lift dumplings out of pot with slotted spoon. Prick each dumpling with a fork to allow steam to flow. Sprinkle with dry cottage cheese, melted butter, and sugar. Serve immediately. Other fruits which are also delicious are cherries, peaches, apricots, blueberries and dry prunes. Pits need not be removed, but the cook should make those being served aware of the pits! These freeze well.

Cream Rolls

Trubičky Se Smetanou

Mrs. Leonard Kapler,
Cresco, Iowa

Dough #1 :
1 pound butter, or part butter and
 part margarine
2 cups flour

Dough #2 :
3/4 cups milk or cold water
2 egg yolks
3 tablespoons lemon juice
2 cups flour
4 tablespoons sugar (optional)
1/4 teaspoon salt

beaten egg for brushing

Filling :
1 package (5 5/8-ounces)
 vanilla instant pudding
1 1/2 cups milk
1 container (12 ounces) whipped
 topping

For Dough #1, combine butter and flour. For Dough #2, blend milk (or water), egg yolks, and lemon juice. Add to dry ingredients. Mix well. Add more liquid if necessary to form a dough. Knead Dough #2 until smooth. Roll out to 1/4-inch thickness. Place rounded Dough #1 in center and fold edges of Dough #2 around ball. Roll this out and fold over. Repeat twice. Refrigerate for 4 hours. After chilling, roll out and fold over 3 to 4 times. Wrap in plastic and refrigerate until ready to use. Roll dough to thickness of noodles. Cut 6 inches long and 1 1/2 inches wide. Wrap around a horn-shaped form. Brush with beaten egg and bake at 400° for 15 minutes. Cool thoroughly.
Filling: Combine pudding mix with milk. Beat until thick. Fold in whipped topping. Fill horns and top with powdered sugar. Makes about 40 medium-sized rolls.

Berry Joe

Marie K. Vileta,
Tama, Iowa

Marie writes a weekly column about the Czech heritage of Tama County, Iowa for the local newspaper. She says: "My mother used many fruits for this dessert: apples, cherries, peaches, or pears, either fresh or canned and sweetened to taste. It is simple and economical. This is a good batter for strawberry shortcake, too. Just prepare and bake without the fruit, then cut into wedges and cover with berries. There may be a Czech name for this, but we've always called it Berry Joe."

1/2 cup sugar
1 tablespoon shortening
1 cup flour
1 teaspoon baking powder
pinch of salt
1/2 cup sweet milk
1 teaspoon vanilla (optional)
2 cups sliced apples
1/2 cup sugar
1 teaspoon cinnamon

Cream 1/2 cup sugar and shortening in mixing bowl. Add flour, baking powder, salt, and milk. Mix thoroughly. Add vanilla. Place apples in a greased 8-inch pie plate and sprinkle with 1/2 cup sugar and cinnamon. Top apples with batter. Bake at 350° for 35 to 40 minutes, until apples are cooked and batter is brown.

Serve in wedges, fruit-side up. Pour cold milk over each portion. Serves 6.

Baba Au Rum
Rumová Bábovka

Stanley Prostrednik,
Pittsburgh, Philadelphia
(Today we call this a Bundt cake)

Stanley Prostrednik was a horticulturist at Hradčany Castle and saw President Thomas G. Masaryk daily as he rode his horse through the gardens. After escaping from a Nazi concentration camp in Illava, Slovakia, he traveled to Budapest, Constantinople (now Istanbul), Marseilles, Casablanca, Martinique, and Bermuda. In the United States, he worked and lived on a 700-acre estate that today is an Allegeheny County public park. He died in 1986.

4 egg yolks
2 tablespoons sugar
1/2 cup softened sweet butter
3 cups flour, sifted with 1 teaspoon salt
 and 2 teaspoons baking powder
3/4 cup warm milk
1 teaspoon grated orange rind

Syrup:
1 cup sugar
1/2 cup water
1/4 cup orange juice
3 tablespoons rum

Beat egg yolks, sugar and butter until thick and fluffy. Add flour and milk alternately, continue beating. Add flavoring last. Pour in a greased fluted cake form and bake at 350° for 45 minutes. Meanwhile, cook sugar with water to a heavy syrup. Add rum and orange juice. Remove cake from the form and pour syrup over it while still hot. Let cool thoroughly before cutting.

Strudelets
Štrudl

Mrs. William Oslak,
Lemont, Illinois

Married for more than 40 years, Mrs. Oslak loves to cook, bake, and quilt. This recipe was handed down from her mother, Barbara Matas, a great cook and baker who lived to be 90 years old.

Dough:
1/2 cup butter
1 cup flour
3 egg yolks, slightly beaten
2 tablespoons lemon juice
1 teaspoon lemon rind, grated

Filling:
2 egg whites, beaten stiff
1/2 cup sugar
1/4 pound walnuts or
 pecans, chopped

Dough: Cut butter into flour until evenly mixed. Add remaining ingredients and mix lightly with fork until the flour is moistened. Gather dough together and press into a ball. Divide into 24 pieces and roll into balls. Refrigerate these for several hours or overnight. After chilling, roll each into a 4-inch circle on a floured pastry cloth.

Filling: Gradually beat sugar into egg whites. Add nuts. Spread a spoonful of filling on each circle. Roll like a jelly roll and place on ungreased cookie sheets. Bake at 350° for 15 minutes until golden brown.

Lady Locks with Filling

Margie Fetsko,
Pittsburgh, Pennsylvania

"This is one of my favorite dishes and guests go wild over it, but it requires a bit of work," says Margie.

Dough:
3 cups all-purpose flour
1 1/2 cups water
1/4 teaspoon salt
3 cups shortening

Filling:
1 cup milk
2 heaping tablespoons flour
1 cup shortening
1 cup sugar
pinch of salt
1 teaspoon vanilla
powdered sugar, optional

Dough: Mix flour, water, and salt to form a dough. Divide into three parts. It will be tacky and difficult to work with at first.

Roll out one part of dough on a well-floured board to a 10-inch square. Spread generously, about 1/8 inch thick, with shortening. Fold into thirds, lengthwise, then in thirds again, making six folds. Refrigerate for 30 minutes. After chilling, do not unfold, but roll out again to a square and again spread generously with shortening. Fold again in six ways and refrigerate for another 30 minutes. After second chilling, repeat rolling into a square, spread with shortening, and refrigerate for at least 6 hours or overnight. Place the dough in a 4-inch-deep floured pan and cover to prevent drying. Follow this procedure with other parts of dough.

After final refrigeration, do not unfold, but place on a floured board. Roll into a 6x15-inch rectangle, about 1/4 inch thick. Cut into strips about 1 inch wide. Wrap strips of dough on wooden dowels (or around clothespins) covered with foil, shiny side out. Roll sideways, over-lapping so strips do not come apart. Place end-down on ungreased cookie sheet, one inch apart. Bake at 400° about 20 to 25 minutes, until slightly brown. Slide baked strips off dowels and cool on paper towels.

Filling: Cook milk and flour to a thick paste, stirring constantly. Cool. Combine paste in mixer bowl with shortening, sugar, salt, and vanilla. Beat until fluffy. Using a pastry bag, fill lady lock from both ends. Dust with powdered sugar if desired.

Divine Crullers
Boží Milosti

Irma and John Kadlec,
Cedar Rapids, Iowa

4 egg yolks, well beaten
4 tablespoons heavy cream
2 tablespoons sugar
1 egg white, beaten stiff
2 tablespoons rum or whiskey
1/8 teaspoon salt
1 3/4 to 2 cups flour, divided

Beat egg yolk, cream and sugar until well blended. Fold in egg white and rum or whiskey. Add salt and 1 cup flour, mix well. Add remaining flour gradually, mixing until stiff dough is formed. Knead for a minute and roll out 1/8 inch thick. Cut into strips about 4x1 1/2 inches. Slash edges and twist slightly. Drop into hot deep fat at 360° and fry until golden brown. Drain and dust with powdered sugar. Makes about 3 dozen, depending on size.

Doughnuts
Koblihy

Mrs. George Manak,
Mississauga, Ontario, Canada

Mrs. Manak's mother made these doughnuts every Sunday after church in her native Trhovy Sviny, Czechoslovakia. Mrs. Manak and her daughter, Mrs. Frances Mackintosh of San Jose, California, translated this recipe from Czech to English expressly for this book.

1/4 pound butter
3 tablespoons sugar
3 egg yolks
2 eggs
1 13-ounce can evaporated milk,
 plus regular milk to equal
 3 cups liquid
2 teaspoons lemon rind
1 square yeast (5/8 ounce or
 1 package dry yeast)
6 cups all-purpose flour
shortening
powdered sugar

Beat butter, sugar, and eggs until smooth. Add milk mixture, lemon rind, and yeast. Stir thoroughly. Add flour slowly, beating after each addition until smooth. Let rise 1 1/2 to 2 hours until double. Spread dough on large breadboard, pulling from middle until about 1 1/2 inches thick. Cut out circles with the cutter size of your choice.

Melt 1/4 pound shortening in Dutch oven or equivalent size pot. Drop dough cutouts three or four at a time into hot shortening. Place lid on pot and deep fry for 2 minutes, until golden brown. Turn doughnuts over and brown on other side, uncovered. Remove with slotted spoon and drain on paper towels. Add additional shortening for frying as needed. Sprinkle doughnuts with powdered sugar when cool.

Christmas Cheese Pie
Vánoční Paštika Tvarohová Nádivka

Anna Petrik,
Caldwell, Kansas

This pie is the final touch for a Christmas buffet. It complements pork well. Anna says "It can be served with a drizzle of rum. The pie can also be made into small tarts and served with coffee. Because this recipe dates before the time of freezers, it does not freeze well. It does refrigerate well, or can be kept in a cold room as grandmothers used to do."

3 large eggs (or 4 small)
1 1/2 cups milk
1 teaspoon vanilla
1/3 cup sugar
2 to 2 1/2 cups small curd cottage
 cheese, drained
cinnamon
1/3 cup white raisins, chopped
3/4 cup pecan meats, finely chopped
1 9-inch pie crust, unbaked
nutmeg

Beat eggs until light and fluffy. Add milk and vanilla and slowly add sugar. Drain all the liquid possible off the cottage cheese. Mixing slowly, add cottage cheese and a sprinkle of cinnamon. Put raisins and nut meats in bottom of pie shell and pour in cheese mixture. Sprinkle nutmeg over pie. Bake at 350° for 30 minutes, until custard is set. Cool before serving.

Embroidery: Pulled or cutwork

Bohemian Christmas Cookies
České Vánoční

Betty Seidl Martin,
Buckley, Washington

These cookies are a family favorite, says Betty, who has been baking them for 35 years. She hasn't been able to find this recipe in any other Bohemian cookbook.

Dough:
1 cup butter
3/4 cup powdered sugar
3 tablespoons cream
4 egg yolks
4 cups flour, sifted

For rolling:
1/4 cup powdered sugar
1/4 cup flour

Frosting:
2 tablespoons water
1 1/4 cup powdered sugar
2 egg yolks, beaten
2 cups almonds, blanched or
 chopped

Dough: Cream butter and powdered sugar thoroughly. Add cream and egg yolks. Gradually stir in flour until dough is stiff enough to roll. Refrigerate dough for one hour.

Sprinkle a board with 1/4 cup powdered sugar and 1/4 cup flour. Place chilled dough on board and roll out to 1/4 inch thick. Cut with star-shaped cookie cutter and place cutouts on ungreased cookie sheets. Bake at 375˚ for 15 to 20 minutes, until edges turn slightly brown. Cool.

Frosting: Combine water, powdered sugar, and beaten egg yolks. Frost cooled cookies and sprinkle almonds on tops.

Plain cookies can be frozen. Frost 2 days before serving. Allow frosting to harden before storing in cookie jar.

Kisses
Sněhové Kopečky

Mrs. Leroy Mollet,
Stanley, North Dakota

These Christmas cookies are baked slowly because they "dry out" rather than bake, the late Mrs. Mollet informed her daughter, Elizabeth Bolen of Burlington, Wyoming.

3 egg whites
2 cups sugar

Beat egg whites stiff until peaks hold. Add sugar gradually and continue beating until very stiff. With a spoon, swirl on a greased cookie sheet. Bake at 200˚ for 1 hour. Cool on cookie sheet and store in a cool, dry place (such as a box lined with wax paper).

Bobbin lace pillow stuffed with prairie hay. Torchon, Cluny, Russian and Burges laces can be made with these bobbins. Pillow was formerly owned by Mrs. Josephine Dhooge, mother of Mrs. Standley Hoffman, who donated it to the Wilber Czech Museum, Wilber, Nebraska.

Holiday Fruit Bread
Vánočka

Ella Brochtrup,
David City, Nebraska

This fruit bread is a "must" at the Brochtrup home every Christmas. It also makes a wonderful Christmas gift, says Mrs. Brochtrup.

2 cups flour, divided
1/4 cup sugar
1 pkg. granular yeast
1/8 teaspoon salt
1/8 teaspoon mace
1/2 cup milk
1/4 cup margarine
3 eggs, room temperature
1/2 cup walnuts, chopped
1/2 cup raisins
1/2 to 1 cup candied fruit

Rum Syrup:
1/2 cup sugar
1/3 cup water
2 teaspoons rum flavoring

For the bread, thoroughly mix 3/4 cup of the flour, sugar, yeast, salt, and mace. In a saucepan, combine milk and margarine over low heat. Add to the flour and yeast mixture and mix at medium speed for 2 minutes, scraping bowl occasionally. Add the eggs, 1/2 cup of the flour and beat for 2 minutes at high speed. Add remaining 3/4 cup flour and beat 2 more minutes at high speed. Cover and let rise in a warm place for 1 hour, or until bubbly. Add fruits and nuts. Turn into a greased and floured 2-quart Turk's-head pan or tube pan. Let rise for one hour, until bubbly. Bake at 350° for 40 minutes. Immediately after removing from oven, prick the surface with a fork and pour hot rum syrup over cake. After syrup is absorbed, remove cake from pan and cool on wire rack. After cooling, frost with powdered sugar frosting.

Rum Syrup: Combine all ingredients in a saucepan and bring to a boil. Slowly pour over cake.

Christmas Twist
Houska

Mrs. Leroy Mollet,
Stanley, North Dakota

2 tablespoons dry yeast
1/2 cup water
1 teaspoon sugar
8 cups flour
1/2 pound butter
1/4 teaspoon mace
grated rind of 1/2 lemon
1 egg
2 egg yolks
1 cup sugar
1 pint milk
1/2 cup almonds (mixed with a
 little flour)
1 cup raisins
egg white
poppyseed

Soak yeast in water and 1 teaspoon sugar. Place flour in large mixing bowl and work in butter, mace, lemon rind, eggs, sugar, milk, and soaked yeast. Add almonds and raisins. Form a soft dough and knead until smooth. Let rise. When risen, cut dough in half. Then cut each portion into 9 pieces (4 large pieces, 3 smaller pieces, and 2 small pieces). Braid the first 4 pieces. Braid the 3 pieces. Twist the 2 pieces. Stack. Brush with egg white. Let rise and sprinkle with poppyseed. Bake at 350° for 1 hour. Makes 2 loaves.

Kolaches

Cottage Cheese Kolaches
Tvarohové Koláče

Joanne Petrick Dinken,
Issaquah, Washington

Basic Yeast Dough:
1/2 cup margarine
1/2 cup lard
3/4 cup sugar
1 cup boiling water
2 pkgs. dry yeast
1/2 cup lukewarm water
1/2 cup cold water
1 1/2 teaspoons salt
4 egg yolks or 2 eggs, beaten
6 cups flour

Filling:
1 1/2 cups cottage cheese,
 drained or dry
1/4 cup sugar
1 tablespoon lemon juice
1 egg, beaten
1/4 cup nuts, chopped
maraschino cherries, halved

Dough: Cream shortenings and sugar. Add boiling water and mix. Cool to lukewarm. Dissolve yeast in lukewarm water and add to first mixture. Stir in cold water, salt, eggs, and flour. Mix until smooth. Grease sides of bowl and top of dough with melted shortening, cover and refrigerate overnight.

To make kolaches, form the cold dough into walnut-size balls and place on greased pan. Brush with melted lard or margarine and place in closed oven that has been preheated for only 2 minutes at 250˚ and turned off. Let dough remain in oven until light and soft to the touch. Make indentations in the rolls by punching with your fingertips, then fill with 1 rounded teaspoon of desired filling. Bake at 450˚ until brown, about 10 minutes.

Filling: Mix first five ingredients. Fill kolaches. Place half a cherry on each kolach before baking.

Variation: Use raisins (quantity optional) and 1/2 teaspoon each of vanilla and cinnamon, instead of lemon juice and nuts.

Kolache Dainties
Koláčky

Vilma Nejdl,
Ely, Iowa

2 packages yeast
1/2 cup coffee cream, warmed
2 tablespoons sugar
4 cups flour, sifted
3/4 pound butter
6 egg yolks
1/4 teaspoon mace
1/4 teaspoon salt
1/2 teaspoon grated lemon rind

Dissolve yeast in lukewarm cream, add sugar, and set aside to rise. Put flour into bowl and cut in butter until mixture is crumbly. Add beaten egg yolks to yeast mixture, add spices and lemon rind and add all to crumb mixture and beat until dough is stiff and smooth. Cover and place in refrigerator overnight. The next day roll out dough 1/4 inch thick and cut into small squares, approximately 2 inches square. Fill with your choice of filling. Brush each corner with beaten egg, bring corners together and seal securely. Brush tops of the kolaches with beaten egg, place on ungreased pan, bake 10 to 12 minutes at 400˚. Yields 6 1/2 to 7 dozen.

Kolaches with Cheese Filling

Mrs. Emilie Bacik,
St. Louis, Missouri

Many Czechoslovakians are now sponsoring festivals and special events, which means party recipes for big crowds. Mrs. Emilie Bacik shares the kolach recipe (which is over 100 years old) used by St. John Nepomuk Church, St. Louis. It's for those who are always looking for another way to prepare this favorite Czechoslovak pastry, even if thousands have to be made.

"We always have the kolachy available for our Czech Festival in May and for our Homecoming in September," *says Rosella Vanac, secretary of the church. "They are a big drawing card for our affairs, as hardly anyone makes them the way we do."*

Dough:
6 cups sugar
6 ounces yeast
1 gallon milk
4 1/2 pounds margarine
1 1/2 pounds butter or lard
5 tablespoons salt
16 to 20 pounds flour
12 whole eggs
6 egg yolks
grated rind from **3 large lemons**
3 tablespoons mace

Filling and Topping:
30 pounds baker's cheese (Made from skim milk, it is softer and finer-grained than cottage cheese).
18 egg yolks
8 1/2 pounds sugar
grated rind from **3 large lemons**

Dough: Dissolve sugar and yeast in warm milk. Let stand until yeast rises to the top of the liquid. Beat together margarine and butter. Add yeast mixture to margarine mixture. Sift salt with flour. Slowly add half of the flour to other ingredients. Fold in eggs, egg yolks, lemon rind, and mace. Beat well after each addition. Add remaining flour a little at a time. Dough should be very soft. Do not add too much flour. Let rise until dough doubles in size.

After dough is doubled, form each kolach by taking a heaping teaspoon of dough, flattening it, and adding one teaspoon of the cheese filling. Roll into a ball and place on a greased pan. Grease the outer edge of the ball of dough. Make a dent in the middle and fill with more cheese filling or your favorite poppyseed, apricot, or prune filling. Bake at 400˚ for 12 to 15 minutes or until light brown. Makes about 30 to 60 dozen, depending on size.

Filling and topping: Beat the cheese until it is light and creamy. Add egg yolks and beat well. Add sugar and grated lemon rind.

Marion Dolney sold kolaches at the Holiday Folk Fair, Milwaukee.

Kolaches

Mákové Koláče S Drobeni
(Koláče or Kolačky)

Františka Brzoň Paleček,
Munden, Kansas

An artist, Františka specializes in organic abstract personality portraits. She also paints historic scenes and wildlife, and sculpts. Františka has had many one-woman art shows. This recipe was developed by Františka, who often freezes the kolacky and warms them before serving. The drobeni recipe used here for topping was given to Františka by her mother, who was born near Humboldt, Nebraska. Františka's grandmother was Austrian and Bohemian and her grandfather was Bohemian. They sailed to the United States in 1868.

Dough:
1/4 cup water, lukewarm
2 packages (1/4 ounce each)
 dry yeast
2 teaspoons sugar
3/4 cup butter, melted
2 cups milk, warm
4 egg yolks
2/3 cup sugar
1 teaspoon salt
7 to 8 cups all-purpose flour, sifted
 (more or less according to brand)

Poppyseed filling:
1 cup poppyseed, finely ground
1 cup milk
1 cup sugar
10 soda crackers, crushed

Drobeni:
3/4 cup sugar
3/4 cup flour
2 tablespoons butter
2 teaspoons vanilla

Dough: Combine water, yeast, and 2 teaspoons sugar in large mixer bowl. Let mixture stand at room temperature, then mix in remaining ingredients. Mix until smooth.

Let rise in a warm place, about 98°. When doubled in size, punch down and let rise again. When doubled in size, pinch off pieces the size of a large black walnut. Grease hands and roll in bun shape. Put on 11x17-inch greased, warm pans. Flatten each bun with hand to 3/8 inch thickness. Let rise in a warm place. When risen, dent the centers and fill with fruit butter, poppy seed, or cottage cheese fillings. Let rise again until light and bake at 400° until golden brown. Brush with melted butter. Makes about 4 dozen.

Filling: Combine ingredients and simmer on low heat for 5 minutes, stirring often. If too thick, add a little more milk. Cover pan until used. Fills about 2 dozen kolacky.

Drobeni: Crumble first three ingredients together, stir in vanilla, and sprinkle on kolacky before baking.

"Eat and be merry. Good Luck!"
 —Frantiska Brzoň Paleček

Michelle Dellamuth, Boddicker Czech Showcase Dancer, Cedar Rapids, Iowa.

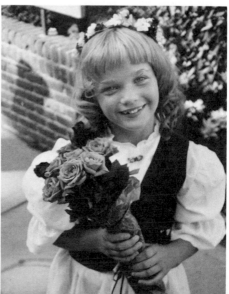

163

Kolaches
Koláče

Geraldine Smola,
Ross, North Dakota

Dough:
1/2 cup lukewarm water
1 pkg. yeast
1 cup milk, lukewarm
1/2 cup sugar
1 teaspoon salt
1/2 cup shortening, melted
5 to 5 1/2 cups flour
2 eggs

Apricot or Prune filling:
3 cups dried apricots or prunes
1/4 cup sugar
1/4 teaspoon cinnamon

Poppyseed filling:
3 cups poppyseed, ground
1 cup milk, or more as needed
1/2 cup sugar or 1/3 cup honey

Streusel topping:
1 cup butter
1 cup sugar
1 1/2 cups all-purpose flour

Soak yeast in water. In separate bowl, mix milk, sugar, and salt. Add shortening. Add 2 cups flour and mix. Add eggs and yeast and mix well. Set aside until spongy and bubbly. Add remaining flour and mix well. Set aside to rise. Punch down and let rise again. Roll out into small balls. Let rest for 10 minutes. Press down in the middle and fill with following fillings. Brush edges with beaten egg. Top with streusel. Bake at 400° for 12 minutes, until brown.

Prune or apricot filling: Stew prunes or apricots. Cool. Run through food grinder. Add sugar and cinnamon.

Poppyseed filling: Place ground poppyseed in saucepan. Pour in milk and sugar or honey. Slowly bring to a boil. Cool.
Streusel: Combine butter, sugar and flour and mix until crumbly. Sprinkle on kolaches before baking.

Pineapple: Mrs. Lumir J. (Norma) Newmeister of Cedar Rapids, Iowa uses this filling with her kolache recipe

Pineapple filling:
1 can (13 1/2 ounces) sweetened, crushed pineapple
1/4 cup water
1/4 cup sugar
2 tablespoons cornstarch
2 tablespoons butter

Cook pineapple, water, sugar, and cornstarch until thick. Stir in butter. Cool filling before using.

Kolache Capitals

Two towns claim to be the kolache capital—Montgomery, Minnesota, population 2,400, and Verdigre, Nebraska, which has 600 residents.

In this friendly competition, the word "kolache" is neutral. In Verdigre, the word is kolach (KO-lach). In Montgomery, it's kolacky (ko-LACK-ey).

Kolache, kolach or kolacky, it's a great boost for each town's annual Czech Festival. In Montgomery, it's the last weekend of July. Verdigre celebrated its centennial in 1987. Its festival is in June each year.

Kolaches
Koláče

June Herdliska Zeising,
Sioux City, Iowa

This recipe is from June's grandmother and was given to June by her aunt, Bertha Herdliska Kurth.

Dough:
2 packages dry yeast
1/2 cup milk or water, lukewarm
2 teaspoons sugar
2 teaspoons flour
1 cup butter
1/3 cup sugar
1 teaspoon salt
1/2 cup egg yolks
1 pint rich milk (or half and half)
2 egg whites
8 cups flour

Poppyseed filling:
1 1/2 cup poppyseed
1/2 cup water
1/4 cup sugar
1 egg
cinnamon (optional)
raisins (optional)
nutmeg (optional)

Dissolve yeast in warm liquid. Add sugar and 2 teaspoons flour. Mix and set in a warm place until bubbly. In a large bowl, adding one ingredient at a time, cream well the butter, sugar, salt, and egg yolks. Scald the rich milk and cool to lukewarm. Combine yeast mixture, creamed mixture, milk, egg whites, and flour. Knead well until dough is not sticky. Cover and let rise in a warm place until double in size. Knead down dough. Pinch off walnut-sized balls. Place balls on greased cookie sheet. Indent in the middle and fill with poppyseed filling. Let rise for 20 to 25 minutes. Bake at 350° for 12 to 15 minutes.

Poppyseed filling: Boil poppyseed and water for 5 minutes. Cool. Add sugar, egg, and spices.

Kolaches
Koláče

Marilyn Ziskovsky,
Swisher, Iowa

"My mom, Mrs. Milo Benesh," writes Marilyn, "likes to bake these every weekend, and when we go visiting she always sends a couple dozen home with us. On Monday morning those kolaches really hit the spot with us and our five children."

3 packages dry yeast
1/2 cup warm water
1/2 cup sugar
2 teaspoons salt
2 cups milk
3/4 cup vegetable oil
6 1/2 to 7 cups flour
8 egg yolks, beaten (or 4 whole
 eggs, beaten)

Dissolve yeast in 1/2 cup warm water. Combine sugar, salt, warm milk, and oil. Beat in 3 cups flour. Add dissolved yeast. Beat, then let rest 10 to 15 minutes. Add eggs and remaining flour. Beat until smooth. Let rise until double in size. Form into balls and place on greased baking pans. Let rise again. Make indentation and fill with a fruit filling such as strawberry, apple, cherry, prune, or a poppyseed or cottage cheese filling. Let rise again. Bake at 475° until brown, about 10 minutes. Watch closely, as they bake quickly. Makes 4 to 6 dozen kolaches, depending on size.

Kolaches
Koláče

Mildred Riehle
Spillville, Iowa

Mildred Riehle won first place in the Iowa State Fair for her kolache recipe. Now that they have moved into town from the farm she says baking daily keeps her too busy for compulsive house cleaning. Her kolaches are lightly browned, beautiful, shining, and very light as people from miles around can testify. There is nothing quite like a Mildred Riehle kolache. The farm is operated by the Riehle son, an only child, and his wife. There are eight kolache-fed grandchildren.

Mildred Riehle

1/2 cup sugar
1/4 cup lard
3 egg yolks
1/4 cup butter
1/2 cup hot mashed potatoes
2 1/2 cups milk, scalded, cooled
 to lukewarm
1 1/2 teaspoons salt
2 tablespoons instant active dry yeast
8 cups flour, divided
1 whole egg, beaten

Filling suggestions: prune, apricot,
 poppy seed or cherry.

With an electric mixer beat sugar, lard, eggs, and butter until creamy. Beat in potatoes, milk, and salt. Combine yeast and 4 cups flour, beat with an electric mixer for 3 minutes. Using dough hook, beat in remaining flour. (Dough should not be as stiff as for bread.) Grease top with lard. Cover with plastic wrap; let rise until doubled. Punch down; let rise 45 minutes. Turn onto lightly floured board; pat out about 1/4-inch thick. Cut into 2-inch squares with pizza cutter. Put about 1 tablespoon filling onto each square. Stretch opposite corners to center and pinch together.

Place on greased baking sheets far enough apart so kolaches do not touch while rising. Cover with plastic wrap; let rise 30 to 45 minutes. Brush with beaten egg. Bake in 400° oven 10 minutes until nice and brown. Remove from oven and brush with melted butter. Makes 5 dozen.

Bread Dolls
A Treasured Folk Art

By Anna Petrik

Czechoslovak women have always used dough in their folk art. Dough was formed into edible specialty breads for religious holidays. These ranged from decorated braided breads to gingerbread formed with wooden molds into figures of animals, religious symbols, or even landscapes.

Gradually non-edible bread dough and salt dough figures were developed. These could be saved and used over and over for a number of years. Examples can be found in Czechoslovakian museums today.

A favorite subject for both edible and non-edible dough was and still is "The Fall of Man" with Adam, Eve, the Snake, and a fruit tree, usually apple.

How to Do It

Working non-edible dough takes many forms and there are many recipes, but this one works well for small as well as large figures:

4 cups all-purpose flour
1 cup table salt
2 teaspoons dry mustard (optional —this will make the figures a bit
 darker)
1 1/4 cups water
2 teaspoons glycerin
Oven 250°
shiny cookie sheet sprayed with non-stick coating
lightweight florist's wire

Combine salt, flour, and mustard in a large bowl. Add glycerin to water, then add liquid to dry mixture. Stir until water is absorbed and dough forms into a ball. It should be workable like soft modeling clay. If it seems dry, add more water, a teaspoon at a time, until the right consistency is reached. You should not need more than an additional one-fourth cup.

Turn dough out on a lightly floured board and knead until smooth and workable. Put it all in a plastic bag and keep closed. The dough will refrigerate, but it must warm to room temperature to be worked again and it should be used within 3 or 4 days.

Forming the Figures

First, cut a short length of florist's wire, bend into a loop (for hanging), and have it ready to work into the top of whatever figure is to be formed. Larger, heavier pieces will require more than one loop if the piece is to be hung. One will have to kind of "see" the point of balance as forming takes place, and position the loops accordingly.

Then pinch off small amounts of dough and form the figure, animal, or ornament. For large pieces it is well to form over florist's wire (lightweight) to provide strength to a hanging piece both before and after it is baked.

Hair, grass, roofs, etc., are dough forced through a garlic press. Try to keep the thickness of the work consistent for even baking, but one-fourth to one-third inch makes baking easier and a substantial, sturdy piece. Plain water brushed on what must be "glued" will help dough pieces stick together.

On the "fattest" parts of the figure, like knees or elbows, or any portion that should be larger, prick the dough with a toothpick before baking.

Bake at 250° on cookie sheet until figure is completely dry. It takes experience to know just how long to bake, but work should be in the oven 4 to 6 hours if it hasn't been formed perfectly flat. If an arm or leg, or some thin spot seems to be browning too fast, cover only that part with a bit of foil.

Finishing

After the work has cooled, it must be sealed. There are many sealers, but the easiest and fastest is clear, quick-drying lacquer or varnish. Give the piece three coats, allowing time to dry between coats. Be sure to spray front, back, and edges. Moisture is not kind to salt dough, and the lacquer will seal the salt inside. After it is completely dry, it can be painted, and acrylic artist's colors work very well. These dry quickly and various shades can be mixed from one palette. Allow at least 24 hours for drying, and then seal with lacquer again.

How to Make Dolls of Corn-Husks

A Pioneer Czech-American Craft

Corncob girl doll

Select the soft, white husks growing next to the ear, the softer and more moist the better. Then dampen them a little in water, to make them more pliable. Next, pick from your entire stock the most perfect piece you can find, the softest, as well as widest. Double it across the center, and place a piece of strong, coarse thread through it, as in Figure No. 1. Lay this aside. Next place the stiff ends of two or three husks together, and folding other husks in lengthwise strips, wind them around the ends thus placed, until they make what you consider the proper size for a head, according to Figure No. 3. Taking the husk you laid aside, as in Figure No. 1, draw it, as in Figure No. 2, until it is bunched tightly. Tie it securely, placing it entirely over the husks you have been winding. Tie thread underneath the head, around the neck, and you have the head as in Figure No. 4.

Next, divide the husks below the neck in two equal parts, and folding together two or three husks, place them lengthwise through the division for the arms, as in Figure No. 5. Holding them in place with the thumb and fingers, proceed to fold alternate layer upon layer of husk over the shoulders, first one and then the other, letting the layers extend down both front and back, and cross each other on the chest and back. If you wish to make the chest fuller than the back, add a few husks, placing the ends just over the tips of the shoulders, and letting them extend only down the front. Then, when you think the form is properly shaped, cover the whole neatly with carefully selected husks, and tie securely about the waist with strong thread, as in Figure No. 6.

Finally, divide the husks in two below the waist, and wind each part neatly with thread, trimming them off at the feet; this forms the legs. Then, giving the arms a twist or two, tie and trim them at the wrist, and bind them to the body for an hour or two, to give them a downward tendency. You will then have your doll complete, as in Figure No. 7. These dolls can be of all sizes, from a foot long to a finger's length, the small dolls serving as babies for the larger ones.

To make the girl doll, you must first find a young ear of corn, one on which the silk has not turned brown; then, with a crab-apple for a head and a leaf of the corn, you have your materials. Roll part of the leaf, as indicated in Figure No. 8, for the arms; then, with a small twig, fasten the head to the arms; stick the other end of the twig into the corncob, and the doll is ready for dressing.

Figure No. 1 The first husk

Figure No. 2 The first husk, bunched together

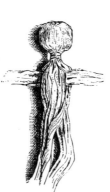
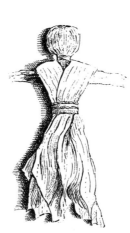
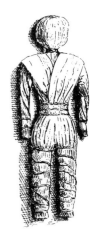

Figure No. 3 *Figure No. 4* *Figure No. 5* *Figure No. 6* *Figure No. 7*

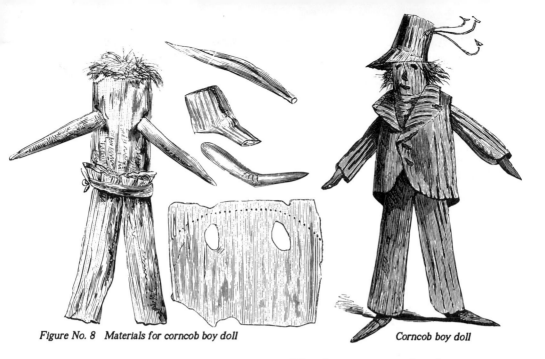

Figure No. 8 Materials for corncob boy doll

Corncob boy doll

Figure No. 8 Materials for corncob girl doll

—From St. Nicholas Magazine, 1881

The bonnet is made of a leaf, just where it grows from the stalk, and is fastened with a thorn. Before putting the bonnet on, however, the silk must be pulled up over the head, to form hair. Make the skirt and scarf from part of the leaf. Thorns are used to form the features, as well as to fasten on the clothes.

The boy doll requires little explanation. A corncob forms the body and head. The legs are a portion of the leaf rolled up and fastened to the body with a strong piece of grass. Wild beans are used for the arms and feet. The cap is made from the same part of the leaf that forms the girl's bonnet, only it is placed on the head differently. Rose-bush thorns, as in the other doll, are used for the features, and the coat is cut from the corn leaf.

171

Planning a Festival?

The Czechoslovak people have always had a highly developed sense of form. They delighted in utilizing ceremonies to accentuate the rhythm of life. The end of harvest, the beginning of spring, weddings, baptisms, holidays, and the completion of a house or other major project called for ceremony, for celebration, for festival.

If your community, club, or organization wants to stage a successful Czechoslovak festival, one important point might make it a whopping success: Keep it Czechoslovak! It is only reasonable that if an Apple Festival is held, only Apple events and foods will be in the spotlight. And if a Czechoslovak festival is to draw crowds, it must feature the Czechoslovak ethnic, and celebrate all things Czechoslovak!

Festivals are more than fun. Fun may be the short-term purpose, but an ethnic festival also has a long-term purpose: the preservation and cultivation of tradition.

If breakfast is served in a tent for visitors, serve something Czechoslovak, like scrambled eggs with mushrooms. The bakery items available for purchase should be kolaches or houskas, not Danish kringles. Contests should have an ethnic flair. Stage a Czech Bake-Off, a contest for Czech baked delicacies. This event celebrates the fine art of Czech baking while encouraging Czechoslovaks to maintain their baking traditions. Stage a kolache-eating contest!

Crown a Czech Prince and Princess. Yes, there is a rule of eligibility that the contestants are to be of Czechoslovak descent. A contest of this type focuses on Czechoslovak pride. In Cedar Rapids, the Czech Heritage Foundation sends two or three high school students to Czechoslovakia in the summer. The Prince and Princess contests help to identify teens who might wish to apply for this summer travel experience.

Hold a Czechoslovak Heritage Parade. Stage a non-competitive pageant of Czech costumes. Encourage as many as possible to create costumes to wear to your festival. One or two participants may own authentic costumes, but remember that most costumes are just fun clothes, in wash-and-wear fabrics. If you insist on a purist attitude, most people will not participate because of the high cost of authentic costumes.

A Czechoslovak Embroidery Workshop displays beautiful needlework while those who will keep the art alive are being taught. Contact local Sokol groups or other organizations, or church circles in which ladies still quilt socially. Ask them to set up and demonstrate for visitors to your festival. Search out someone who knows how to tat or make bobbin lace. If this artist is 100 miles away, perhaps your state has an Arts Foundation that funds such programs.

Czechoslovak egg decorating may be celebrated in similar manner. Show off this art during your festival. Methods for egg decorating are found in this book and in other places. Treat your artist like the celebrity he or she is. Write press releases for newspapers, television and radio stations about these artists and their work. Use this copy to publicize your event weeks before it is held.

Events that are not directly Czechoslovakian can be refocused to blend nicely. For instance, if you want to hold a popular 5,000-meter race, tie that event into a tribute to the Sokol zeal for fitness of mind and body.

Take a new look at the area where your event is to be held. The Cedar Rapids Czech Village is on the banks of the Cedar River. Merchants have utilized that river to Festival advantage. Raft races have been held, recognizing the historical significance of the river to the early Czechoslovaks. Merchants take charge of specific events and contests. For instance, the Village baker prepares and donates many dozens of kolaches and helps "time" the contestants in the Kolache-Eating Contest. One merchant, who owns a bait shop, sponsors a Carp Fishing Contest. Hundreds of fishermen enter this event, with a prize of $100 for the one who lands Mr. Big. The second-place winner receives a custom-made fishing rod. Festival guests love to see the winning entries on ice and on display at the Village Bandstand area.

In Cedar Rapids, St. Joseph Day is observed each March 19, a celebration which claims roots in Bohemia and admits to a certain proximity to the St. Patrick's Day celebrated by the Irish each March 17.

It all makes for three days of fun times, beginning with green including green beer, and shifting to red beer on St. Joseph Day. You can also buy red bread. There are discounts in Czech Village stores for all Joes and Josephines who buy red items on March 19. Proceeds of a St. Joseph Dance are used to send teen-age students to visit Czechoslovakia in the summer.

Involve your entire community in partnership with your organization's festival. Czech Village partners include the local Jaycees (Junior Chamber of Commerce), boat club members, church circles, booster clubs, Boy Scout troops, and individual volunteers representing many organizations. To my

knowledge, no organization has ever declined a request for help with Czechoslovak festivals. Your excitement is contagious.

Open your festival with American and Czechoslovak flag-raising ceremonies. The Czech Village festivals are opened officially this way: First, a color guard from a local American Legion raises the American flag to the music of *The Star Spangled Banner,* the national anthem. This is followed by the raising of the flag of Czechoslovakia by costumed Czechoslovaks to the music of the Czechoslovak national anthems played in their entirety and sung in Czech and Slovak. This is a beautiful ceremony.

And music! This is a tough one, but stand firm if you are a festival organizer. Music sets the entire festival atmosphere. You will hear that "the kids won't attend if you don't hire rock bands," but the "kids" can listen to radio 24 hours a day and get their fill of that music.

Feature Czech dancing! Import musicians and dancers if you must. Your crowds come to a Czech festival. Don't disappoint them.

Many festivals stage amateur talent shows. During Czech Village festivals, one big success has been the Button Accordion Contest. A local Czech band co-sponsors this event with the Czech Village Association. As many as 20 button accordianists vie for trophies by playing two selections, a waltz and a polka, for the delighted audience. This combined entertainment-contest costs nothing but the price of the trophies.

The polka reportedly was first danced in 1830 by a young girl at Elbeteinitz in Bohemia. Give the polka a share of your event. Polka club members can help you, and if you must charge admission to pay for big bands, these fun-loving people will buy the tickets.

—*Pat Martin*

Where the Festivals Are

A partial listing. Dates subject to changes; it's well to check.

Florida
Lake Worth, Florida—Slovak Day at Slovak Gardens, first Sunday in March.
Masaryktown, Florida—First Sunday in March, Tomás Masaryk's birthday; Last Sunday in October, Czechoslovakian Independence Day is celebrated with Czechoslovak foods and entertainment.

Illinois
Countryside-Berwyn, Illinois—Annual Moravian Day, end of September (in 1989, the 50th annual).
Cicero-Berwyn, Illinois—Houby Days, first weekend in October. The Cermak Road Business Association sponsors a Houby Parade; President Bush rode in the parade during his 1988 campaign.

Iowa
Cedar Rapids, Iowa—Five annual celebrations: St. Joseph Day, March 19; Houby Days (Mushroom Days), the Saturday and Sunday after Mother's Day in May; Ethnic festival, last weekend in May; Czech Village Festival, the Saturday and Sunday after Labor Day in September; St. Nicholas Day, celebrated in the Czech Village the Saturday preceding December 6, which is the feast day of the Czechoslovak Santa Claus,
Ely, Iowa—Czech Day, July 4.
Protivin, Iowa—Protivin Czech Days, August.
Traer, Iowa—Czech Folk Fest, mid-July.

Kansas
Caldwell, Kansas—Czechoslovak days at Sumner County Fair, first Saturday in September.
Cuba, Kansas—Early in April.
Wilson, Kansas—Czech festival in "the Czech Capital of Kansas," last Saturday in July.

Louisiana
Deville, Louisiana—Czech Heritage Days, early March.

Michigan
Wyandotte, Michigan (just south of Detroit)—Czechoslovak-American Festival.

Minnesota
Montgomery, Minnesota—"Kolacky Kapital of the World," Kolacky Days, last weekend of July.

Missouri
Sugar Creek, Missouri—Annual Slavic Festival.

Nebraska
Clarkson, Nebraska—Czech Festival, June.
David City, Nebraska—Butler County Czech Heritage Days, last week in June or first week in July.
Fremont, Nebraska—Polka Party, February.
Lodgepole, Nebraska—Czech Heritage Day, October.
Omaha, Nebraska—Sokol South Festival, June.
Utica, Nebraska—Nebraska Polka Days, April.
Verdigre, Nebraska—Kolache Days, June.
Wilber, Nebraska—"The Czech capital of Nebraska," Czech Festival, first full weekend in August.

New Jersey
Holm, New Jersey—Slovak Heritage Festival, Garden State Arts Center, September.

New York
Astoria, New York—Annual Czechoslovak Festival, Memorial Day weekend.

Ohio

Cleveland, Ohio—Annual Slovak Heritage Festival, Labor Day weekend, sponsored by Slovak Dramatic Club. In June there is an annual Memorial Service for the people of Lidice, Czechoslovakia. St. Joseph Day, March, Karlin Hall. Český Den (Czech Day), second Sunday of June (68th in 1990), DTJ farm, Auburn Corners, Ohio. Annual Czech Catholic Day, third Sunday in July (72nd in 1990). Harvest Festival at DTJ farm, Auburn Corners, Ohio, August. St. Wenceslaus Day is celebrated the last Sunday in September, the feast day sponsorship rotating among the Czech Catholic churches in Cleveland. Holiday Fair, Bohemian National Hall, November.

Metamora-Seward, Ohio—The first weekend in August is the Czech Polka Fest, sponsored by the celebrated Czech Dancers Polka Club, Inc. Annual Duck Dinner in November. Annual Jiternice Dance in late winter. This area is near the Michigan border, about 12 miles west of Toledo, or some 120 miles west of Cleveland.

Parma, Ohio—Slovak Heritage Festival, Labor Day weekend.

Oklahoma

Prague, Oklahoma—Annual Kolache Festival, first Saturday in May.

Yukon, Oklahoma—Czech Festival in "The Czech Capital of Oklahoma," first Saturday in October.

Pennsylvania

Erie, Pennsylvania—Polka Festival, September 1, 2, 3, & 4.

Pittsburgh, Pennsylvania—The Pittsburgh Folk Festival for 24 ethnic groups, including Slovak-Americans, is held annually the Friday, Saturday, and Sunday before Memorial Day.

University Park, Pennsylvania—Slavic Folk Festival, Penn State University, April 4, 8, & 9.

South Dakota

Tabor, South Dakota—Czech Days, third Monday and Tuesday in June.

Texas

Caldwell, Texas—Caldwell Kolache Festival, second Saturday in September.

Corpus Christi, Texas—Czech Heritage Society Festival, spring.

Ennis, Texas—Polka Festival: Czech meals and street dancing, first weekend in May.

Rosenberg, Texas—Fort Bend County Czech Fest, first full weekend in May.

Victoria, Texas—Fall Festival.

West, Texas—Westfest, Labor Day weekend.

Wisconsin

Hillsboro and Yuba, Wisconsin—Český Den, second Saturday in June.

Milwaukee, Wisconsin—Holiday Folk Fair.

Phillips, Wisconsin—Czechoslovakian Community Festival, third weekend in June.